GESTURES OF DESPAIR

in Medieval and Early Renaissance Art

GESTURES
OF
DESPAIR

in Medieval and Early Renaissance Art

MOSHE BARASCH

NEW YORK UNIVERSITY PRESS
New York • 1976

In my book *Gestures of Despair* the illustrations (here listed by their numbers in the book) are reproduced by permission of the following institutions:
By permission of ALINARI, Florence—Figs. 1, 2, 3, 9, 13, 18, 28, 34, 34a-b, 36, 37a-b, 38, 42, 43, 43a-b, 46, 51, 53, 54, 58.
By permission of Archivio Fotograf. di Gall. e Mus. Vaticani—Fig. 48.
By permission of Gabineto Fotografico Nazionale, Rome—Figs. 4, 32, 33.
By permission of GIRAUDON, Paris—Fig. 57.
By permission of Instituto Centrale di Restauro, Rome—Fig. 39.
By permission of Prof. H. W. Janson, New York—Figs. 49, 52, 53a.
By permission of (the late) Prof. M. Meiss, Princeton, N.J.—Figs. 19-27.
By permission of the Victoria and Albert Museum, London—Fig. 50.
The other illustrations are based on my private photographs.

Library of Congress Cataloging in Publication Data

Barasch, Moshe.
 Gestures of despair in medieval and early Renaissance art.

 Includes bibliographical references and index.
 1. Gesture in art. 2. Despair in art. 3. Art, Medieval.
 4. Art, Renaissance—Early Renaissance.

I. Title.
N5975.B37 709'.45 76-4601
ISBN 0-8147-1006-9

Introduction

Gestures expressive of moods are so old and so common that one is inclined to relate them to a basic layer in human nature, a layer so fundamental that it would seem beyond historical change. It is tempting to believe that this is particularly true for the expression of such primordial experiences as despair and fear. Yet such gestures do have a history in which variations and transformations prevail. That history shows that archetypal patterns of human behavior are intricately interwoven with cultural trends, social heritages, and the emotional attitudes of different historical periods.

The significance of gestures for the study of art needs no further elaboration, and scholars have been aware of it. So far, however, not much has been done in tracing the history of specific gestural motifs. The few available studies, some of real merit, deal mainly with highly conventionalized gestures which are consciously performed as part of religious or political rituals. In the present study I have concentrated on some more emotional, spontaneous gestures which are usually performed without premeditation. The group of gestures, the representation of which is analyzed in this book, can be defined both in mood—despair and fear—and in formal configuration, consisting mainly in raising the hands to the head.

I am fully aware that the present study cannot make any claim to completeness. My intention was to find a narrow path in a vast territory which, I am convinced, is full to treasures.

The study was begun during a temporary membership at the Institute for Advanced Study in Princeton, New Jersey, sponsored by the late Professor Millard Meiss. Professor Meiss's interest in this study was a source of encouragement. Discussions with other friends and colleagues often helped me to better clarify a problem, or to find a link between works of art belonging to different periods. Their generosity will be acknowledged in the notes. Here I would like to record my gratitude to Professor H.W. Janson for his constant interest and assistance.

M. B.

Contents

List of Illustrations

GESTURES OF DESPAIR

in Medieval and Early Renaissance Art

I

The Damned

LAST JUDGMENT

The profound transformation that affected Italian art from the late thirteenth century onward achieved one of its most significant expressions in the vitalization of body movements and of gestures. The tendency to enliven attitudes and motions of course pervaded the entire art of the period, but it crystallized with particular intensity in the representation of certain themes. A focal theme in this process is that of the damned in the Last Judgment. While the elect are quiet and restrained, the damned often perform violent and dissonant movements. In the art of the thirteenth and fourteenth centuries, there emerged a group of gestures culminating in actions of violent self-injury which seem to have been regarded as appropriate for the representation of the damned in the Last Judgment. Examples can be found in the works of Nicola Pisano, Francesco Traini, Giotto, and Fra Angelico, and at Torcello.

NICOLA PISANO

In Nicola Pisano's Siena pulpit the damned perform many passionate movements. I would like to concentrate on the detail of the nude woman, seen from the back (Fig. 1), who upon being dragged by a demon, raises her hand to her mouth. Most of the hand is obscured by the head and the neck; only the thumb and a small part of the hand are visible. But the posture suggests that the woman in her sudden terror has abruptly raised her hand to

1

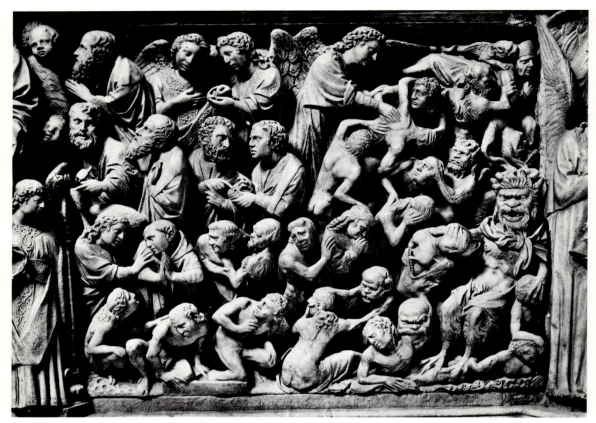

1. Nicolo Pisano, Pulpit, (detail), Siena.

her mouth, and is perhaps even biting it. The motif, which is not prominent, becomes meaningful when it is seen in the context of similar, and more explicit, gestures of the damned in later works of art. An inquiry into the origin of this figure convinces us that Nicola Pisano carved this particular gesture deliberately. As is well known, he probably derived the motif of a nude female figure seen from the back from Roman sarcophagi. This has been pointed out in relation to a figure of the elect,[1] but it also seems to hold true for the figure of the sinner. The posture of the latter (very similar to that of the woman in the group of the elect) and the closely related organic modeling of the nude bear witness, I believe, to its ultimate origin in classical art. It is, therefore, significant that the specific gesture of raising the hand to the mouth does not occur in any of the sarcophagi that Nicola Pisano could have known. In his classical models the analogous figure keeps one hand on the ground (in Pisano's work this arm is pulled at by a devil) while the other is either obscured from sight or grasps a windblown drapery. Instead of covering the hand, Pisano raised it to the mouth. This particular gesture is thus an addition of the thirteenth-century artist, and it is significant that he carved it in a representation of the damned in the Last Judgment.[2]

TORCELLO

Another early example of the motif (not too far removed from Nicola Pisano in region as well as in time) may be found in the monumental *Last Judgment* in Torcello. In the right half of the lowest stratum six groups of sinners are represented being tormented in hell. In one group are depicted four naked men standing erect, who do not seem to be suffering any obvious kind of torture (Fig. 2). The second figure from the right is clearly biting his hand. The figure to his left holds his right hand, clasping it with his left, before his mouth.[3] In the next compartment (to the right) an elderly man, immersed up to his breast in some liquid, perhaps molten metal, also seems to be biting his hand, although the hand is held slightly below the mouth, and there is no actual contact between fingers and lips. Both the standing and the immersed figures maintain their bitten hands (which are seen from the back) in a horizontal position which echoes the horizontal composition of the mosaic as a whole. In spite of a certain stiffness in the representation of the movements, the action of biting the hands is, at least in the first example, clearly readable.[4]

GIOTTO

A variation of the motif of the bitten hand in the art of the early fourteenth-century, and one of extreme violence and emotive power, may be seen in Giotto's *Last Judgment* in the Arena Chapel in Padua, where one of the damned (placed between Lucifer's feet) forces both his hands into the corners of his mouth, as if he wished to tear his face apart (Fig. 3). His dramatic action accords with the symphony of death and destruction that surrounds the damned; it is a focus of the expression of fear and despair that permeates

2. Torcello, *The Last Judgment* (detail).

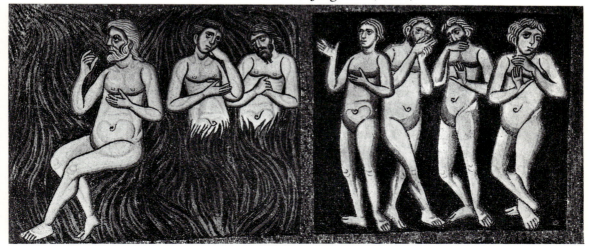

the bitten spot. In yet another *Last Judgment* by Fra Angelico, also in the Academy of Florence, the damned perform a variety of gestures of despair and self-injury. Particularly conspicuous is the figure of a sinner, bent forward, who, standing in front of another, grasps his head with one hand and impetuously bites the other.[6] Such motifs obviously made a deep impression in Fra Angelico's circle, and were employed in his workshop.[7]

The few examples which I have briefly described indicate that a continuous tradition existed of representing the damned in the act of inflicting pain on themselves. There are, of course, differences in the representation of the motif, arising from diverging stylistic tendencies, from an increasing degree of naturalism, and from a changing attitude toward the rendering of emotions. The changes and differences, however, should not obscure the basic fact that all these representations constitute one broad pictorial tradition, the variations and transformations only attesting to the vital force of the pattern, which persisted in spite of artistic modifications.

THE MEANING OF THE GESTURES

The meaning of these gestures of self-injury is not as obvious as they may appear at first glance. Do they represent an actual punishment meted out to the damned? Or are they rather an expression of fear and despair? And, since in representations of the Last Judgment such gestures occur only in the group of the damned, could they not be a feature that characterizes as sinners the figures performing such actions?

In scholarly literature such gestures (mainly the biting of the hand in the Torcello mosaic) have occasionally been noted but have not been thoroughly discussed, and the few remarks made on them are vague and do not lead to any conclusions. Jessen, probably the first art historian to observe this motif in Torcello, assumed that the upright naked figures represent the wrathful while the immersed are the perjured. Jessen vaguely implies a connection between the character of the figures and the gestures they perform. He does not substantiate his explanation, but rather admits its doubtfulness. The main difficulty, he says, is that neither Byzantine painting nor the *Guide of the Painters* of Mount Athos yields any parallels.[8] Voss, in his little book on the Last Judgment in art, also noticed the gesture, but did not comment on it; he simply said that in Torcello "sinners gnawing their hands" are represented.[9] A. Bouillet attempts an interpretation. In this particular context he mentions only the standing figures who "seem to move in darkness, symbolizing those who have committed the sins of anger and violence; two of them gnaw their hands".[10] Like the other authors, Bouillet does not substantiate his interpretation, but the idea implied in his observation is that, as violence is carried

TORCELLO

Another early example of the motif (not too far removed from Nicola Pisano in region as well as in time) may be found in the monumental *Last Judgment* in Torcello. In the right half of the lowest stratum six groups of sinners are represented being tormented in hell. In one group are depicted four naked men standing erect, who do not seem to be suffering any obvious kind of torture (Fig. 2). The second figure from the right is clearly biting his hand. The figure to his left holds his right hand, clasping it with his left, before his mouth.[3] In the next compartment (to the right) an elderly man, immersed up to his breast in some liquid, perhaps molten metal, also seems to be biting his hand, although the hand is held slightly below the mouth, and there is no actual contact between fingers and lips. Both the standing and the immersed figures maintain their bitten hands (which are seen from the back) in a horizontal position which echoes the horizontal composition of the mosaic as a whole. In spite of a certain stiffness in the representation of the movements, the action of biting the hands is, at least in the first example, clearly readable.[4]

GIOTTO

A variation of the motif of the bitten hand in the art of the early fourteenth-century, and one of extreme violence and emotive power, may be seen in Giotto's *Last Judgment* in the Arena Chapel in Padua, where one of the damned (placed between Lucifer's feet) forces both his hands into the corners of his mouth, as if he wished to tear his face apart (Fig. 3). His dramatic action accords with the symphony of death and destruction that surrounds the damned; it is a focus of the expression of fear and despair that permeates

2. Torcello, *The Last Judgment* (detail).

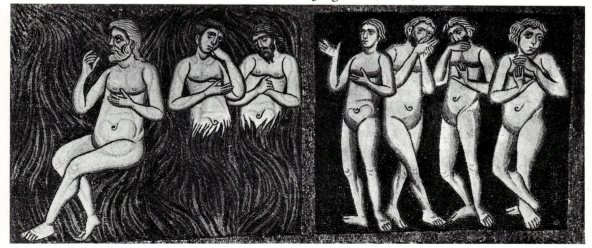

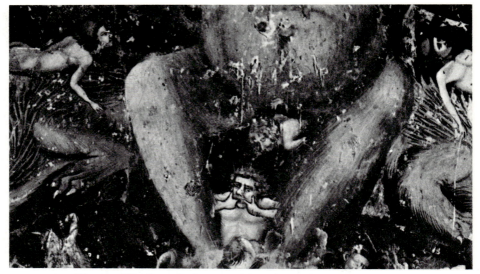

3. Giotto, *The Last Judgment*, (detail), Arena Chapel, Padua.

4. Francesco Traini, *The Last Judgment*, (detail), Camposanto, Pisa.

the whole group. Giotto's figure is important in the historical context. It shows, on the one hand, that in the early fourteenth-century the image of the sinner causing himself suffering was a traditional, established element in the depiction of the Last Judgment. On the other hand, it proves that by now the archetype of the sinner wounding himself could undergo clear transformations (rending the face instead of biting the hands) without losing its original meaning, and even without changing its basic formal pattern.

FRANCESCO TRAINI

In fourteenth-century art similar gestures are frequent, although usually they are not as violent as in Giotto's mural. In Francesco Traini's *Last Judgment* in the Camposanto of Pisa (Fig. 4) three sinners raise their hands to their mouths, the motif being the climax of a wide range of gestures of despair and imploring. One of them (second row from the top, fourth figure from the right) raises his hand to his mouth in sudden terror. Another (first figure from the left in the same row), pushed by an angel, bows his head and turns it inward in a self-protective movement strongly expressive of fear, looking at the retributory angel from the corners of his eyes, and bringing his hand to his mouth. A third figure, finally, a bearded man in an oriental headdress (third row from the top, second figure from the left), brings this gesture to its most dramatic, and psychologically most plausible, form. Struck by terror, he abruptly raises his hand to his mouth, the finger almost touching the lips. Traini's representation differs from the former ones in many respects, the most important probably being that in the Camposanto fresco the damned do not hurt themselves, although their movements are motivated by the emotions of fear and despair.[5]

FIFTEENTH CENTURY: FRA ANGELICO

The tradition of depicting the damned inflicting pain on themselves persisted in fifteenth-century art. In Fra Angelico's work, for instance, similar motifs may frequently be observed. In a *Last Judgment* in the Academy of Florence (Fig. 5) two of the damned bite their hands; one of them, a Pope or a bishop, does so with an angry, furious face, lending an immediate emotional reality to the act of self-injury. In another *Last Judgment* by Fra Angelico, now in Berlin (Fig. 6), the same gesture occurs again, rendered with the full vigor of quattrocento naturalism. One of the damned, perhaps patterned after Giotto's figure in Padua, is wildly tearing his face. Another sinner, placed in hell, bites his hand, and drops of blood issue from

the bitten spot. In yet another *Last Judgment* by Fra Angelico, also in the Academy of Florence, the damned perform a variety of gestures of despair and self-injury. Particularly conspicuous is the figure of a sinner, bent forward, who, standing in front of another, grasps his head with one hand and impetuously bites the other.[6] Such motifs obviously made a deep impression in Fra Angelico's circle, and were employed in his workshop.[7]

The few examples which I have briefly described indicate that a continuous tradition existed of representing the damned in the act of inflicting pain on themselves. There are, of course, differences in the representation of the motif, arising from diverging stylistic tendencies, from an increasing degree of naturalism, and from a changing attitude toward the rendering of emotions. The changes and differences, however, should not obscure the basic fact that all these representations constitute one broad pictorial tradition, the variations and transformations only attesting to the vital force of the pattern, which persisted in spite of artistic modifications.

THE MEANING OF THE GESTURES

The meaning of these gestures of self-injury is not as obvious as they may appear at first glance. Do they represent an actual punishment meted out to the damned? Or are they rather an expression of fear and despair? And, since in representations of the Last Judgment such gestures occur only in the group of the damned, could they not be a feature that characterizes as sinners the figures performing such actions?

In scholarly literature such gestures (mainly the biting of the hand in the Torcello mosaic) have occasionally been noted but have not been thoroughly discussed, and the few remarks made on them are vague and do not lead to any conclusions. Jessen, probably the first art historian to observe this motif in Torcello, assumed that the upright naked figures represent the wrathful while the immersed are the perjured. Jessen vaguely implies a connection between the character of the figures and the gestures they perform. He does not substantiate his explanation, but rather admits its doubtfulness. The main difficulty, he says, is that neither Byzantine painting nor the *Guide of the Painters* of Mount Athos yields any parallels.[8] Voss, in his little book on the Last Judgment in art, also noticed the gesture, but did not comment on it; he simply said that in Torcello "sinners gnawing their hands" are represented.[9] A. Bouillet attempts an interpretation. In this particular context he mentions only the standing figures who "seem to move in darkness, symbolizing those who have committed the sins of anger and violence; two of them gnaw their hands".[10] Like the other authors, Bouillet does not substantiate his interpretation, but the idea implied in his observation is that, as violence is carried

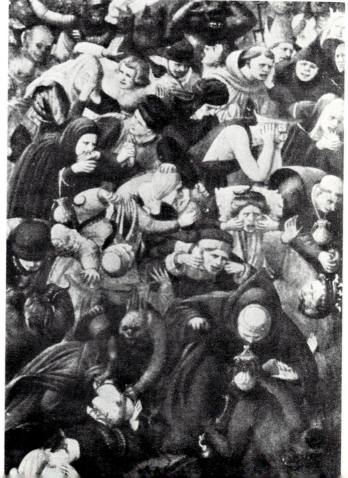

5. Fra Angelico, *The Last Judgment*, (detail), Academy, Florence.
6. (right) Fra Angelico, *The Last Judgment*, (detail), Berlin.

out by the hand, it is the hands of the violent that are punished. Following this trend of thought, the self-affliction of the damned should be understood as representing tortures in hell.

Such an interpretation does indeed seem to fit the Torcello mosaic, but it does not explain the whole group of closely interrelated gestures. It cannot be applied to other representations of the Last Judgment in which the damned, trembling with fear and despair, are still outside hell, and are not yet being tortured. Moreover, the interpretation suggested by the authors mentioned above does not explain what seems to be the crucial feature of this motif, namely, that the hands are not punished by another figure (a demon, for instance, as is usual in other contexts of the Last Judgment) but are bitten by the sinners themselves. The same applies, of course, to the other gestures, like the laceration of the face. Obviously the meaning of the gestures is more complex, and any attempt to understand it must be undertaken on a broad basis.

II

Some Medieval Motifs

When looking for the sources that might have inspired the artists of the thirteenth and fourteenth centuries in depicting the damned tearing their faces and biting their hands, we realize how rare these gestures are in early medieval art. They do not seem to occur in representations of the Last Judgment before the thirteenth century. The history of the Last Judgment as a theme of art — a much debated issue[1] — lies, of course, outside the scope of this study. Representations of the Last Judgment are pertinent to our investigation only if they depict the damned as performing actions of self-injury, particularly by applying a hand to the face. In some of the early works the damned are highly expressive in their bent and twisted postures, but they do not perform the specific actions under discussion, and no particular significance is given to the hand.[2]

THE LAST JUDGMENT

A deeper concern with the figures of the damned and the tendency to transform the movement of their hands into expressive formulas may be observed in illuminated manuscripts of the eleventh and twelfth centuries. In this art one also finds more frequently the motif of the hand being violently raised to the face. The examples discussed below offer no more than a representative sampling. In an Ottonian manuscript, one of the damned touches his forehead with his hand in a tense gesture;[3] but the touching of the forehead is a traditional gesture of sadness which differs from

9

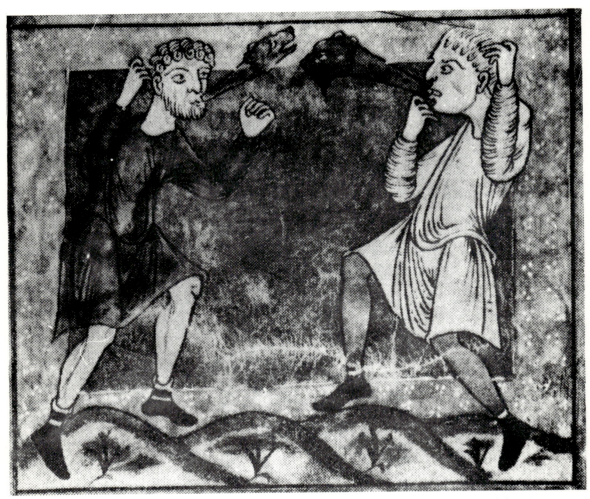

7. The Damned, Munich, Bayerische Staatsbibliothek, Cod. lat. 935, fol. 60 r.

self-injury both in the specific action portrayed and in broad emotional mood.[4] In the Bamberg Apocalypse a sinner, represented in a dramatic bodily posture, holds his hand to his cheek.[5] This gesture, too, is based on a well-known classical formula of restrained sadness and does not suggest self-injury. The Wolffenbüttel Gospels abound in expressive postures of the body and movements of the hand. Here one of the damned holds his clapsed hands with intertwined fingers against his chin or cheek, another supports his head with the hand, performing another famous classical gesture of sadness, and a third figure seems to pull his beard.[6] Again one notices that in the wealth of expressive movement, acions of self-injury such as the biting of the hands and tearing of the face are not portrayed.

Probably the earliest representation of a Last Judgment that shows some vague relation to the specific group of gestures investigated in this study is an

illumination in the so-called Prayer Book of St. Hildegard (ca. 1170) depicting the elect and the damned (Fig. 7).[7] It differs from the well-known compositional scheme of the Last Judgment in that the damned, symbolized by only two figures, are placed not opposite the elect but beneath them. Both sinners pull their hair with force, and the one on the left holds the curved fingers of his hand to his mouth in a very tense posture. This illumination has the high emotional pitch of gestures of self-affliction, but the action performed remains ambiguous; it may be interpreted as rending the face or biting the hand, but it may also be read as an emotional movement portraying no specific action. Representations of the damned in twelfth- and probably also in thirteenth-century illuminated manuscripts do not seem to go beyond such ambiguous movements.

Nor do we find the gestures under discussion in early monumental representations of the Last Judgment. In what is probably the earliest large-scale depiction of the Last Judgment in Italian art, the mural in S. Angelo in Formis,[8] the damned — a separate group — perform dramatic movements. Particularly remarkable are two naked sinners, a man and a woman, who are being pushed by devils toward hell;[9] both in posture and in their backward-turned heads they recall a well-known motif from the Expulsion of Adam and Eve from Paradise (a theme to which we shall shortly return). However, actions of self-injury are not depicted in S. Angelo in Formis.

A representative example of a later stage in the depiction of the Last Judgment is the well-known Vatican panel, a work of the mid-thirteenth century.[10] In this work the movements of the damned are articulate both in general posture and in the gestures of the hands. At the lower edge of the panel a man raises his hand to his face in a rhetorical movement, with the palm turned outward; and a woman wipes away her tears with her veiled hand. The woman's gesture is a classical formula for depicting grief and weeping,[11] which did not disappear in the Middle Ages. It is illuminating to notice that, although the artist of the Vatican panel was obviously attracted by the figures of the damned, he did not represent gestures suggesting self-injury.

In Tuscan art of the late thirteenth century dramatic gestures, which in formal arrangement and expressive mood more closely approach actions of self-injury, appear more frequently, sometimes in monumental representations of the Last Judgment. In the *Last Judgment* mosaic of the Baptistery of Florence, the damned form a compact and impressive group, exhibiting traditional motifs of grief and fear. Some figures hide their eyes, other cover the face with the hands or grasp the chin, two raise their hands to the

mouth.[12] But here, too, the precise action performed cannot be definitely established. The gestures may indicate the biting of the hand, but they could also be read as a forceful clutching of the beard. A central figure in this group, holding his hand to his mouth, recalls the damned in Torcello, but the posture of the Florentine figure is more dramatic and his elegant hand, with long, curved fingers, looks less rigid. An interesting detail is the group of resurrected sinners emerging from a sarcophagus. The figure to the left of the group vehemently raises his hand to his mouth.[13] Although he does not bite the hand (again the precise action performed cannot be established), the forceful movement has the emotional intensity of gestures of self-injury. These motifs announce the more precise gestures encountered in works of the early fourteenth century.

This study deals mainly with Italian art, and I shall make only a very brief comment on some works created outside Italy. In the monumental representations of the Last Judgment in French sculpture of the late twelfth and of the thirteenth century, the figures of the damned display dramatic postures of the body and expressive gestures of the hand. Whether led, chained, in a group (as in many Gothic representations), or standing freely (e.g., Autun), their twisted postures and violent movements have great expressive force. These movements, so clearly contrasting with the quietness of the elect, were perpahs intended to visualize the emotions of fear and despair, and the characterize the figures as sinners and damned.[14] Most of their gestures (like hiding the face in the plams of the hands, or grasping the neck with both hands) are traditional formulas for representing fear and mourning, the history of which can be traced back to antiquity.[15] But, as in the Italian works of art, this abundant store of gestural motifs only rarely yields actions of self-injury. Very seldom does one find a representation of the laceration of the face, perhaps the most articulate example being a figure in Autun (Fig. 8).[16] Additional examples of such gestures may certainly be found in French sculpture, but they do not seem to be of the same significance for French as they are for Italian art of roughly the same period.

As I have said earlier, the depictions of the damned in the Last Judgment so far mentioned are only a sampling. Nevertheless, they permit the drawing of a tentative conclusion: the specific gestures of self-injury do not precede the late thirteenth century, and they attain full articulation only in the early fourteenth century.

EXPULSION OF ADAM AND EVE

In medieval art similar gestures occur also in scenes other than the Last Judgment. The Expulsion of Adam and Eve from Paradise is intimately

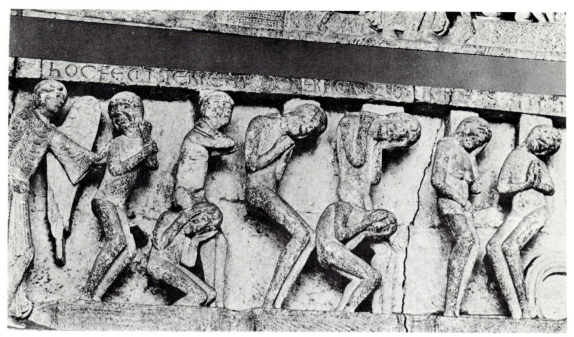

8. Autun, Cathedral (detail).

related to the Last Judgment in theological meaning, and often also in artistic form.[17] The numerous representations of the Expulsion from Paradise — a major theme in Christian art — do not follow a set pattern, but certain gestures frequently recur. In many depictions of the Expulsion from Paradise either Adam or Eve holds one had to the mouth, recalling the self-injury of the damned. In a few rare cases this gesture may indeed have been meant as an indication of self-injury. However, even if it has not this specific meaning, it is so close in form and expression to the gestures of the damned that it may have exerted some influence on later artists representing the Last Judgment. I shall briefly discuss some of the major examples, proceeding from later to earlier works.

In *The Lord Rebuking Adam and Eve* on the bronze doors of S. Zeno in Verona, Adam holds his hand to his mouth in an expressive gesture of pain, or perhaps of remorse.[18] In the small compass of the panel the hand and the lower part of the face almost merge into one mass, insufficiently articulated, and one cannot say whether Adam is grasping his chin, or only holding his hand to his mouth in a gesture of sadness. In other scenes, however, the artist is able to distinguish between closely related gestures in spite of the small-ness of the panel. Thus, in the *Expulsion from Paradise*, the following panel on the same door, Adam protects himself with one hand against the pushing angel, and clearly holds the other under his chin.[19] The latter gesture appears again in the *Last Judgment* on the same door.[20] Since the gesture is clearly readable in the other scenes, one cannot exclude the possibility that the merging of hand and chin in the *Rebuking* is meant to suggest some self-injury. Be that as it may, in composition, posture, and mood Adam is

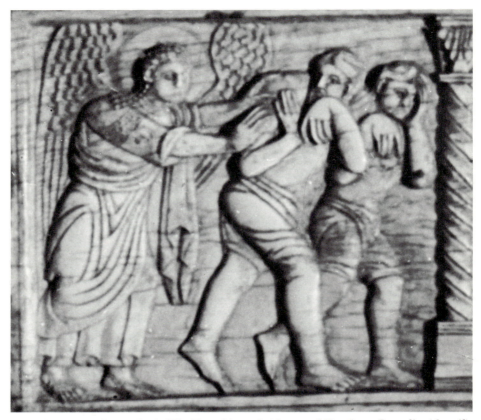

9. Salerno, Cathedral, *The Expulsion of Adam and Eve from Paradise* (detail).

closely related to later representations of the damned in the act of injuring
themselves.

In the *Expulsion from Paradise* on an ivory panel in Berlin an interesting
variation of this motif is suggestively rendered. Adam touches his mouth
with the back of his hand, which is sharply bent at the wrist.[21] The motif of
the hand forcefully bent at the wrist, giving the impression of its being
fractured, occurs frequently in medieval art, and we shall encounter it
several times in this study. On a silver cross in the Lateran Museum in
Rome,[22] Eve turns her head backward to the Paradise from which she has
been expelled (a symbolic movement that has been noticed in the Middle
Ages)[23] and at the same time performs a vehement mourning movement;
Adam, pacing forward in grief, keeps his "fractured" hand to his mouth in a
tense gesture expressing despair. In an eleventh-century relief in the

Cathedral of Salerno (Fig. 9) these movements are of a particularly dramatic quality. Caught in the conflicting actions of going forward and looking backward, Adam's figure is twisted in an almost spiral movement. Protecting himself with one hand against the retributory angel, he touches his mouth with the other, which is again sharply bent at the wrist. This hand — a good example of the "fractured" position — is oversized, protrudes from the figure, and becomes the compositional focus of the whole group.[24] Again the action performed cannot be identified; one may perhaps even doubt if the artist intended to portray a specific action. However, the dramatic form of the fractured hand, which nothing in the relief explains, makes the gesture a symbol of destruction arising from the figure itself. The nearby Eve grasps her head with both hands, a motif which we have already encountered.

The fractured hand is frequently encountered in Carolingian book illumination, and may have originated in this art. In the famous page of the Vivian Bible illustrating the first chapters of Genesis the Rebuking scene occupies a whole register. One of the figures (probably Adam) holds his hand to his mouth in a tense gesture, the meaning of which is obscure.[25] The other figure (probably Eve) is represented in a bent position, suggesting tension and fear. Her head is hunched between her shoulders, and looking at the rebuking angel from the corners of her eyes, she raises the back of her hand to her mouth. The hand, barely touching the lips, is shaped in the fractured form. The emphasis placed on gesticulation and the articulated form of the fractured hand are characteristic of the artist who illuminated this page, an artist whose main conern was — as Köhler noticed — the conveying of expression by means of gesture, particularly of the hand.[26] However, the motifs of the hand held to the mouth and of the fractured hand are not confined to this particular artist. In Carolingian illuminated manuscripts they occur several times, although usually they are less articulate and expressive. Often they are probably meant to express melancholy meditation, thoughtfulness, and attentive listening.[27] But in the *Expulsion from Paradise* in the Vivian Bible Eve holds her hand to her cheek in a gesture which, I believe, cannot be interpreted as quiet sadness; it represents either the tearing of the face or a violent pulling at the cheek. In either case it is a movement suggesting that the figure is performing an act of self-injury.[28]

The reading of these gestures is often inaccurate since the actions represented cannot be clearly identified. It is, therefore, not surprising that modern scholars should have interpreted them quite differently. Tikkanen, for instance, stressing the antique origin of the fractured hand, described the motif in medieval art as "the hand that hangs limply from the chin," expressing quiet sadness.[29] In antiquity this gesture was indeed a formula for

the expression of restrained, subdued sadness,[30] but in Carolingian art it was transformed into a more dramatic motif. This follows from both stylistic and iconographic arguments. In medieval art the posture of the figures performing this particular gesture is not "limp." They are either turned inward in a movement of self-protection, or they are represented in intricate Maenad-like positions, meant to express dramatic emotions, especially fear; the relaxation necessarily connected with "limpness" cannot be discovered in them. But probably more important for the correct reading of the gesture is the iconographic context of the scenes in which it appears, a context which always indicated extreme tension. Both the Rebuking, i.e., the moment when Adam and Eve realize the fatal consequences of the Fall, and the actual Expulsion from Paradise, could not have been understood as simple "sad" events, but rather as the most disturbing turning-point in the divine design. The meaning of these scenes was, needless to say, the emergence of destruction and death, caused by man himself. With this meaning in mind, the movement of the hand—a gesture of paramount importance in the representation of the scenes mentioned—should also be understood as a manifestation of tension. The fractured hand (a motif which I was unable to find in pre-Carolingian periods) seems to have been an artistic expression of despair, vaguely associated with the idea of self-caused destruction. If our interpretation is correct, it would seem to follow that the fractured hand is a precursor of the more explicit gestures of self-destruction that appear in the art of a later period.

Works of medieval literature, particularly mystery plays describing the Expulsion from Paradise, shed some light on the gestures of Adam and Eve as represented in works of art of the period. The story of Adam and Eve has been presented on the stage since the twelfth century. We do not know, of course, what gestures were actually performed by the actors; the artistic representations of the biblical narrative, almost the single contemporary means of recording gesture, cannot in the present context be regarded as a source. There is, however, one mystery play, the so-called *Adam Play*, composed in the twelfth century, where the author gives valuable instructions as to the most significant gestures which the actors should perform.

The author of the *Adam Play* demands that the gestures be closely related to the changing contents of the play. The actors, he says, should perform movements appropriate to the things of which they are speaking.[31] He refers in a general way to Adam's "sad face" and "gestures of pain." But he also gives more detailed instructions. Whenever Adam or Eve mention Paradise, they should look in that direction and raise their hands. Their sadness after the Expulsion should be demonstrated by their sitting in a "crouching position," and by tears flowing over their faces.[32] More violent movements

are also mentioned, to be performed when events reach a climax and emotions are particularly distrubed. Thus, when Adam learns that the devil has planted thistles in the fields, he is to throw himself to the ground, an old gesture of despair.[33] Other passionate gestures, conveying the emotions of grief, despair, and remorse, are restricted to actions of the hand violently turned against the body. The most important of these gestures are those of beating the breast and striking the thighs,[34] both old gestures with an almost continuous history of representation since antiquity. These gestures, which have been described by modern scholars as "crude movements,"[35] clearly fall into two groups: (i) gestures of quiet sadness and submission to fate (crouching position, weeping) which indicate a durable situation' (ii) gestures of a tense and dramatic character (beating of breast, striking of thighs) which can endure only for brief moments. The latter consist of actions of self-injury.

In a later mystery play representing the story of the fall and Expulsion, another dramatic point of action is mentioned: at the very moment when Adam tasted the forbidden fruit he desperately grasped his throat to prevent himself from swallowing the apple; the pressure he applied to his throat brought about the "Adam's apple," the symbol of sin.[36] This gesture must have evoked, however vaguely, the image of self-strangulation; it certainly belongs among the motifs for study here.

The particular gestures of tearing the face and biting the hands are not described in the mystery plays. Nevertheless, these texts help us to understand the representation of such gestrues in works of art. They certainly speak agains the interpretation of the fractured hand as being simply limp. They also show that in medieval representations of the Expulsion violent actions of self-injury are appropriate.

The damned in the Last Judgment and the Expulsion from Paradise are the major themes calling forth represenations of gestures of self-injury. These themes hold in common an iconographic meaning and an emotional attitude. One may assume that the specific gestures which appear in these two scenes evoked particular associations and acquired, in the course of time, a more or less articulate meaning.

But even before the emergence of these articulate motifs, related gestures appeared in other contexts which, although less precisely delimited than are the two principal themes, seem to have some affinity with the damned in the Last Judgment and the Expulsion from Paradise. It is characteristic of the

earlier representations that their meaning is equivocal. Thus traditional
mourning gestures, mainly inherited from antiquity, somtimes acquire an
implicit connection with sinfulness. The tearing of the hair, for example, the
most typical gesture of the wailing women of antiquity,[37] is represented in
the Utrecht Psalter in scenes which have the meaning of both death and
damnation. Women frantically clawing at their hair are seen in the illumina-
tions to Psalms 49:11 ("Their graves are their everlasting homes") and 109:0
("May his children become fatherless and his wife a widow").[38] One notices,
of course, that these verses are not only lamentation formulas, but have clear
overtones of a curse.

The tearing of the hair is a well-known formula of mourning, frequently
occurring in both classical literature and classical art, as will be shown, but it
does not seem to occur in the art of the seventh and eighth centuries. Its
reappearance in the early ninth century may therefore be considered as a sign
of the "Carolingian Revival." It continues to be represented in the following
centuries, often simply as a gesture of mourning (especially in depictions of
the Massacre of the Innocents),[39] but sometimes also in some vague connec-
tion with sin. Thus, in the Prudentius manuscript from St. Gall this gesture
is performed by a woman in the scene of the Fall of the "Cultura Deorum."[40]

Equally equivocal is the meaning of the somewhat related gesture of
clutching the beard. Althoug less violent than the pulling of hair and rending
of the face, clutching the beard has some connections with gestures formerly
discussed, both in the emotional mood it betrays and in the formal arrange-
ment of a forceful juxtaposition of the hand to head. Representations of this
gesture in medieval art have recently been discussed, and different interpre-
tations of it have been offered. On the one hand, it has been shown that
defeated and disturbed heretics clutch their beards, the motif being exp-
lained as a "sign of great tension." In the Ildefonsus manuscript of Parma the
heretic Jovinianus, defeated by Ildefonsus, clutches his beard.[41] The same
gesture appears in an illumination of the Codex Aureus representing Christ
exorcising the demon from a possessed man.[42] But, on the other hand, it has
been shown that in medieval art the same gesture is frequently performed by
holy figures. To mention but two early examples: it appears in a late
Romanesque bronze statuette of Moses in the Ashmolean Museum Oxford,
and is performed by St. John (from the foot of the Cross of St. Bertin) in the
Museum of Saint-Omer.[43] On the basis of the two latter examples the
gesture has been interpreted as an expression of "awe in presence of the
Divine."[44] As will be shown, a similar gesture frequently appears in works of
late antiquity, especially on sarcophagi, where it also leaves room for varying
interpretations.

So far I have discussed only scenes of a religious character. In medieval art, vehement gesticulation appears also in representations of secular themes, as can be seen, for instance, in the illuminations of the Terence manuscripts. Pulling the hair, clutching the beard, and tearing at the face occur in most Terence manuscripts, but they seem to be particularly frequent and articulate in the Leyden (Leydensis Vossianus 38) and Paris (Parisus Latinus 7900) manuscripts, both written and illuminated in the tenth century.

The relationship between texts and illuminations in the Terence manuscripts is important to our study. The illuminators depicted violent gesticulation in scenes of great tension, but the texts themselves never describe such gestures and thus never directly require their representation. We may then say that the representation of actions of self-injury was the artist's means of visualizing emotional strain. A few examples will suffice to indicate the nature of this relationship. In the Leyden manuscript of *The Lady of Andros* the slave Davus is represented as he tears his hair (Fig. 10). In the text he discusses—in a long monologue—his dangerous situation from which he sees no escape, but no mention is made of any gesture.[45] In the Paris manuscript of Terence's play *The Eunuch*, a figure pulling his hair in exasperation is represented in the scene in which, in the text, Pythias angrily informs

10. Illustration to Terence's plays, Leydensis Vossianus 38, fol. 6 v.

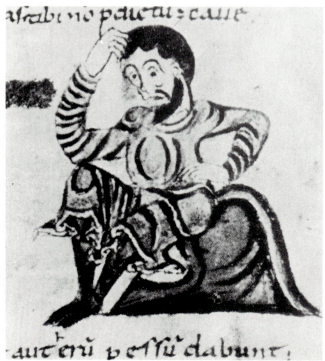

Phaedria that his eunuch has ravished a girl.[46] Most illuminated manuscripts of Terences' *Phormio* depict figures tearing their faces and clutching their beards when the text describes poor Phaedria's deep anxiety at having to raise a large sum of money at short notice, a task which he is unable to fulfill.[47]

Opinion seems to be divided on the question of the precise sources of these gestures in the Terence manuscripts. Some scholars (Sittl, Jones, and Morey) believe that they are independent of actual performances on the ancient stage;[48] others (Margarete Bieber, and before her Tikkanen) argue that they ultimately go back to stage representations of Terence's plays.[49] Whatever the particular channel of transmission, these specific gestures are certainly derived from ancient culture, rites, and art, and therefore represent an interesting example of the persistence, or revival, of antique culture in the medieval language of gestures; but at the same time they also show significant transformations.

More important in this context is the meaning attached to these gestures. Since they are not necessitated by the text, one may safely assume that in the period when they were depicted they were considerd as appropriate means of visualizing conflict and distress. It is further interesting to notice that while in ancient art these particular gestures occur primarily in depictions of mourning, in medieval renderings they never appear in this specific context but are seen as expressions of a broad scale of emotional moods.

Considering in a more comprehensive context the examples which I have discussed so far, one notices that in medieval art gestures of despair are both less frequent and less articulate than are other gestures typical for the art of the same period. It is sufficient to compare our movements with, for instance, the gestures of benediciton, of thought, and of speech.[50] While in the latter the beholder always knows what action is performed and what meaning is conveyed, in gestures of despair one often cannot determine the exact action performed and therefore cannot read the precise meaning.

However, there emerges from the works of art discussed the realization that at least one of the major contexts of the representation of self-injury in medieval art is that of sin and damnation. One may then assume that the gestures here studied were considered as appropriate expressions of that sinister realm (although this need not be the only meaning attached to them). In chapter IV I shall come back to some of the motives of such a relation of actions of self-injury and sin, but before turning to this difficult problem of historical interpretation, it might be useful to analyze briefly some of the antique traditions that provided the models for medieval as well as for Renaissance art.

III

Classical Sources

Many gestures in medieval art are based on antique models and conventions that underwent deep changes, both in spirit and in formal pattern, when they were adapted to Christian themes. Nevertheless, they did not lose their basic character, and a continuous history of such motifs can therefore often be traced from classical origins to fully developed Christian representations.

In turning to antiquity we face within the limits of the study, problems of definition differing from those already discussed. Many passages of ancient literature articulately describe gestures of self-injury, clearly proving that such actions were cast into stereotyped, conventional patterns. Similar actions are also frequently represented in ancient art. In the works of art, however, such gestures do not seem to have achieved a definite, conventional form. We see in ancient reliefs and paintings free variations on gestural motifs, rather than stereotyped applications of ready-made formulas. Even in typical workshop productions such as sarcophagi, which naturally tend to be conventional, the mourning gestures are indeed conceived in a traditional spirit, but their form is not definitely established. They have, therefore, a certain "spontaneous" quality, which is rare in medieval art, and which often poses difficult problems of interpretation and even of simple "reading" of what is represented.

It is important to recall that in ancient, especially in Roman, culture symbolic and expressive gestures were familiar social acts, their form firmly established and their meaning accessible to all.[1] The process of conven-

21

tionalizing gestures was enhanced by a rhetorical education which stressed the significance of body movements as a means of persuasion, in addition to the choice of words and the modulation of the vice,[2] and thereby contributed to establishing a wide range of crystallized gestures, each one being regarded as appropriate to a certain context and occasion. The theater afforded another impetus toward such stylization, particularly in Rome, where it granted an important position to the *mimus* whose play was mainly based on gestures.[3] While the Greek theater favored the play of the "ensemble" (thereby inevitably reducing the value of the individual actor's gesticulation), on the Roman stage the "star" occupied a central place, with the result that the significance of his gesticulation was necessarily increased.[4] On the ancient stage mimicry by means of costume played a rather marginal part (the actors often wearing masks), and the passions had to be expressed by modulations of the voice and movements of the body.[5] Both, moreover, had to fit the size of the theater, a condition which favored the emergence of articulate, simple, and clear movements.

But articulate and conventional gestures were not found only in the schools of rhetoric and on the stage; they also formed part of social life. Of particular importance are the mourning rites that occurred in all strata of late antique society[6] in both the East and the West. A type of action that must be described as gesticulation played a significant part in lamentation ceremonies. John Chrysostom, a Christian writer of the late fourth and early fifth century, whose passionate rejection of violent movements will be discussed in the following chapter, says that mourning consisted of two parts, of words and of gestures.[7] In the crystallized ritual of Roman *conclamationes*, acts of self-injury were prescribed by social consent. A piece of satyrical prose by Lucian ("On Funerals") shows the extent to which such actions were formalized. After describing how the body of the deceased is anointed and adorned with flowers, Lucian says: "Next come cries of distress, wailing of women, tears on all sides, beaten breasts, torn hair, and bloody cheeks. Perhaps, too, clothing is rent and dust sprinkled on the head, and the living are in a plight more pitiable than the dead; for they roll on the ground repeatedly and dash their heads against the floor."[8] Lucian refers here, of course, to the typical actions of professional wailing women, who reappear in various contexts. Yet, in spontaneous lamentations, performed not by professional mourners but by the wives and children of the dead, precisely the same actions are described. Nonnos, a late antique author, relates a scene of genuine mourning in almost the same phrases as Lucian. "Dirgefond women," he says, "tore their cheeks with their nails in mourning; they rent off the garments from their bodies and bared their chests,

beating their circled breasts with this hand and that until the blows made their blood flow. . . . Women in heavy affliction mourned one her brother, and one her father. . . and the newmade bride unveiled, unkempt, tore the clusters of her hair".[9]

THE VEILED HAND; THE OUTBURST ARMS

Keeping these literary descriptions in mind, one is not surprised to find many representations of violent gestures in the art of late antiquity.[10] As late antique art is of particular importance for medieval and early Renaissance imagery, I shall mention a few motifs which attest both the significance of gestures in the art of that period and its originality in inventing them. The representation of weeping by raising the veiled hand to the eye is probably a Roman invention, frequently occurring in sepulchral monuments of the Roman empire.[11] Another dramatic gesture, apparently also an invention of the same period, is that performed by the frantically mourning figure who, bending forward, throws its arms up and back; it is the famous Hippolytus gesture. It is interesting to notice that in European art of later periods this figure was revived at precisely the same time and in the same region where the other gestures of self-injury reached their full articulation.[12]

In spite of the wealth of dramatic gesticulation, there are but few gestures in late antique art that can be directly related to the theme of this study. Sarcophagi, often representing scenes of battle, pain, and death, of course yield many familar gestures of lamentation — women tearing their hair and beating their breasts, and men touching (or smiting?) their foreheads. Yet even on sarcophagi, the most frequently represented gestures of sadness are the more restrained movements that late Hellenistic and Roman sculptors inherited from classical Greek art (veiling of the face, and supporting the head with the hand).

VIOLENT GESTURES

Violent gestures belonging to the types studied in this work frequently occur in two groups of sarcophagi, the so-called Meleager and Hippolytus sarcophagi. I shall briefly describe some of the most important examples of the two groups. On the lid of a sarcophagus in the Palazzo Sciarra in Rome, representing Meleager's death, we see a wide range of violent gesture, increasing in intensity and dramatic force (Fig. 11). The climax is reached in the figure of Althaia (Meleager's mother, who brings about his death), who frantically tears her hair with both hands. Not far from her another woman

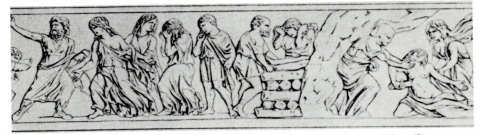

11. Rome, Palazzo Sciarra, Meleager Sarcophagus (detail).

hides her face in her hands. The precise action of the latter figure is difficult to establish; her gesture may be intended to show that she tries to avoid seeing the terrible sight, but her tense posture perhaps indicates a more violent movement. Three additional figures in the same relief raise their hands to the mouth or chin, but they do so with restraint.[13] We find similar motifs on the sarcophagus in Broadlands, Hampshire (Fig. 12), representing the hunting scene of the Meleager story; in a movement of terror Oeneus raises his hand to his mouth or chin.[14] Robert describes these gestures as

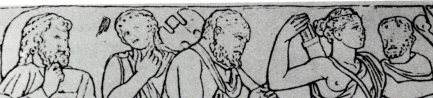

12. Broadlands, Hampshire, Meleager Sarcophagus (detail).

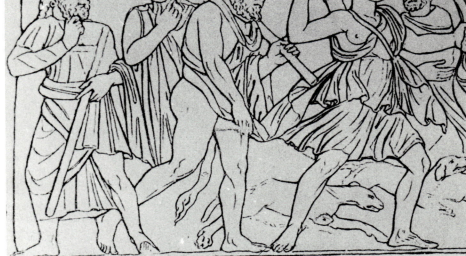

expressions of sadness ("*Trauer*"), well known from classical Greek art. It is, of course, true that in formal configuration they are derived from classical gestures of sadness. But while in classical art these gestures are restrained both in the actions represented and in the mood conveyed, in the sarcophagi they are of a more violent nature, in excess of anything of their kind known from classical art. If expressive quality is a criteron, these gestures on the sarcophagi cannot be classified simply as "sadness formulae" but must be considered as a specific group.

On the sarcophagi of a second group, representing the life and death of Hippolytus, similar gestures frequently occur. The story of Hippolytus, like that of Meleager, has been transformed into a "comprehensive picture of human passions"[15] and it is therefore not surprising that the artists who represented its dramatic scenes should have often depicted the gestures of violent passion. One sample of this group, a sarcophagus in Florence (Fig. 13), exhibits an almost full range of such gestures: on the left-hand side a woman, standing in a twisted posture, frantically tears her hair with both hands; another female figure nearby expresses her horror with reticence, showing the palms of her hands in a movement which recalls the protective gestures performed by some of the damned in the later representations of the Last Judgment. A young man, standing near the center of the sarcophagus, raises his hands to his face. His action may be understood as the wiping away of tears, but it may also have the more general meaning of sadness and lamentation without representing a particular action.[16] A similar gesture can be seen on the Hippolytus sarcophagus in the Duomo of Girgenti.[17] On another sarcophagus belonging to the same group, now in the Louvre, Theseus raises his hand in terror to his mouth or chin.[18] The same gesture is performed by Theseus on a sarcophagus in Spalato.[19] In the two last-mentioned examples the precise action performed by Theseus' raised hand is again obscure. It may be a spontaneous movement expressing sudden terror without representing a specific action, but it may also depict clutching of the beard.[20] Theseus' raised hand is sometimes particularly dramatic in quality, as, for instance, on a sarcophagus in the Lateran Museum in Rome.[21]

From these two groups of sarcophagi one finds frequently recurring and typical gestures of violence directed against the performer's own body. They always have the same meaning: the frantic tearing of the hair visualizes excessive grief; the sudden raising of the hand to the mouth or chin expresses terror and alarm. It is interesting to note that the texts relating the stories of Meleager and Hippolytus do not prescribe, or even indicate, the specific gestures represented by the sculptors. The different literary versions tell, of course, that Theseus or Oeneus was afraid, and describe the tragic mood of

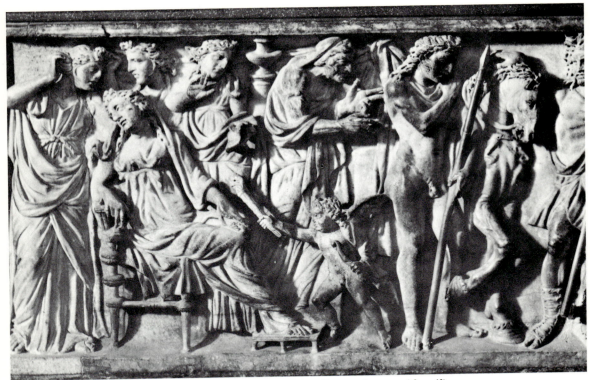

13. Florence, Hyppolytus Sarcophagus (detail).

Althaia demanding revenge for her brother's death. But they do not give a detailed account of these figures' behavior while in the grip of such emotional states.[22] The artistic representation of the specific gestures which I have described cannot be derived from literature, but rather must be understood as the artist's contribution to the visualizing of those high-pitched emotions of which the stories speak.

It is not too difficult to find some of the sources from which the artists derived these movements of self-directed violence. We know that precisely these gestures formed part of the customary mourning rites, and were typical of the behavior of the wailing women. Artists wishing to express the dramatic emotions characteristic of the Hippolytus and Meleager scenes could, so to speak, use these gestures as visual idioms.

The specific iconographic contexts in which these gestures appear on the two groups of sarcophagi seem to support the assumption that they are related to what could be observed in actual mourning. Althaia tears her hair while she is putting the fatal ember into the flames, thereby extinguishing the life of her son, and possibly causing her own death. Her gestures may be said to have a double meaning: in an anticipation of the typical mourning gesture the death she is to cause by her action is symbolically shown, and at the same time her emotional distress is given an immediate expression. In the

Hippolytus sarcophagi the tearing of the hair obviously represents the ritual mourning over the hero (whose death has already occurred), and is at the same time a means of emotional expression.

In linking the figures tearing their hair with actual mourning customs, I do not wish to exclude an artistic ancestry of these motifs as they appear on sarcophagi. Tearing of the hair is, of course, well known from works of art of a much earlier period. Female figures tearing their hair, seen in frontal view (as is Althaia's figure on the Palazzo Sciarra sarcophagus), are found in Greek archaic art,[23] and one may safely assume that the sculptors of late antiquity drew this motif from earlier artistic traditions. On sarcophagi, however, one finds variations of the same action for which precise models do not seem to exist in the art of earlier periods. An interesting example is the mourning woman, seen in three-quarter view, who is bending forward and tearing her hair (lefthand side of the sarcophagus in Florence, Fig. 13). Her posture is not typical of the art of earlier periods, and one has the impression that in creating this figure the sculptor was influenced by the actual sight of wailing women.

The meaning of the other gesture, raising the hand to the mouth, is not so unequivocal as that of tearing the hair. It is intuitively understood as an expression of startled fear, and both Oeneus and Theseus are indeed struck with terror at the moment when they perform this gesture. So far as I know, there is not enough textual evidence to explain this gesture,[24] and an attempt to interpret it must therefore be based mainly on the visual testimony which the ancient world has bequeathed to us. Some Greek and Hellenistic works of art do indeed seem to indicate an artistic tradition of representing fear by similar gestures. An interesting example is found in a vase painting in Berlin, on which the concluding scene of Euripides' *Antiope* is represented (Fig. 14). Here we see Dirke being dragged by the bull, while Antiope rushes from sight, raising her hand to the mouth. Since the outlines are slightly blurred, it is difficult to establish exactly the action performed by Antiope's raised hand. But whatever the specific action, this is not a gesture of quiet sadness, but a tense and highly dramatic movement, being the climax of the twisted posture of the whole body.[25] It is noteworthy that in Greek theater this particular scene was not represented on the stage but was narrated by a messenger.[26] Antiope's gesture of terror is, therefore, not a pictorial record of what could actually be seen in the theater; it is the artist, or the artistic tradition, that formulated this gesture as an expressive motif.

The raising of the hand to the mouth as an expression of shock and fear appears not only on sarcophagi and in illustrations of tragedies (both naturally tending toward an elevated style) but also in themes of a lower level. A

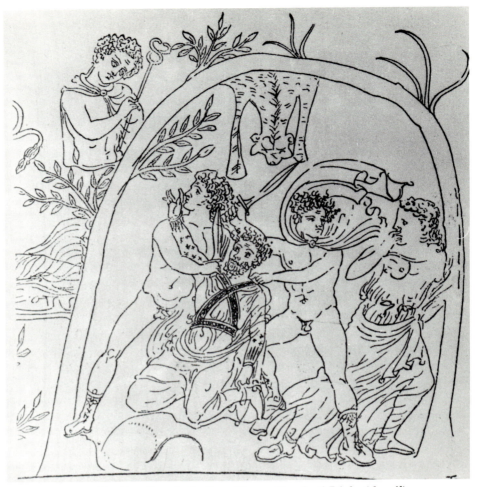

14. Berlin, South Italian Vase, *Death of Dirke* (detail).

particularly interesting example is a comedy scene, represented on a wall painting in Pompeii. Here we see an old slave mocking, or frightening, two women, a young woman standing in front, and an older one standing behind her. The young woman, who has been interpreted as a hetaera,[27] convincingly expresses her sudden fear in posture and mime. Hunching her head between her shoulders, she—so to speak, instinctively—raises her clasped hands to her mouth. The same scene has also come down to us in another work, a wall painting found in Herculaneum. Since both paintings are almost identical, it has been suggested that they go back to a common prototype, probably a work famous in antiquity and now lost.[28] It is again difficult to describe precisely the action performed by the raised hand, but all scholars agree that the woman's gesture is intended to convey sudden fear, or a similar emotion.

The examples adduced show, I believe, that the raising of the hand to the

mouth was used in large sections of ancient art as a formula for expressing fear. The gestures of Theseus and Oeneus on the sarcophagi may well have had some connection with this tradition. But this particular action has also been noticed in literature. In a more diluted form it is described by Quintilian. "I do not know," he says, "why some persons disapprove of the movement of the fingers converging toward the mouth. For we do this when we are slightly surprised, and at times also employ it to express fear or entreaty when we are seized with sudden indignation."[29] Although the gesture as described by the teacher of ancient rhetorics lacks the dramatic quality of the artistic representations, it agrees with them both in formal pattern (the converging of the fingers toward the mouth) and in emotional context (surprise, fear, and indignation). It is thus an additional illustration of the meaning attached to this gesture in ancient culture.

Dramatic, emotional gesticulation may not be a typical feature of late antique and early Christian art as a whole, but in some works of that period one finds such movements in representations of mourning and despair. An important example is the famous Vatican Vergil. In the illumination showing Dido's death (Fig. 15), a group of women perform what was obviously

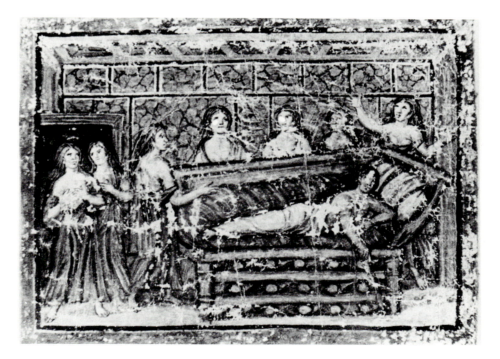

15. Vatican Vergil, *Dido's Death*.

16. Vatican Vergil, *Aeneas' Departure* (detail).

intended as a traditional mourning scene. The figure to the right throws her arms wildly sideways and out, assuming the posture of a dramatic Orans. To the left, a group of women hold their hands to their bare breasts, indicating that they are beating or tearing them, another traditional feature of the *conclamamationes*.[30] In the representation of Aeneas' departure (Fig. 16), Dido, looking out from the window, raises her hands to her unbound hair. The illumination illustrates the lines describing how Dido, while watching Aeneas' departure, beat her breasts and tore her hair.[31] In these illuminations the gestures are clearly readable and attest to the vitality of traditional formulae in late antiquity.

The throwing up of the arms as an expression of despair was a common motif in the art of that period, and may be found in both pagan and Christian works. An interesting representation is found, for example, on a relief decorating the vault of the Porta Maggiore, Rome, where one of the Discurides holds one of Leucippus' daughters in his arms. The woman throws up her arms almost vertically, the gesture clearly having the meaning of fear and despair.[32] In the Massacre of the Innocents on the famous fifth-century ivory plaque in Berlin, a mourning mother throws her hands aloft.[33] This well-known mourning gesture appears with particular force in the Vienna Genesis. It is performed by one of the woman lamenting Deborah's death and by the mourners in the lamentation over Jacob, but the frightened prisoner to whom Joseph interprets his dream also throws up one of his arms.[34]

The artist of the Vienna Genesis also used another formula for the depiction of excessive grief, the pressing of the hand to the cheek. We find it in the illuminations representing Benjamin bidding farewell to Joseph, and Joseph interpreting the dreams of the prisoners (Fig. 17); it is performed by some of the wailing women in Deborah's death, and, with veiled hands, in Jacob's death and entombment.[35] This gesture may represent various actions. Sometimes it indicates the laceration of the face, in other cases it can only have the meaning of pressing the cheek. In the scene of Joseph interpreting the dreams of the prisoners (Fig. 17), the chief butler holds one of his hands with curved fingers to his cheek while he raises the other in a protective gesture. Here, I think, the hand raised to the cheek is meant to represent the tearing of the face as a visual expression of sudden distress. A very similar gesture may be seen in Deborah's death where it obviously represents the self-affliction customary in the mourning rites. In other scenes, however, the same gesture can be interpreted only as a pressure of the hand to the face, particularly when the hands are veiled.[36] But even in the latter case it is not the restrained sadness gesture of classical art, nor does it convey the intention of controlling weeping as in some later examples; it rather has a violent and extroverted character.

The representation of grief and sorrow seems to be of particular significance for the Vienna Genesis, in respect of both style and spiritual attitude.

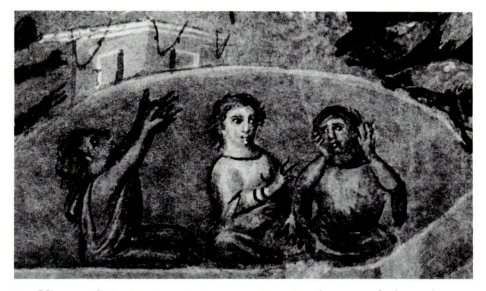

17. Vienna Genesis, Joseph interpreting the dreams of the prisoners (detail).

In style the Vienna Genesis preserves many elements of classical art. The painter who illuminated this manuscript evinces a deep feeling for the organic unity of the body, and for its ability to act and to suffer pain. In posture and movements — although not in details — the figures are indeed often rendered with an expressive naturalism which culminates in the gestures of sorrow. But behind the tendencies of style, which are largely derived from the classical tradition, there emerges a spiritual, emotional attitude which differs from that predominating in classical art; it is an attitude more typical of Christian ideas. While even in elaborate and dramatic pagan sarcophagi the mourning figures were but concomitant motifs serving to emphasize the main theme — the mythological story and its allegorical meaning, or the glorification of the dead — in some pages of the Vienna Genesis the expressions of grief and suffering become themselves the main theme. Moreover, the classical spirit of restraint that can be felt even in the Meleager sarcophagi seems to have been abandoned in the Christian manuscript. This may reflect the new conception of human suffering which, at that time, found perhaps its most significant expression in the concern with the Passion and in a new interest in the human aspect of Christ.[37] The emotionalism of the Vienna Genesis may, then, be seen both as the climax and as the end of ancient art in the representation of gestures of mourning and despair.

This brief discussion of ancient monuments does not intend, of course, to provide a survey of the gestures studied here, but only to point out some conspicuous and typical examples. Naturally, no definite conclusions can be reached from such brief investigation, but the examples adduced suggest, I think, some broad lines of reasoning.

Gestures of fear, despair, and self-affliction were frequently represented in the art of late antiquity. In the course of classifying the welter of these motifs at our disposal, it soon becomes apparent that only a few actions are represented (mainly tearing the hair, raising the hand to the mouth or clutching of the beard, perhaps laceration of the face, and that insufficiently explained gesture of touching the forehead which may perhaps indicate the smiting of it). But the artists who represented these gestures display a remarkable variety of nuance which gives the impression of richness, but also often poses difficult questions of precise reading. The very variety in representation suggests that these gestures, although age-old, have not yet been completely and finally formulated and "frozen." The wide range of variations is perhaps also due to the fact—a characteristic element of classical art—that the representation of a gesture is usually not restricted to the hand

(or to any other isolated limb) which actually performs it, but involves the posture and movement of the whole figure, and sometimes even of neighboring figures.

For present consideration, the most important aspect is that gestures of fear, despair, and self-injury obviously had definite, traditional meanings, which clearly emerge from the works of art discussed. In representing such gestures the artists clearly aimed at expressing the high emotional pitch of tragic situations, but they never used them as formulas for visualizing the character or quality of the figure performing them. These gestures are therefore not typical for sinners or the damned, nor do they even characterize figures of a lower status. The relating of such gestures to sinners is the result of Christian, medieval attitudes, which are alien to the spirit of classical art.

IV

Early Medieval Attitudes

Several considerations suggest that between the sixth and the twelfth centuries violent gesticulation, and particularly self-injury, must have acquired some pejorative connotations. As I have tried to show, in the art of that long period one rarely finds dramatic gesturing, the important exception being the rather brief span of the Carolingian Revival.[1]

The study of early medieval literature has arrived at similar conclusions, especially with regard to descriptions of lamentation. In the pre-Court period, it has been said, scenes of wailing are rare and of an extraordinary restraint. Scholars of medieval literature have stressed the "static" character of such scenes, and the "universal" style in which gestures of mourning are described.[2] It was only in later periods (roughly corresponding to the Romanesque in art) that secular literature described vehement gesticulation more frequently and more vividly.

It is not our task to investigate the reasons for this early restraint. Stylistic tendencies in both art and literature favoring hieratic images of minimal dramatic movement were certainly a significant factor in impeding the representation or description of violent self-injury. Another factor, requiring serious consideration in the context of this study, is the prevailing attitude toward violent gesticulation, and especially self-injury, as it emerged in the centuries after the disintegration of late antique culture. It is difficult to define such an attitude completely, since it never consists of a single trend, but rather has a complexity and multivalence which cannot be compressed into a rigid frame. Nevertheless, certain tendencies which are interesting as

34

background to the artitstic development can be observed, and it is only as such a background that I shall discuss some quotations from Patristic writings and early medieval literature.

The moral teachings of the Church Fathers and some trends of early medieval literature often express a firm condemnation of violent, uncontrolled gesticulation, which is frequently attributed to devils and to sinners. In Patristic literature, probably influenced by Stoic ideals, moderation in all spheres of life including that of body movements is praised as a value, and as a sign of virtue, while uncontrolled behavior and wild gesturing are considered as betraying the presence of vice.[3] The sixth-century Spanish bishop, Martin of Braga, for example, gives in his *Formula vitae honestae* detailed counsels for a moderate way of life, expressly including moderation in behavior, bodily movement, and gesture.[4] The tradition of such advice, especially recommending moderation in gesture, can be followed into later periods. At the end of the eighth century, Alcuin instructs his pupil to avoid exaggerated gesticulation.[5]

While all kinds of strong gesticulation, and the uninhibited revealing of emotions, including unrestrained laughter,[6] are condemned, gestures of lamentation are frequently singled out, and become the prototype of violent gesticulation in general.

The condemnation of passionate lamentation seems to have been widespread in the early Middle Ages. The Biblical account of Jacob's mourning over the supposed death of Joseph is theologically explained: in Jacob's time the Gates of Hell were not yet opened and, therefore, death was not merely a slumber,[7] a passage to eternal life, but rather a final end. With the appearance of Christ, however, the meaning of death changed, and this change should affect our behaviour. According to St. Ambrose, the Virgin Mary did not shed tears over the death of her son. The reasons for her restraint seem to be of a theological (belief in redemption and resurrection) as well as a moral nature. Other authors admit that she wept while standing beneath the cross, but believe that she did not lament loudly and did not perform any gestures of mourning.[8] A fifth-century author says that Christ's tears over the death of Lazarus show that our mourning should not become "bacchantically frenzied."[9]

Some of the authors mentioned provide vivid descriptions of funeral rites and of mourning gestures. An important source for the study of the mourning gestures and of the Christian attitude toward them is the writings of St. John Chrysostom. He condemns the shrill voices of lamentation, the rending of garments, the tearing of hair and beard, the clawing at the face and breast, and the embracing and kissing of the dead. These actions are described as

pagan or Jewish customs and rites, to be avoided by Christians.[10] The wailing women especially, those "gesture figures,"[11] aroused the anger of St. John Chrysostom. He was suspicious of their moral intentions. The wailing women, he says,

> make a show of their mourning and lamentation: baring their arms, tearing their hair, making scratches down their cheeks. Moreover, some do this because of grief, others for show and vain display. Sill others through depravity both bare their arms and do these other things to attract the gaze of men. . . . I have heard that many women, forsooth, attract lovers by their mournful cries, gaining for themselves the reputation of loving their husbands because of the vehemence of their wailings. Oh, what a devilish scheming! Oh, what diabolic trickery![12]

Throughout the Middle Ages the widow's frantic mourning over the death of her husband aroused suspicion. Her crying and her violent gestures of lamentation were often denounced as pagan and arising from the desire of ostentation; her behavior is suspected of being a means of attracting men. The widow's tears are compared to the proverbial "tears of the crocodile,"[13] and stories are told to illustrate the moral danger inherent in passionate mourning gesticulation and in the rending of garments. In a late medieval poem a queen mourns the death of her husband by tearing her hair and rending her clothes. A nobleman, present at the scene, is aroused to love by the sight of her body[14]

I shall briefly mention another realm where the condemnation of violent gesticulation is often clearly expressed, namely, the general contempt of the teachers of the Church for acrobats and jugglers. The acrobat's exaggerated gesticulation is often given as one of the reasons for condemning these performers. Thomas Aquinas expressly condemned the acrobats, except those who recite the legends of the saints, because of their indecent dancing and gesticulation.[15] In a Penitential ascribed to Thomas of Cabham, those mimes of whom it is said "*quidam transformant et transfigurant corpora sua per turpes gestus*" are considered as being the worst.[16] In Middle English poetry persons who lack the virtue of moderation and who display an uncontrolled behavior ("doynge wip here bodies") are described as "halfyng fooles."[17] Quotations pointing to the same idea can easily be multiplied.

Considering the views expressed in these and similar passages, it has been proposed that in medieval literature, at least of certain periods and regions, the very fact of forceful, uncontrolled gesturing characterized a figure as a sinner.[18] The exaggerated gesticulation in some of the works of art

studied here (especially the damned, but also the first couple and particularly Eve) may perhaps be understood not only as an expressive representation of sorrow but also as a characterization of these figures as sinners.

So far we have outlined the attitude of the early Middle Ages toward violent gesticulation in general. If we now turn to the specific actions of self-injury, we seem to be on surer ground, as the connotations of such actions are more articulate. Self-injury, especially that performed by the mouth and involving the actions of biting or gnawing, is frequently described in the apocryphal writings of the early Christian period. Actions of self-hurt may have different meanings, but they are mainly regarded as tortures, suffered by the damned in hell. The *Apocalypse of Peter*, a work of the early second century A.D., describes the infernal torments: "And beside them that there are, shall be men and women, gnawing their tongues. These are they that slander and doubt my righteousness,"[19] In another place the same work reads: "And again, other men and women, gnawing their tongues without ceasing, and being tormented with everlasting fire. These are the servants [slaves] which were not obedient unto their masters; and this is their judgment for ever."[20]

In the *Apocalypse of Paul*, probably composed in the late fourth century, similar images occur which, in certain details, almost recall the Torcello mosaic. This Apocalypse relates that the soul of the sinner is "cast into the outer darkness, where is weeping and gnashing of teeth."[21] In his vision of hell the author describes "a multitude of men and women sunk [in fire] up to their knees, and other men up to their navels; others up to their lips and others up to their hair." The second group consists of those who "when they have received the body and blood of Christ, go and commit fornication," while in the third group are those "that slandered one another when they gathered in the Church of God." From here the author is led to another place. "And I saw . . . men and women gnawing their tongues, and asked: who are these, Lord? And He said unto me: These are they that mocked at the word of God in the Church."[22]

It should be borne in mind that the *Apocalypse of Paul*, a document that aroused a considerable amount of controversy, exerted a deep influence on medieval thought and literature. Branded by St. Augustine as a forgery, it nevertheless circulated in the monasteries, especially in the West.[23] Its influence can be felt, sometimes faintly and often plainly, in many medieval visions of the other world.[24] Dante obviously knew it, and borrowed at least one specific motif from it. Dante's early commentators were clearly aware of the poet's source.[25]

Although the biting of the hands and the tearing of the face are not

specifically mentioned in these early writings, the passages quoted lead to certain conclusions. They show that self-injury was regarded as one of the tortures suffered by the sinners in hell. Moreover, they suggest a relation between the sin committed and the torture suffered or the limb punished. Thus the gnawing of the tongue is a punishment for sins committed with the tongue.[26]

Self-injury had, however, still other significant meanings. Certain types of self-mutilation were considered to be a grave sin; this is most obvious in the case of self-castration. The *Apocalypse of Peter* describes the tortures undergone by sinners "who cut their flesh as apostles of a man."[27] Another interesting early Christian testimony (one of many examples), the so-called *Rules of the Church* composed by Hippolytus, a Bishop of Rome in the early third century, contains a list of several groups of people who cannot be admitted to the Church. Among them are painters, sculptors (if they produce idols), actors, prostitutes, and self-castrates.[28]

In all these examples from early Christian literature, from wailing women tearing their faces to men castrating themselves, self-injury was regarded either as the punishment of a sin or as a sin in itself; in other words, it always has negative connotations. It is true that sometimes one perceives a certain ambivalence in the attitude of early Christianity toward self-injury; pain inflicted by a person on himself may also be regarded as having positive value. An example can be found in the so-called *Sayings of Sextus*, another document from late antiquity which, although probably pagan in origin, betrays a strong ascetic tendency and exerted a considerable influence on medieval thought. Thus, "it is not the eye and the hand and the like that commit sin but [man] who makes bad use of the hand or the eye. Any limb of the body that tempts you to unchastity, throw it away."[29] In early Christianity, self-inflicted pain could also be regarded as a kind of atonement which, when performed while the sinner is still alive, may save him from the tortures of hell. Irenaeus the Presbyterian could thus advise the believers "to tear off the eye that annoys you, and likewise the foot and the hand" in order to save the body, i.e., the soul.[30] Later developments of ascetic doctrines limited the influence of these tendencies, but they did not completely disappear during the Middle Ages.

In spite of this ambivalence it cannot be doubted that the predominant conception of self-injury was that of punishment or sin. This conception, which may have something to do with the gradual disappearance of violent gesticulation in literature and in visual art, was probably a significant factor in establishing the pejorative meaning that is attached to some later representations of self-injury.

V

Dante and His Early Illuminators

The intimate relation of actions of self-injury, particularly self-biting, to sin, damnation, and hell finds important expression in the *Divine Comedy*. The opinion is offered that later representations of figures attacking their own flesh with their teeth can be explained only by assuming the artists' acquaintance with Dante's poem.[1] While this statement is probably exaggerated (we have seen pictorial examples preceding Dante of figures biting themselves), it is true that the *Divine Comedy* played a significant role in the diffusion of such traditional gestures in Renaissance art. In Dante's poem, morever, the gestures of self-injury acquired a shade of meaning which one does not encounter in earlier periods, and which was to be of great significance for Renaissance art.

In the *Divine Comedy*, gestures of self-injury, especially biting of the hands occur several times. The precise meaning of this gesture differs slightly from one specific context to another, but in the most prominent passages it obviously indicates both despair and impotent rage. In the Canto XII of the *Inferno* Dante descends to the seventh circle of hell which is guarded by the Minotaur and where those who have committed violence are punished in a river of blood. Centaurs try in vain to prevent the poet and his guide from entering the circle. Seeing his failure, the Minotaur rages,

> "And seeing us, he bit himself in spleen
> Like one whose breast with inward rage is heaved.
> (vv 14–15)

39

The poet does not say exactly how the Minotaur attacked himself, nor in what part of his body; we shall, however, see that artists (some of them almost contemporary with Dante) invariably represented the monster in the act of biting his hand. In Canto XXXIII of the *Inferno*, Count Ugolino describes to the poet the cruel manner in which, upon the command of the Archbishop Ruggieri, he and his four sons were starved to death in the tower of Pisa. At the climax of the dramatic story he says:

> "But, when a faint and broken ray was thrown
> Within this dismal dungeon, and I viewed
> In their four looks the image of my own—
> Then both my hands through anguish did I bite."
> (vv. 55–58)

The action of figures biting themselves, as related in these two passages, certainly has the high dramatic quality and the emotional character appropriate to self-injury. Both passages, however, bear additional overtones: it is not just emotional tension and despair that move the Minotaur and the count to bite themselves, but also the rage of frustration in a vital purpose. Dante says this explicitly of the Minotaur. In Count Ugolino's monologue greater emphasis is placed on pain and despair, but impotent fury against the bishop's cruelty is perceptible. In any case, it was thus interpreted by Dante's early commentators, who certainly reflect fourteenth- and early fifteenth-century comprehension of these passages.

One of the earliest commentaries on the *Divine Comedy*, composed by an anonymous contemporary of Dante, gives a rather allegorical explanation of the Minotaur's behavior. The Minotaur, he says, represents tyranny. He is made half-man, half-beast in order to indicate the bestial character of (human) tyrants. The anonymous commentator does not explicitly refer to the self-biting; implicitly, however, he seems to suggest that the eating of human flesh is an image of the essence of tyranny.[2] Another early commentator, Jacopo della Lana, who wrote his commentary in the 1420s, formulates this idea more clearly. The action of the Minotaur, he says, "shows the anger of the wicked tyrants which is directed against themselves when they cannot harm others."[3] Francesco da Buti, a fourteenth-century Pisan commentator of Dante, very briefly explains the Minotaur's action, emphasizing the importance of the word "anger" (*ira*). According to him, the line "*Si come quei, cui l'ira dentro fiacca*" shows that violence, although born from pride (*superbia*), is always accompanied by anger, "as is obvious to anybody who looks at violence; and he [i.e., Dante] especially says *fiacca* [which means also "breaking down"] because in anger the soul breaks away from her constancy

and duty."[4] The Minotaur biting himself thus becomes an image of the soul uprooting herself in anger.

The second passage, concerning Count Ugolino biting his hands, is explained by the early commentators in the same spirit. To the line "*Ambe le mani per dolor me morsi*" Jacopo della Lana says that the knight did so "apparently" out of anger.[5] Francesco da Buti understands the count's action as "provoked by anger which caused the pain."[6] These brief comments are remarkable for introducing the emotion of *ira* (a word which Dante did not use in this particular context). Their interpretation recalls the strong emphasis which both Jacopo della Lana and Francesco da Buti placed on anger in interpreting the Minotaur's behavior. All this suggests that in the fourteenth century self-injury, and particularly the biting of the hand, was conceived as an act expressing anger. The connection between self-injury and anger is not unprecedented in European imagery, as can be demonstrated by a few examples of such images in literature and art.

The discussion of wrath occupies a central place in moral literature since the earliest periods; at certain times at least, wrath was a significant theme of artistic representation. One of the early and influential literary works discussing different aspects of anger is Seneca's *De ira*. This work is of particular interest for the study of art because the author analyzes the physiognomic aspects of anger, and devotes long and interesting passages to the description of the gestures performed by the furious. Seneca stresses the restless and violent actions of the raging man's hands and mouth, and evokes images of tearing and breaking. The angry man, like the madman, has "restless hands," his "teeth are clenched" and he "strikes his hands together." Anger is betrayed by its countenance, among its distinct features being the "crushing of the joints as the hands are violently struck together." The angry man "bites his own lips," he rushes to destroy his fellow—"destructive of himself as well."[7] Although Seneca does not mention the specific gestures which we are studying, he portrays the angry man as injuring and even destroying himself.

Plutarch, in his essay *On Restraining Anger*, also describes the appearance, behavior, and gesticulation of the wrathful, although he pays less attention to the physiognomic features than did Seneca. He, however, stresses that the physical features of the angry man seem distorted, and suggests self-injury as an action of the mouth. "For, indeed, when I consider revenge, I find its angry method to be for the most part ineffectual, since it spends itself in biting the lips and gnashing the teeth."[8] In our present context it should be noticed that Plutarch links these to the importance of anger, or what he calls its "ineffectiveness."

Another small but interesting fragment of classical literature, attributed

to Petronius, almost reads as a description of one of our gestures: " 'Canidia biting her thumb' : He expressed the appearance and movements of Canidia in a rage. Petronius, wishing to portray a furious person, says 'biting his thumb to the quick.' "[9]

A famous and probably the most influential description of anger is given in Prudentius' chapter on the contest between *Ira* and *Patientia*. As is well known, *Ira* commits suicide by stabbing herself. While the particular gestures we are discussing do not appear in Prudentius (nor in the many illustrations of the *Psychomachia*),[10] he suggests self-injury as being behavior typical of the wrathful. In spite of his influence, Prudentius probably cannot be regarded as a "source" for the study of such gestures; he does not describe actions of self-injury performed with the bare hand. However, in the passages of other ancient authors which I have quoted, the angry subject is shown injuring himself not by means of a sword or any other weapon, but only by the movements of the hand and the actions of biting and gnawing.

Ira, needless to say, is a figure frequently represented in medieval art. In some representations the figure performs a gesture that could be related to the theme of this study. I shall here mention only two works. One, a late eleventh-century illumination, depicts the famous encounter between *Ira* and *Patientia*. The figure of *Ira* is shown tearing her hair and holding her disproportionately large hand close to her mouth so that the back of the hand almost touches the lips while the twisted fingers point outward.[11] While the action of pulling the hair can be clearly established, the second gesture may be ascribed different meanings. The biting of the hand is only one possible reading, although the expressive character of the movement would agree with such an interpretation. Another example, contemporary with Dante, is Giotto's famous representation of *Ira* in Padua (Fig. 18). Here, one recalls, the figure tears her garment at the chest, and the distorted shape of the mouth may indicate that she is biting her tongue.[12]

Dante's description of the wrathful and their tortures, though introducing a new psychological realism, largely agrees with the traditional image of *Ira*. In Canto III, when the poet enters hell, he hears

> Parole di doloro, accenti d'ira,
> Voci alte a fioche, e suon di man con elle
> (vv. 26–27)

thus combining the "sounds of anger" with the striking of the hands, a gesture already mentioned by Seneca as a characteristic of the angry man.

18. Giotto, *Ira*, Arena Chapel, Padua.

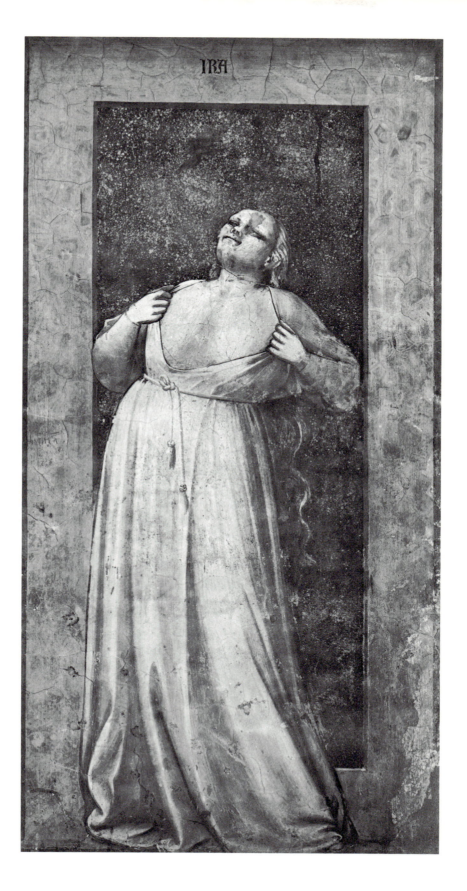

Especially important for our purpose is Canto VII of the *Inferno* where Dante, after passing the fourth circle of hell where the avaricious and prodigal are punished, enters the fifth circle in which the wrathful are tortured in the lake of Styx. Plutus, the guardian of the fourth circle, who attempts to prevent Dante and his guide from entering, is thus rebuked by Vergil:

> Then turning round: "Be silent, Wolf accurst"
> He sternly said to that swollen lip abhorred;
> "And let ferocious rage within thee burst."
> (vv. 8–10)

Dante's early commentators use this canto for lengthy expositions of the accepted doctrines on *ira*, sometimes describing the physiognomical features of the angry. As we follow the fourteenth-century commentaries in chronological order, we notice that these descriptions become more vivid and the imagery enriched. The fourteenth-century Anonymous Florentine Commentator describes *ira* in traditional terms as a "*disordonato appetito*" and quotes "the philosopher" as saying that "*ira est appetitus vindictae.*"[13] Jacopo della Lana says that *ira* is a "fury of the soul wishing revenge", and is always mixed with sadness. In his interpretation of Dante's text he emphasizes the concept that the feeling of importance is part of the torture of the wrathful. As they are immersed in the boiling waters of Styx, the wrathful cannot speak, and their attempts to utter words only produce bubbles. Saying that one "can imagine their movements," Jacopo della Lana explains that the wrathful use their teeth for mutual dismembering because they are unable to use their hands.[14]

The most detailed commentary is that of Francesco da Buti. Da Buti, like some of his predecessors, explains the words "*Consuma dentro con la tua rabbia*," which Vergil addresses to Plutus, as indicating the self-consumption which is characteristic of the avaricious. On the last part of the canto (lines 109–114, in which biting and tearing of the limbs is described as the torture of the wrathful) he gives a commentary consisting of a long and interesting discussion of anger, of its symptomatic features, the means of preventing it, and its proper punishment. Francesco da Buti here summarizes the traditional interpretations of this canto, but he also adds new concepts and observations taken from life. He quotes Aristotle, Cassiodorus, and St. Augustine in order to prove the well-established definition of anger as a wish for revenge, and he also elaborates in great detail on remedies against anger and the means of preventing it, increasing their number to eight. Characteristically, the last of these remedies is the consideration of one's own

impotence. Important in our context are his views on the tortures of the wrathful which consist of their nakedness, the loathsomeness of the swamp, and the pain they cause their fellow-sufferers and themselves. Da Buti stresses the appropriateness ("*convenienza*") of this torture. In Dante's poem, as in many medieval visions of hell, the tortures of the sinners are often immediately related to the sins committed and sometimes refer to the very organ that performed the transgression. In Canto VII, the wrathful hurt each other with head, breast, and teeth, and strike one another with hands and feet. Francesco da Buti comments in detail on these different kinds of striking. Tearing with the teeth is the punishment for that type of anger ("*specie dell' ira*") that proceeds from "the coarseness of lips either of oneself or of one's fellow man"; by the striking of the hands, the poet means the anger which leads to the "offense of one's own person, of oneself, or of one's fellow man"; the torture of being struck by the feet is related to the anger which leads to the destruction of property "either one's own or of one's fellow man." It should be noted that self-injury is a constant element of the torture suffered by different types of the enraged. This interpretation, da Buti suggests, is based on observation from life. "In the world," he says, "self-injury is a characteristic feature of the behavior of the angry." Transferring his observations from "the world" to the Inferno, he concludes: "And it is proper that in hell they [i.e., the wrathful] should strike themselves as they

19. Florence, B. N. Palat. 313, fol. 28 r.

did in the world, and that they should tear themselves to pieces as in the world they have torn their fellow men and themselves, because many of the wrathful strike themselves and bite their hands."[15] Although Francesco da Buti suggests that his interpretation is based on the observation of actual behavior, in fact it reflects a traditional image.

In turning to the early visual renderings of the *Divine Comedy*, I shall discuss the different scenes separately. In the earliest illuminated Dante manuscript, produced in Florence in the 1330s, the figure of the Minotaur is consistently rendered in strict profile (Fig. 19).[16] He bites one of his hands while with the other he performs a rhetorical gesture in addressing himself to the poet and his guide. As will be recalled, Dante speaks only of the Minotaur biting himself but does not mention the hand or any other limb, nor do the early commentators suggest this particular detail. It would thus seem that the illumination, produced no more than two decades after the completion of Dante's poem, surpasses any literary image or description in this detail. In the illumination the Minotaur holds his hand in an almost horizontal position and bites it on the back, near the wrist, displaying a certain general resemblance to that particular gesture in the *Last Judgment* of Torcello.

If one compares this illumination with another early representation of the

20. Holkham Hall, Library of the Earl of Leicester, MS 514, p. 17.

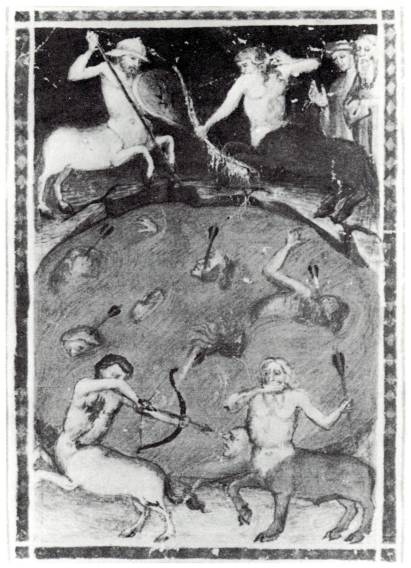

21. Vatican lat. 4776, fol. 42 v.

same scene, the one in the Holkham Hall manuscript produced in the third
quarter of the fourteenth century (Fig. 20),[17] one notices many differences.
In the latter illumination the lower, bestial part of the Minotaur's figure
remains in profile, but his upper, human part, especially his head and hands,
is turned toward the observer and is represented in three-quarter view. The
turning of the body gives the Minotaur a certain hesitant, reticent quality,
minimizing the bestial element in his character. This impression is further
reinforced by the fact that the Minotaur is now smaller in size (as compared
to the figures of Dante and Vergil, and in relation to the whole page) than in
the former illumination. The difference between these manuscripts is also

obvious in the specific detail of biting the hands. Unlike the early Florentine manuscript, the Minotaur of the Holkham Hall manuscript pushes both his hands into his mouth, although one of them is hidden beneath the other. But in spite of a certain clumsiness in representation, the meaning of the gesture is clear.

In a Florentine illumination of the late fourteenth century the tendency visible in the Holkham Hall manuscript is further developed (Fig. 21). [18] The upper part of the Minotaur's body is seen in almost full front view. His long, orderly, combed hair, his upright posture, and especially his facial expression conveying a certain restrained sadness, give him almost the appearance of an old sage. The bitten hand and the arm are held in a nearly horizontal position, again somewhat reminiscent of the Torcello mosaic; in the other hand, outstretched to the right, the Minotaur holds an arrow as if it were a scepter. The turbulent movements of the surrounding figures only emphasize his majestic calmness.

In an Italian illumination from the middle of the fifteenth century (Fig. 22)[19] the figure of the Minotaur differs completely—in general conception as well as in gesture—from all former representations. To begin with, he occupies an unusual place on the page: he is represented on the left-hand side of the illumination, turning to the right, and standing behind the poet and his guide. The dramatic encounter between the Minotaur and the poet, so vital in this context, described by Dante himself, and rendered in all other representations, is here avoided. In contrast to the other illuminations the

22. Madrid, B. N., 10057, fol. 22 v.

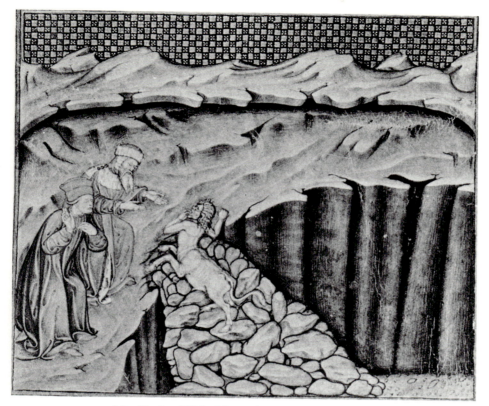

23. Paris, Bibl. Nat., It. 2017, fol. 134 v.

Minotaur is here conceived as a largely bestial creature. This impression is conveyed by the general expressive quality of the figure; but the brutish character of the Minotaur can also be seen in the details, above all in the fact that there is no division between the lower and upper parts of his body, which are usually clearly distinguished as his bestial and human parts. The bestial forelegs, which in all other illuminations marked the borderline between the Minotaur's two natures, are here omitted, and thus the Minotaur, which is normally represented with four legs, here has only two. In this minature special importance is also given to the tail, which in the other illuminations is either hidden or barely visible, a feature which further emphasizes the bestial character of the whole figure. Standing awkwardly erect, the Minotaur tries to push his hands into his mouth. The representation is rather clumsy. But in spite of this, and although the Minotaur's mouth is firmly closed, it is clear what action the artist wished to indicate. As in the other representations, the self-biting is of the hands.

Finally, I shall consider two Lombard illuminations, produced ca. 1440 by the *Vitae Imperatorum* Master. In one of them (Fig. 23)[20] the Minotaur, conceived in the traditional image and again seen in strict profile, rushes up a chasm biting one of his hands, while with the other, turned backward, he is performing a menacing gesture in the direction of Dante and Vergil. Here

the Minotaur, although not as bestial as in the former illumination, is of a vehement, aggressive nature. In the other illumination of the same manuscript[21] a figure is seen which may represent the Minotaur but can also be one of the centaurs who shoot arrows at the damned in the lake. This figure is represented in a dynamic, twisted movement, but it is placed behind the poets. In one hand he has a bow while the other, raised high (as if he had just shot an arrow), is held to the mouth. The action depicted is not clear. But since no arrow is seen, this gesture may perhaps be interpreted as a biting of the hand, or it may be influenced by former representations of this movement.

By comparing the illuminations discussed, some interesting conclusions can be drawn. First, it seems that there was no single tradition, or single model, for the representations of the Minotaur biting himself, and one had, rather, to assume that they derived from different sources. In many fourteenth- and fifteenth-century illuminations the encounter between Dante and the Minotaur is represented without the latter being shown biting himself.[22] But even where he does so, both the overall quality of the figure and the specific gesture vary so considerably that they indicate different models. Nevertheless, wherever the Minotaur is represented as biting himself, he bites his hand. I do not know of any representation in which the self-injury is rendered in a different way. The hand thus becomes a symbol of the self. It will be recalled that the visual representations of this gesture precede its literary descriptions. The first literary reference by a Dante commentator to the biting of hands is found in Francesco da Buti's work,[23] which was composed long after the gesture was depicted in illuminations to the *Divine Comedy*. It seems therefore possible that artists, faced with the task of representing the Minotaur biting himself, relied on such well-known models of hand-biting as were provided by traditional images of the damned in the Last Judgment, and perhaps of *ira*.

In other cases, however, it seems to be a literary commentary that accounts for certain new features in the visual representations, or, at least, reveals the tendency toward self-injury where it is lacking in Dante's text. One instance of such a relationship lies within the scope of our study.

In Canto V of the *Inferno* Dante, entering the second circle of hell, sees Minos, the infernal judge, to whom the carnal sinners are led.

> The guilty soul confesses all its crimes
> When brought before him: then the judge decrees
> Its proper place in hell . . .
>
> (vv. 7–9)

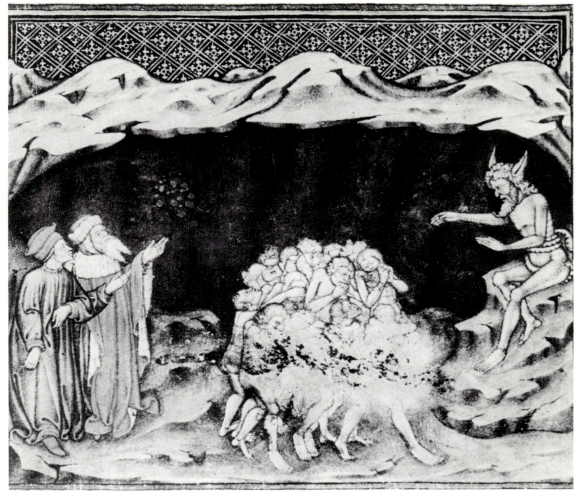

24. Paris, Bibl. Nat., It. 2017, fol. 59 r.

In a representation of this scene, done by the Lombard Master of the *Vitae Imperatorum* (Fig. 24),[24] we see a compact group of sinners advancing toward Minos. Some of them perform dramatic gestures: one raises his hands to his face in a movement of imploration and despair (reminding one of a prominent gesture in Traini's fresco in the Camposanto), a second hides his face in the palms of his hands, another common gesture in depictions of the Last Judgment. The figure in the center of the group, whose size gives him prominence, performs the most dramatic gesture: he raises his clasped hands to his mouth, biting his fingers. Such a motif does not appear in the earlier representations of this canto. In fourteenth- and early fifteenth-century illuminations, the carnal sinners are often shown as they are swept along by a violent hurricane, but they do not perform any gestures leading back to their own bodies or suggesting self-injury. From a purely formal point of view the

closest approximation to the figure biting his clasped hands that one can find is the nude female figure wiping away her tears in a Florentine manuscript of ca. 1390–1400.[25] But, needless to say, the wiping of tears has an altogether different meaning from the biting of hands.

The text of the canto does not suggest this gesture nor does it imply any action of the sinner against himself. The imploring gesture of the clasped hands and the hiding of the face in the palms could perhaps be understood as visual metaphors suggesting the confession of sins, and may thus be connected, although in a very loose and general way, with the text. But nothing in the canto itself explains the biting of the hands. One of the commentaries to the *Divine Comedy* perhaps provides some hint. The earliest commentators of Dante take Minos to be a symbol of justice.[26] Francesco da Buti, however, notices the inconsistency of such an explanation. Calling former commentaries to this passage "fictions," he says that in hell there is no need for a judge "since the soul judges herself as she leaves the body." Even Minos' tail which, according to Dante, encircles the sinner's soul and by this action assigns to her the proper place in hell is, in da Buti's opinion, a symbol of human conscience. It is the conscience which, like a serpent, wishes to kill the soul by making her acknowledge her sin, "and she [i.e., the soul] condemns herself to what she deserves".[27]

Francesco da Buti's commentary, of course, does not simply describe a specific gesture of self-injury, such as biting the hand. But it does bring out the reflexive nature of the punishment by conceiving of the soul as judging herself. There is, then, a certain similarity between da Buti's conception and that of the illuminator. We should further bear in mind that this illumination postdates da Buti's commentary by about two generations, a period in which the monumental commentary had become influential. All this makes it likely that the commentary also had some influence on the illuminator, who translated da Buti's concept of the self-judgment and self-condemnation of the soul into the visual image of a figure biting itself.

We shall now briefly look at the interplay between commentaries and illuminations in a few more instances that belong to our scene.

Priamo della Quercia's illumination of Canto VIII of the *Inferno* (Fig. 25)[28] represents the dramatic moment in which Argenti is thrown overboard into the pool. His plunging body performs a twisted movement and he is shown biting his arm above the wrist. The motif of self-biting is based on Dante's text:

> And with his teeth, his furious wrath to vent,
> Himself this savage Florentine did maul
>
> (vv. 62–63)

Dante's earliest commentators explain these lines very generally and do not refer to the vivid image of self-biting. It is again Francesco da Buti who noticed this gesture and suggested its connection with the traditional image of *ira*. Filippo Argenti delli Adimari of Florence, our commentator says, was a "very arrogant and wrathful person, and notorious for the vice of anger." His torture is appropriate because the wrathful man should suffer what he did to others. In assigning his torture, da Buti goes on, the poet intended to portray the behavior of the wrathful on earth where "one wrathful man tortures the other, and because of rage the wrathful one gnaws himself and bites himself and tortures himself."[29] No direct influence by the commentator on the artist can be proved, but since da Buti's well-known commentary discussed gestures of self-injury on several occasions, it may have had an effect on the illuminators of the *Divine Comedy*.

Other examples significant in the present context are two miniatures of the Holkham Hall manuscript, representing the scenery of the fifth circle of hell. In the first illumination (Fig. 26)[30] we see almost the full range of dramatic gestures known from the Roman *conclamationes*. In the center of the group a figure, towering over all the others, violently tears at his face; another hides his face in the palms of his hands, and a third performs a protective movement, bending his hand so sharply at the wrist that the Carolingian motif of the fractured hand is recalled. To the right of the group, half-immersed in the muddy lake, a figure holds his hand to his mouth (in a posture similar to that of Torcello) and seems to bite it. In the second illumination of the same scene[31] a half-immersed figure (near the boat)

25. London, Brit. Mus., Yates Thompson 36, fol. 14 r.

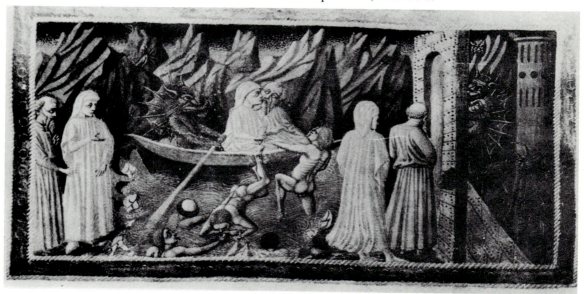

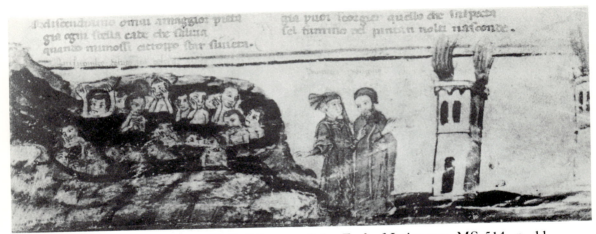

26. Holkham Hall, Library of the Earl of Leicester, MS 514, p. 11.

displays a rather unusual combination of the two most high-pitched gestures of self-injury: he lacerates his face and, at the same time, bites a finger of the rending hand.

These representations cannot be explained only by the verses of the canto. Dante describes the wrathful mutually attacking each other, but he does not, in this particular context, speak of self-injury. It was Francesco da Buti who, as we have already seen, described self-rending as a characteristic feature of wrathful behavior. Commenting on the line "*Trocandosi coi denti*," he says that the poet here meant the tearing of "each other's limbs, but it could also be understood as [tearing of the limbs] of themselves."[32] Again no direct connection between the commentator and the illuminator can be proved, but da Buti's commentary shows that in the late fourteenth century actions of self-injury belonged to the image both of the wrathful man's behavior and of his punishment.

In the early illuminations of the *Divine Comedy* we sometimes find gestures of self-injury, especially tearing the face and biting the hands, where neither Dante nor his commentators described or suggested such actions.

The illuminator of the Holkham Hall manuscript, in the illumination to Canto XIII of the *Inferno*, represents the suicide Lano di Siena (who is identified by an inscription) as he holds his hands to his mouth.[33] The action performed is not clear; the movement of the hands may be understood as a lamentation gesture, but it may also mean the biting of the hands. The latter meaning is perhaps suggested by the context, as the canto describes the tortures of the suicides. In this particular canto, however, Dante does not mention any self-injury specifically performed by the hands, or any hurting of the hands themselves. The language of the commentator is also very vague. Only the Anonymous Contemporary Commentator speaks of the "power of their violent hands" which the suicides turn "against themselves."[34] The other commentators, including da Buti, do not evoke

any articulate image that would explain our figure. If the gesture of the suicide raising his hands to his mouth does indeed mean the biting of the hands, it must have been taken over from a visual tradition and has the meaning of self-affliction in general, taken as symbolic of the suicide.

Also interesting is the illumination by the same master to Canto IV of the *Inferno* where the virtuous pagans dwell, their torture being

> . . . to live
> Tormented by desire, when hope is flown
> (vv. 41–42)

The illuminator here represents a variety of violent lamentation gestures, a veritable ancient *threnos*. One figure grasps his head with both hands; another grasps his chin, performing the most famous classical sadness gesture; two figures clearly perform gestures of self-injury: a crouching man forcefully tears at his cheeks, a standing figure pushes both hands into his mouth, obviously intending to bite them (Fig. 27).[35] These gestures are not

27. Holkham Hall, Library of the Earl of Leicester, MS 514, p. 6.

motivated by the text of Canto IV, nor are they suggested by any of the commentators. They are visual images of despair, probably drawn from artistic traditions only, and employed as expressive devices. Here the artist has translated the idea of spiritual despair into the well-known language of violent gesticulation.

The *Divine Comedy*, its illuminations, and its commentaries show that the traditional connection of self-injury with sin and hell, which we have found in the figures of the damned in the Last Judgment, was still very much alive in the fourteenth and fifteenth centuries. But they also show that these gestures were, to a certain extent at least, permeated with a new spirit of psychological empathy. The attraction which these and similar gestures exercised on the artists of the period was not restricted to the illuminations of Dante's poem but characterized a broad current in the art of the time.

VI

The Lamentation over Christ and Related Themes

In the first part of this study we have discussed violent gesticulation in one specific context. We have seen that sinners, the damned, and infernal creatures (like the Minotaur) are often represented as furiously hurting themselves. Actions of self-injury are particularly frequent in depictions of the wrathful, and as Dante's early commentators prove, they have been regarded as appropriate to the personification of *ira*. All this seems to reflect an attitude according to which vehement gesticulation indicated states of sin and damnation.

But from the late Middle Ages onward, and especially in the fourteenth century, unrestrained gestures also appear in other scenes, the meaning of which is altogether different from those discussed so far; such gestures are now performed by figures of a high spiritual character and of central religious significance. How are we to explain this fact? Did a process of transformation take place? And if so, are we to assume a change in the meaning of the gestures, or was there rather a radical modification in the meaning of the religious scenes and sacred figures?

In attempting to answer this question we must now turn to the representation of central religious themes, such as the Crucifixion and Lamentation over Christ. In fourteenth-century representation of these scenes violent gestures are so numerous, and are crystallized in so many specific motifs unknown to former periods, that I shall be able to discuss only a few examples which, I think, are representative of broader tendencies.

As a starting point I have chosen the Lamentation over Christ. The

57

transformation of the Entombment, a scene that had been represented
earlier, into a Lamentation—or the isolation of one phase of the Entombment
and its reshaping as a Lamentation—was the outcome of a long process that
began in Byzantine art[1] and was carried to the full articulation of the
Lamentation as a scene in its own right, in thirteenth-century Italy. For
Western art, the Lamentation over Christ was mainly a creation of Italian
painting of the dugento.[2] The emergence of the scene bears witness to the
increasing significance of emotional tendencies in both art and religion,
especially in the conception of the Passion. However, emotional tendencies
did not automatically lead to the depiction of violent gestures. Perhaps the
most famous motif that resulted from the emotionalism of late medieval
religion and art, the Pietà, is a highly emotional group, but very restrained in
gesticulation. The artists of the late Middle Ages expressed the grief of the
Virgin Mary holding the dead Christ on her lap in a variety of ways, but they
usually renounced frantic gesticulation as a means of conveying her sorrow.
The motif of the Pietà has been defined — in my opinion correctly — as
originating from a "lyrical" source, and as pervaded by a lyrical spirit.[3] In
this study we deal (to remain within the realm of literary similes) with a
dramatic type, that is, with works of art in which emotions are made visible
by vehement actions and movements of the body. In this sense the Lamenta-
tion is a dramatic scene. For our purpose, the main formal difference
between the Pietà and the Lamentation may be summed up in two charac-
teristic features: the Virgin Mary throws herself upon the dead Christ,
distractedly kissing Him (a motif that is too dramatic for the traditional Pietà
type); and by the presence of several additional figures (varying in number as
well as in posture) who mourn Christ. Since the Virgin's gesture of kissing
the dead Christ is beyond the scope of this study, I shalll concentrate on
the mourning figures only.

 In Italian art of the thirteenth century the Lamentation scene is both
frequent and crystallized in its basic forms (the general horizontal composi-
tion, the posture of Christ, and the act of the Virgin bending for the kiss).
The established pattern allowed, however, for a great variety in detail,
especially in the movements of the auxiliary figures. In an early representa-
tion of a fully articulate Lamentation, the work of a late thirteenth-century
Umbrian Master (Fig. 28, in Perugia),[4] a wide range of mourning gestures is
portrayed. Besides the Virgin Mary who kisses the dead Christ, two figures
wipe away their tears; an old man does so with his bare hand, while a female
mourner raises the tip of her mantle to her tear-wet face. Another female
mourner, standing behind Christ's head in an inclined position (as if she had
rushed to the scene), throws up her hands, curiously recalling in posture as

28. Umbrian Master, *Lamentation*, Perugia.

well as in movement, Dido's sister in the fourth-century Vatican Vergil. Another woman, placed in the center of the composition and bending her head over the group of Christ and the Virgin, tears at her face. Here one clearly senses that no formula for the realistic representation of the laceration of the face was available to the artist. The fingers are not curved but held against the face in a rather flat position, so that the action performed could also be interpreted as a pulling of the cheek or as a forceful pressing of the face. For the purpose of this study there is no essential difference between these interpretations, as all of them would indicate dramatic mourning gestures, more or less connected with self-injury as an expression of grief. I believe, however, that in this work the artist's intention was to represent the tearing of the face, and that we have here an early, and as yet unconvincing, formulation of this gesture.

The most conspicuous mourning gesture that appears in this panel, the throwing up of the arms, was a common motif in late dugento art in Italy, and it was capable of undergoing many variations. In a *Lamentation* on a late thirteenth-century Pisan cross, now in S. Martino, Pisa (Fig. 29),[5] a woman

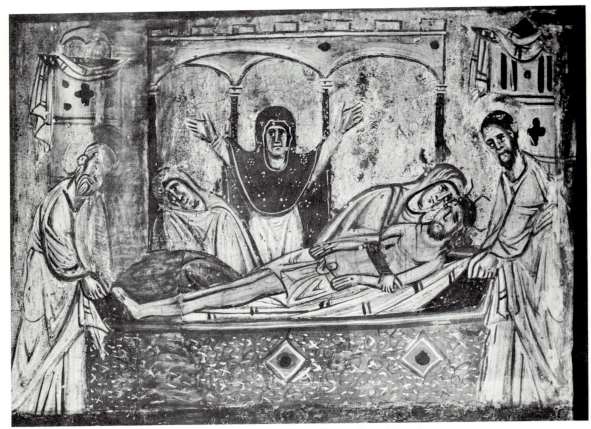

29. *Lamentation of Christ*, Pisa, San Martino.

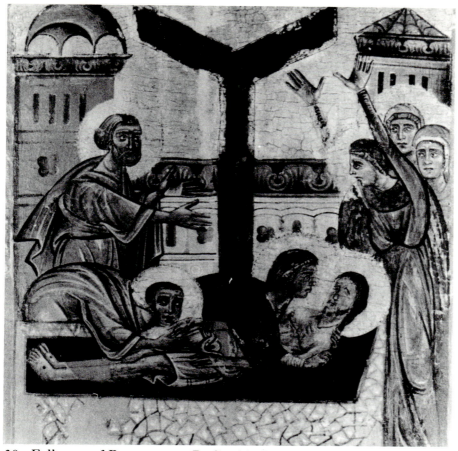

30. Follower of Bonaventura Berlinghieri, *Lamentation of Christ*, Yale.

performing this gesture is placed in the center of the composition and represented in a full frontal view. Almost motionless and with a stern expression on her face, she raises her hands symmetrically. The regular arrangement of the arches behind her, and the postures of the two figures below her (the Virgin Mary stooping to kiss Christ, and a female mourner bending to wipe her tears with the edge of her mantle), moving in opposite directions, further emphasize the strictly symmetrical composition. This mourning figure has a pronounced hieratic quality, strongly reminiscent of early Christian representations of the Orans; judging by expression alone, she could be understood as performing some kind of emotionally detached ritual. There is, however, no doubt that here the artist intended to represent a mourner throwing up her arms in deep sorrow. The highly emotional gesture is here represented in an archaic style.

In Italian art of that period, figure throwing up their arms in despair were also represented in more lively postures. In a *Lamentation* by a follower of Bonaventura Berlinghieri, now at Yale (Fig. 30),[6] the gesture is performed

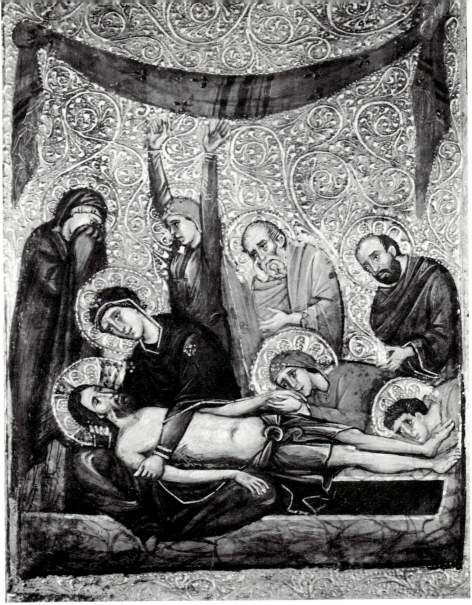

31. Icon, Sinai.

by a woman who is seen in three-quarter view. Her vertically raised arms, which are held stiffly parallel, emphasize the dynamic movement of her body. How widely diffused in thirteenth-century art was this particular version of the figure throwing up her arms can be seen from an icon in the monastery on Mount Sinai, representing a Byzantine *Threnos*, with strong Western, probably Italian, influences (Fig. 31).[7] The similarity of this mourning figure to the female mourner in the Yale panel is obvious at first glance. As in the Yale panel, the frantically mourning figure in the Sinai icon is seen in three-quarter view, the depth of space being further emphasized in the plastic modeling of her body. Opposite her is another female mourner

hiding her face with her mantle, and also represented in three-quarter view.

A famous example of throwing up the hands, which occurs outside the Lamenation proper, can be found in Cimabue's mural representing the Crucifixion in the Upper Church of St. Francis in Assisi (Fig. 32). The group of mourners to the left of the cross is rich in intricate and well-balanced movements, some of the figures performing traditional mourning gestures (a woman to the left of the group wipes her tears with her mantle, a woman in the center raises her hand to the chin, echoing the Greek gesture of sadness). As a whole, the group forms an almost rectangular pattern—a form further emphasized by the fact that the heads are at the same height and form an almost continuous row—and no impetuous gesture interrupts the composition. To the right of the group, however, the woman (probably Magdalen) who is nearest to the cross throws up her arms violently. Although held exactly parallel, her arms are slightly inclined toward Christ, and the hands are raised, so that in the flow of line they seem to continue the movement of Christ's twisted body. Seen in three-quarter view, this figure vaguely suggests a twisted movement leading from the beholder into the depth of space. Her dramatic gesture is not prepared by the figures behind her, but it corresponds with the gestures of two figures in the opposite group, to the right of the cross. In Cimabue's mural the traditional gesture of throwing up the arms has been infused with a new vivacity and expressive power.

32. Cimabue, *Crucifixion*, Church of St. Francis in Assisi.

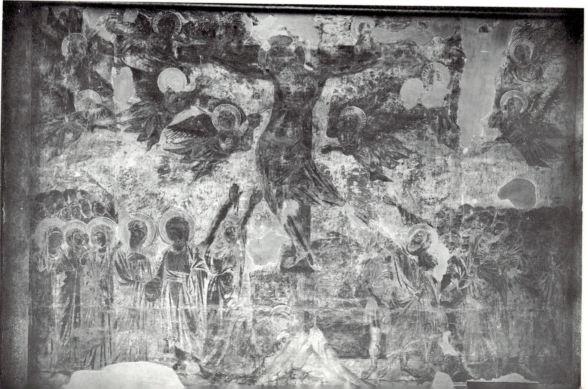

Italian art of the thirteenth and fourteenth centuries introduced many variations into the traditional gesture of throwing up the arms,[8] but its originality and force are more clearly revealed in the dramatic gestures of self-injury, the pulling of the hair and the tearing of the face. Some expressive representations of such motifs are to be found in the murals of the Church of St. Francis in Assisi. In the *Death of the Knight Celano* in the Upper Church (Fig. 33) a woman, overcome by horror, kneels at the feet of the dead knight, rending her face. Both by her posture and by the place she occupies in the composition, this woman reminds us of the figure of Mary Magdalen in some representations of the Lamentation of Christ, as the other female figure who grasps the knight's shoulder and looks into his dead face reminds us of the Virgin Mary. A comparison between the Perugia panel (Fig. 28) and the mural in Assisi instantly shows the transformation which the gesture of tearing the face had undergone, a transformation that reflects the general development of art in this period. In Assisi the basic anatomic and artistic formula for the act of lacerating the face seems to have been found. Here the fingers are no longer rendered as isolated units that are flatly applied to the cheek, as we saw in the Perugia panel. Although differentiated from each other, they all repeat the same movement, their curved form giving a more convincing character to the representation of the self-injuring action. Lights and shadows are also consistently applied and enhance the naturalistic effect, as may be noted, for instance, in the shadow of the depressed cheek, showing that the fingers enter into the flesh.

Although the tearing of the face, as we know, is a typical mourning gesture, the figure performing it in the *Death of the Knight Celano* expresses, I believe, not only grief and sorrow but also horror and sudden shock. This impression may be confirmed, I think, by the agitated gestures of the other figures (especially the standing ones on the right-hand side of the mural) that seem to express sudden disturbance. If this impression is correct, we may say that here the painter introduces a new emotional quality or uses the old gesture in a new emotional context. While mourning, even of a spontaneous type, is a continuous process or performance (and this intrinsic quality was essential to its ritualization), the rending of the face in sudden horror is an act which, so to speak, has no duration. This particular use of a traditional motif grants the gesture a new psychological immediacy, an aspect that was to become of great importance in the art of the following centuries.[9]

In the murals of the Lower Church of St. Francis in Assisi several violent gestures are represented. Particularly rich in such motifs is the fresco representing the *Massacre of the Innocents* (Fig. 34). In the lower left-hand corner of the mural, a mourning mother, huddled on the ground, her dead child on

33. *Death of the Knight Celano* (detail), Church of St. Francis in Assisi.

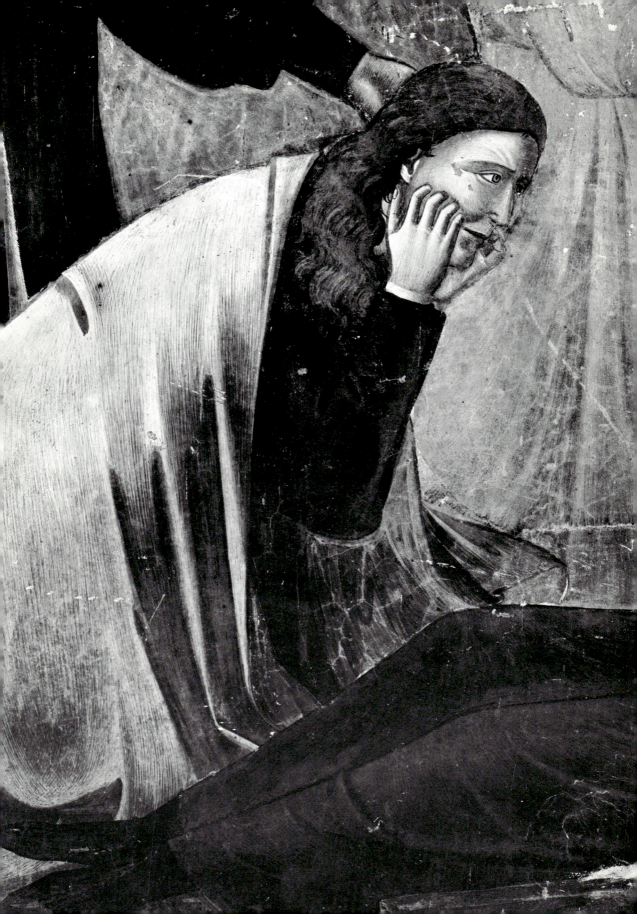

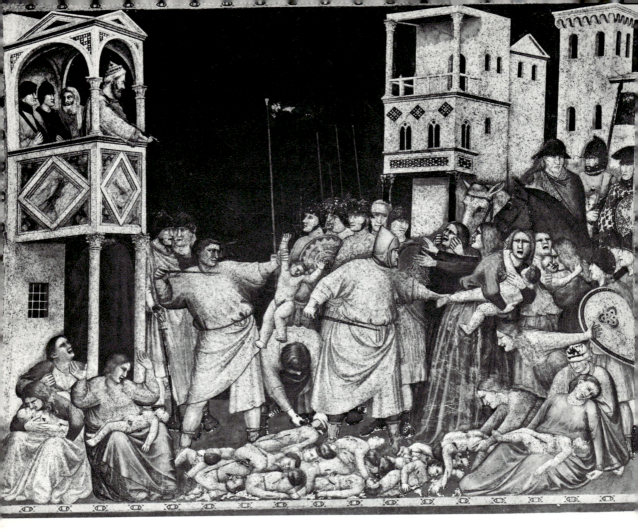

34. *Massacre of the Innocents*, Church of St. Francis in Assisi.

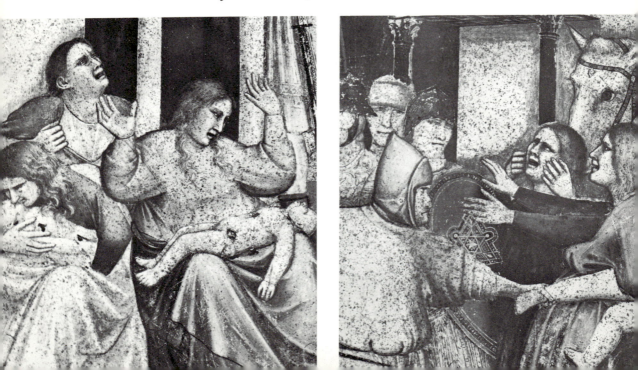

her lap, raises her hands. Since the arms are only half-raised, the gesture is somewhat ambiguous in meaning. It was probably meant as an expression of unbridled, high-pitched mourning, but the modern beholder can understand it also as a gesture of resignation and submission to fate. The movement of the figure behind her is less ambiguous; it is the figure of a mother frantically rending the garment on her breast (Fig 34a).

In the center of the same mural, a woman is tearing her face (Fig. 34b). The hands are less clearly articulated, and the action less convincingly rendered, than in the *Death of the Knight Celano* (Fig. 33). Particularly her left hand (the hand more fully displayed) seems flat and reminds us of the similar gesture in the Perugia panel, although in Assisi it is of a more massive form. In the lower right-hand corner of the same mural, a mourning woman wildly throws back her arms, performing the gesture we are accustomed to associate with the Hippolytus sarcophagus. This figure, bent forward and seen in pure profile, vividly reminds us of the figure of St. John in Giotto's Paduan *Lamentation* (Fig. 37). Only one arm of the mourning woman is seen. Its posture is rigid, and the hand is so sharply turned inward that it looks as if it were fractured. The other arm (of which in Giotto's St. John we see a foreshortened fragment) is here completely obscured. The relation of this figure to the Hippolytus gesture seems, however, evident.

A variation of the Hippolytus gesture recurs in the *Crucifixion* in the right transept of the Lower Church of Assisi (Fig. 35). Here the figures below the

35. *Crucifixion*, Church of St. Francis in Assisi.

cross are calm and restrained, their gestures indicating adoration rather than mourning. Only the woman at the extreme left of the scene raises her hands in a gesture of mourning. In front of her, another female figure, bending forward as if rushing to the cross, throws back her arms. Again we see only one arm, which is held much lower than in Giotto's *Lamentation* and in the *Massacre of the Innocents* in Assisi; moreover, the arm is covered by a cloth, wrapped around the whole figure and somewhat obscuring the movement. In spite of these variations, both the posture of the body and the position of the arm clearly indicate the Hippolytus gesture used as a formula of violent mourning. In discussing the sources and the historical significance of the Hippolytus gesture in Giotto's *Lamentation of Christ* in Padua, these over-looked examples should be taken into account.[10]

In another mural of the Lower Church, the *Death of the Young Man from Suessa* (Fig. 36), gestures of self-injury are rendered as formulas of mourning. In the center, a woman clad in black cloth pulls her hair; another woman, seen in profile, tears her face, and both figures open their mouths in unrestrained lamentation.

36. *Death of the Young Man from Suessa* (detail), Church of St. Francis in Assisi.

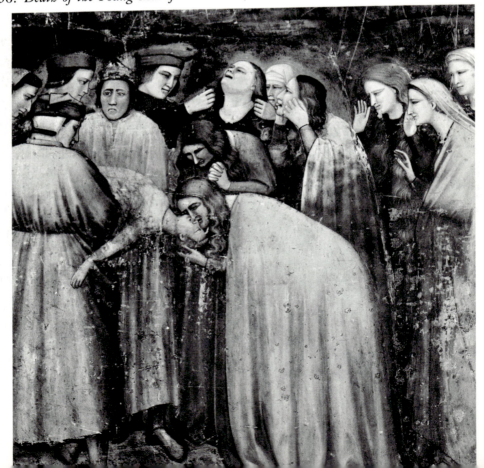

The frequency and variety of such gestures is characteristic of at least one trend in early trecento art. A famous example is Giotto's *Lamentation of Christ* in the Arena Chapel (Fig. 37a). Christ's body is held by several women who huddle on the ground, or kneel and stoop in different positions. One of the women holds His head, two hold His hands, and His feet. All these women take an actual part in the event, a fact that is shown by their physical contact with Christ's body. These figures, as well as those standing to the left of the scene, perform, suggest, or transform traditional mourning gestures. A significant innovation by Giotto is the introduction of the figures in contact with Christ sitting on the ground and seen from the back, a motif which Panofsky has called the "huddled mourners."[11] Similar figures appear also in other works of Giotto's time and surroundings;[12] but he seems to have been the first artist to represent them in a Lamentation scene. Giotto might have derived his huddled mourners from ancient sarcophagi, although I do not know of any sarcophagus where they occupy an equally important position.[13] As I shall suggest later,[14] in representing these figures Giotto may have been inspired by actual social customs and perhaps by biblical images. The significance of these figures for the creation of spatial illusion has often been discussed; one should, however, also notice that they fulfill a well-determined expressive function. The beholder cannot see their faces, and only small portions of their hands are visible (that is, the minimum necessary for indicating the action of supporting Christ's body); nevertheless Giotto's huddled mourners may be described as "gesture figures," that is to say, as figures whose main function is to perform a specific gesture. Their gesture, taking this notion in a very broad sense, is composed of two main elements: the posture itself, i.e. the huddling to the earth, the crouching or stooping attitude, the lowered head, may be interpreted as an intuitive symbol of mourning, conforming, as I have already suggested, to what could actually be observed in reality. But Giotto added a further "gestural" feature by suggesting that these woman are veiled. It is true that since we cannot see the front of these figures, we cannot be positive that this was indeed his intention; however, the heavy cloth enveloping their heads and the fact that, although they are represented in *profil perdu*, nothing of the face is seen, strongly suggests a complete veiling. It ought to be said that, if Giotto here applied the traditional mourning gesture of veiling the face, he did so in a highly original way, casting the established image into a new form.

Several dramatic gestures are represented in the group of the standing women at the left of the mural, behind Christ's head. The first woman in this group throws up her arms. Such a representation is a traditional feature which we have already encountered.[15] But Giotto has transformed this motif

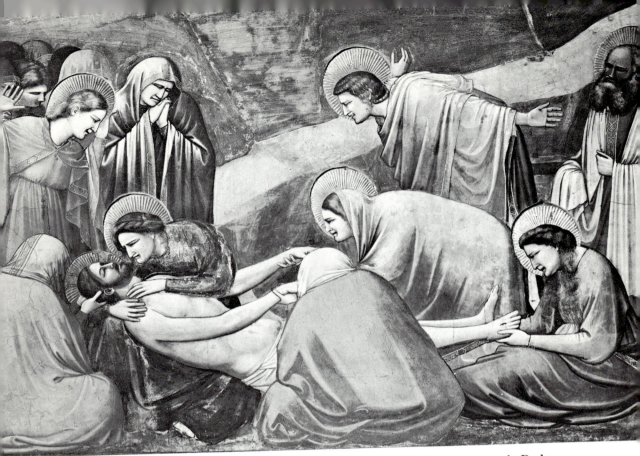

37a. Giotto, *Lamentation of Christ* (detail), Arena Chapel, Padua.

37b. Giotto, *Lamentation of Christ* (detail), Arena Chapel, Padua.

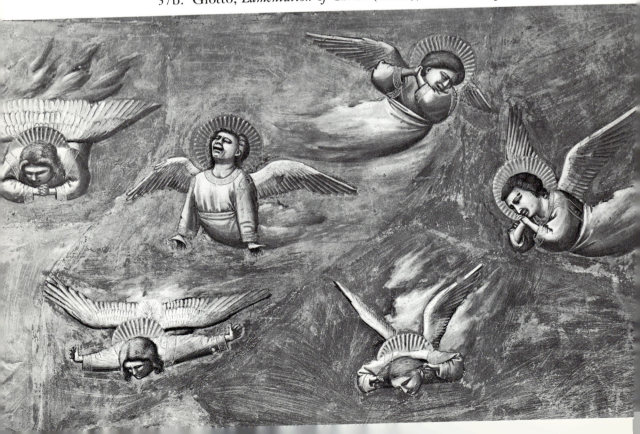

too. The figure is seen in three-quarter view, rendering dramatically visual the depth of space. Its spatial quality is emphasized by a movement which indicates a turning into space; while her body is seen in three-quarter view, the face is represented in pure profile. Moreover, the head and the halo overlap one of the hands and partly cover it from sight. The throwing up of the arms is also transformed by the spatial quality of the figure.[16] The arms are not thrown up vertically, as is frequent in many previous representations; they are only half-raised, remaining somewhat below the level of the head, but they are extended in space: one hand faces the beholder, the other is obscured in the depth of space. The new spatial conception of the figure may also carry some iconographic allusion and give the gesture a double meaning; we here clearly recognize a mourning gesture, but at the same time, the open palm facing the beholder recalls the movement of astonishment and adoration, often expressed by the angels in Crucifixion scenes through a similar movement. The woman behind this figure raises her folded hands to her cheek.[17]

The climax of dramatic gesticulation is reached in the figure of St. John who performs the well-known Hippolytus gesture which was revived in the late thirteenth century by Nicola Pisano. In the *Massacre of the Innocents* in the Siena pulpit one on the lamenting mothers throws her arms backward in a form that makes it certain that Pisano derived the gesture from an ancient sarcophagus.[18] There has been some discussion as to whether Giotto derived this motif directly from a sarcophagus or through the mediation of Nicola Pisano's pulpit.[19] Whatever his precise source, Giotto transformed his model. Both in the ancient sarcophagi and in the Siena pulpit the figure performing this gesture is seen from the back, fully displaying both arms. In Giotto's Paduan *Lamentation*, St. John is represented in pure profile; only one arm is revealed to the beholder, while of the other, depicted in bold foreshortening, we see only the hand. It is, of course, difficult to establish the motives for this transformation, but some of its effects in the composition can be observed. There seems to be a certain correspondence between the principal female figure standing behind Christ's head and the St. John; what is suggested by the female mourner is carried to full realization in St. John. Several features are obviously common to both figures, such as the raising of the hands to the level of the face, the standing position, the bowing of the upper part of the body, and the inclined head. These features increase in force in the figure of St. John, as can be seen by comparing the movement of the hands. The Hippolytus gesture of St. John is a kind of dramatic fulfillment of the movement of the hands of the woman mourner. It is also significant that in both figures, but in St. John more dramatically than in the

other, the spatial relations play a role in the expression of tension and violence. This was to become a major aspect in later representations of mourning gestures.

In spite of the dramatic tension that permeates the whole picture, and which is expressed mainly by movements of the body, the figures do not pull their hair or tear at their faces. These gestures are performed only by the angels hovering in the sky, to which we shall return in a later chapter of this study.

These gestures appeared, however, in Giottesque art. In an *Entombment*, originating from Giotto's studio (Fig. 38), a female mourner standing behind the head of Christ rends her face. The hand performing the action seems to be more compact than that of the kneeling woman in the *Death of the Knight Celano*, but both in the conception of the gesture as a whole and in the representation of the curved fingers there is obviously a close relationship between the two works. In a *Lamentation* by a contemporary of Giotto, a figure in the center of the crowded scene throws up her arms.[20]

It may be worth recalling that in the fifteenth and sixteenth centuries dramatic gesticulation was considered a characteristic feature of Giotto's style. Alberti reports the praise bestowed upon Giotto's *Navicella* in which, as he says, each of the Apostles "expresses with his face and gesture a clear indication of a disturbed soul in such a way that there are different movements and positions in each one."[21] In the sixteenth century, the Florentine humanist Benedetto Varchi said that Giotto was the first modern artist who expressed emotions.[22] Although Varchi does not specifically mention gestures, it is likely that he had them in mind. Vasari's descriptions also suggest that he understood the gestures in Giotto's works as having an expressive meaning and that he considered them as a characteristic feature of that artist's style.[23] Gesticulation as an expression of emotions was perceived, as I shall try to show later, as a significant aspect of that type of "naturalism" of which Giotto was commonly regarded as the founder.

Some types of violent gesticulation, introduced or brought to full articulation by Giotto and his school, persisted in Florentine art and were used as formulas of the expression of grief. Originating in the Lamentation of Christ, they soon appear in different scenes of mourning, even if these scenes do not depict the Passion of Christ and have no connection with the Gospels. To give but a few examples: In a painting of the Giotto school, the Berlin *Dormition*—a scene that has usually been depicted in a more restrained mood than the Lamentation of Christ[24]—certain well-known mourning gestures are rendered, although they are more restrained than in Giotto's works. Here one Apostle, bending his head toward the dead Virgin, raises his

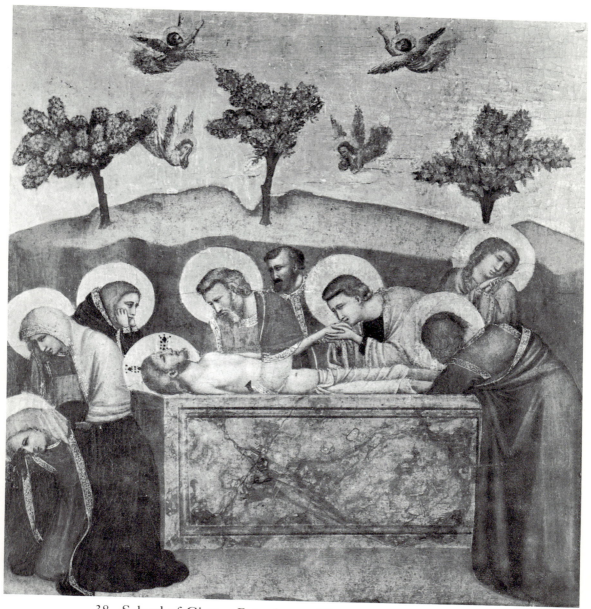

38. School of Giotto, *Entombment*, Florence, Coll. Berenson.

folded hands to his cheek; another Apostle seems to clutch his beard, and a crouching mourner (whose face, however, is not veiled) kneels in front of the burial casket.[25] Giotto himself used similar motifs, in an even more restrained form, in the *Death of St. Francis* in the Bardi Chapel in S. Croce.[26] A further example, not connected with Florentine art, shows how widely diffused the composition and the gestures of the Lamentation of Christ were by the middle of the fourteenth century. In a Neapolitan manuscript of about 1350–1360, the illumination *Hecuba Embracing the Dead Body of Troilus* can hardly be distinguished from a Lamentation of Christ.[27]

Toward the middle of the fourteenth century the dramatic tendencies in Florentine art seem to have subsided, at least as far as religious painting is concerned. Scenes which a generation or two earlier had been depicted with great vivacity were now presented with more restraint. In the *Entombment* by Taddeo Gaddi (in the Cappella Bardi di Vernio in S. Croce),[28] for example, none of the violent gestures that were so significant in Giotto's *Lamentation* can be found. The only dramatic feature in this mural is the broad, sweeping gesture of the Virgin Mary embracing Christ. The holy woman kissing His hand is moving but reserved in posture and gestures as compared with earlier representations of the same theme. Another woman, seen in profile as she gently raises her hands, seems to express astonishment and adoration rather than mourning. Motifs of passionate gesticulation, such as the throwing up and out of the arms, the tearing of the face, or the pulling of the hair, are altogether omitted.

Another example of the lowering of the emotional key is Maso di Banco's *Crucifixion* mural in the Sala del Capitolo in the Church of St. Francis in Assisi.[29] The principal figures, arranged in hieratic symmetry, are represented in sober and majestic postures. More agitated movements can be observed in the hovering angels, especially in the angel above the cross to the left of Christ, who seems to plunge toward the crucifix. Even these figures, however, perform gestures of prayer and adoration rather than of violent mourning and despair. The symbolic action performed by the angels, the catching of Christ's blood in ritual chalices, is depicted in a spirit of elevation and temperance.

The mood of restraint is clearly visible in the depiction of the gestures themselves. Lorenzo Monaco's *Lamentation of Christ*[30] in Prague is an interesting example. The scene is composed in bold diagonals and foreshortenings which are dramatic elements in themselves, and thus distinguish the painting from mid-fourteenth-century depictions of the Lamentation. The crouching mourner sitting on a bare rock, the slightly twisted posture of the dead Christ, the dense crowding of the figures, and their facial expressions

do not suggest majestic calm and dignified restraint. It is, therefore, interesting to notice that no violent gesture is performed by any of the mourning figures. The more dramatic mood of this painting, and of its period, had not yet crystallized in more dramatic gestures. I should also like to mention another *Lamentation*, probably by Pietro di Miniato, in a lunette of the church of St. Francis in Pistoia.[31] Here we see several moderate gestures of mourning: St. John and a holy woman wring their hands, and two tiny angels throw up their arms. But once again no distracted mourning gestures are represented. It was only later in the quattrocento that such actions reappeared.

In Sienese painting of the early fourteenth century one also finds many violent gestures, although certain tendencies and the pace of development

39. Duccio, *Lamentation of Christ* (detail), Siena.

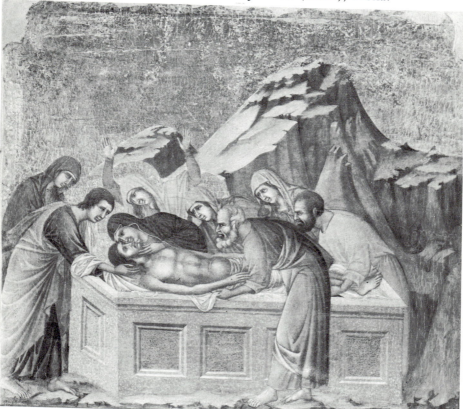

are here somewhat different from those of Florence. One of the earliest, and most famous, Sienese paintings in which such a gesture occurs is Duccio's *Lamentation of Christ* (Fig. 39). The spirit of Duccio's style — in Vasari's words: a *"maniera greca mescolata assai con la moderna"*[32] — can also be seen in this *Lamentation*. Both in some tendencies of style and in details of iconography this picture betrays its origin in Byzantine *Threnoi*. It is significant that certain Giottesque motifs, which in his period were probably considered as hallmarks of "modern" art, are omitted in Duccio's picture. There are, for example, no huddling mourners (instead, Duccio painted an old man standing in front of the sarcophagus and holding Christ's hand). He also omitted all violent gesticulation; only a female mourner, placed behind the Virgin Mary, throws up her arms. Although this gesture is well known in late Byzantine art, its specific form in Duccio's painting would seem to point to a Western source. Even in the most dramatic Byzantine *Threnoi*, figures throwing up their arms in fact only raise them moderately.[33] In the late Middle Ages, it was in Western art that the vertical position of the thrown-up arms became popular, and Duccio essentially followed a Western pattern in his representation of the act.

The impact of Duccio's picture on Sienese art as well as on painting in Northern Europe in the early fourteenth century can easily be traced. From Sienese art I shall mention the Berlin *Entombment* by Ugolino da Siena.[34] Here, one of the female mourners, occupying the center of the composition, vehemently throws up her arms. The arms are maintained in a stiff, rigid position, lacking the rhythmic quality characteristic of Duccio's representation. Another follower of Duccio, Segna di Bonaventura, also uses dramatic gesticulation as a means of expressing grief. In his *Crucifixion*,[35] in the Crawford Collection, the Virgin dramatically raises her hands to the cross, as if addressing Christ. In fact, however, the raising of the arms is meant as a violent mourning gesture.

A climax in the force and variation of dramatic mourning gestures is reached in Simone Martini's late works. What may be called his *ultima maniera* differs, as one knows, from the delicate style of his earlier period both in the massiveness of the groups that densely fill the space and in the passionate gesticulation of the figures. In the *Way to Calvary* in the Louvre (Fig. 40) a woman, hovering over the group of the mourning disciples following Christ, and made conspicuous by her red garment, throws up her hands. This gesture, with arms slightly bent at the elbow and with the hands slightly turned outward, probably echoes the similar motif in Duccio's *Lamentation*. There may even be some reminiscence of Duccio in the fact that this figure is placed above and behind the Virgin Mary, who in Duccio's

40. Simone Martini, *Way to Calvary*, Louvre, Paris.

Lamentation kisses the dead Christ and in Simone Martini's *Way to Calvary* is prevented from touching Christ by a rude Roman soldier.[36] In another painting by Simone Martini, the *Descent from the Cross* in Antwerp,[37] we encounter the same figure as she performs the same gesture. In dramatic gesticulation, all other works of the master are overshadowed by the *Lamentation* in Berlin (Fig 41). In this picture, one female figure, standing behind Christ's head, frantically throws up her arms; another mourner tears her hair in a broad impressive movement. The foreshortening of her face lends further emphasis and realistic quality to the violent gesture. An additional female mourner to the right of the picture—echoing perhaps the earliest examples of the *pleurants*—completely veils her face. In front of the sarcophagus, still another figure, seen from the back, huddles on the ground. This mourner not only creates the impression of deep space, thus adding to the tense, dramatic mood of the whole scene, but also raises her hands to her face. The specific action performed cannot be definitely established; the movement might be interpreted either as tearing the face or pulling the hair.

41. Simone Martini, *Lamentation of Christ*, Berlin.

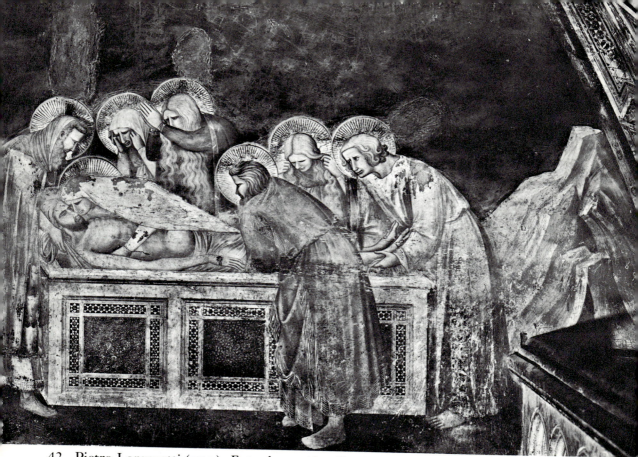

42. Pietro Lorenzetti (attr.), *Entombment* (detail), Church of St. Francis in Assisi.

In shrillness of gesticulation Simone Martini's Berlin *Lamentation* remains unsurpassed in Sienese art. In a less dramatic manner, however, Sienese painters continued to represent violent mourning gestures, using particularly the most crystallized forms.

An *Entombment* in the Lower Church of St. Francis in Assisi (Fig. 42), often attributed to Pietro Lorenzetti but probably executed by his pupils,[38] is typical of the representation of such gestures in Sienese art. A female mourner, standing behind the Virgin Mary and adorned with a halo, is leaning forward and tearing at her face. The representation of the hands is somewhat clumsy and does not convincingly portray the violent action. The fingers of one hand are curved, but the hand lacks the tension which is so clearly brought out in the similar gesture in the *Death of the Knight Celano* (Fig. 33). The other hand, seen in profile, with clearly curved fingers, does not grasp the face or claw into the cheek. There can be no doubt, however, as to the artist's intention to represent the laceration of the face, and in his depiction of the movements he followed well-established gestural patterns.

Another woman in the same mural (second figure from the right),

bending forward in a typical mourning posture, is pulling her hair. Here again the gesture lacks the high artistic qualities and the dramatic force characteristic of its representation earlier in the century. The hands grasp the hair rather gently, the hair itself falls in a slightly undulated form, thus avoiding the impression that it is being forcefully pulled. But these modulated softened characteristics of representation do not affect the meaning of the gesture.

The same gesture occurs in the *Massacre of the Innocents*, a mural in the Church of St. Maria dei Servi in Siena (Fig. 43).[39] A symmetrical group of lamenting mothers, placed in the center of the first row of figures, reaches its climax in the woman who throws up her head and tears her hair (Fig. 43a). The foreshortened head betrays the influence of a recently found formula in which spatial dimensions contribute to expressive quality. The tendency toward dramatic action prevailing in this work perhaps indicates a clearer connection with Pietro Lorenzetti than can be seen in the mural formerly discussed; nevertheless, the *Massacre of the Innocents* also seems to have been executed by pupils and followers of the master, as some details betray. De Wald has rightly stressed that in this mural the hands are "very weakly done, conveying no effect of grasping or holding."[40] This holds true also for the tearing of the hair, but, as in the former cases, it does not affect the meaning of the gesture.

In the same fresco another violent mourning gesture occurs. In the center of the back row, a mother is rending her cheeks. As in the figure previously discussed, her face is foreshortened, and in fact, the physiognomic features are almost identical in both figures. An obvious attempt is made to display the gesture fully and to represent it convincingly. The heads of the other figures are arranged in a semicircle around the lamenting mother, none of them overlapping her head. Moreover, no other forceful gesture detracts the viewer's attention from her mourning. In composition and arrangement one sees a great master at work. The representation of the hands themselves, however, betrays the style of a pupil or follower, who did not entirely understand the dramatic structure of this gesture or did not master its representation. The curved fingers do not claw into the cheek but rather seem to be sliding off the surface. But this, again, does not obscure the meaning of the gesture (Fig. 43b).

Gestures of mourning in Italian painting influenced also the art of Northern Europe. As we know, in the art of France and the neighboring countries there was very little dramatic gesticulation in scenes of a sacred character before the fourteenth century. Gothic representations of the Crucifixion and the Entombment were dominated by tendencies which

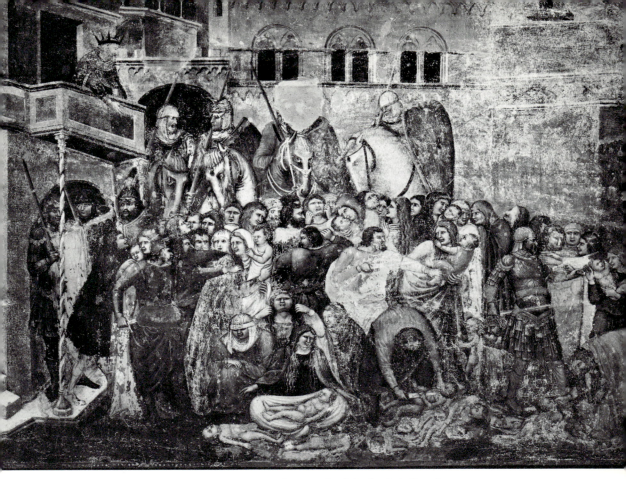

43. *Massacre of the Innocents*, Siena, S. Maria dei Servi.
43a. *Massacre of the Innocents* (detail), Siena, S. Maria dei Servi.
43b. *Massacre of the Innocents* (detail), Siena, S. Maria dei Servi.

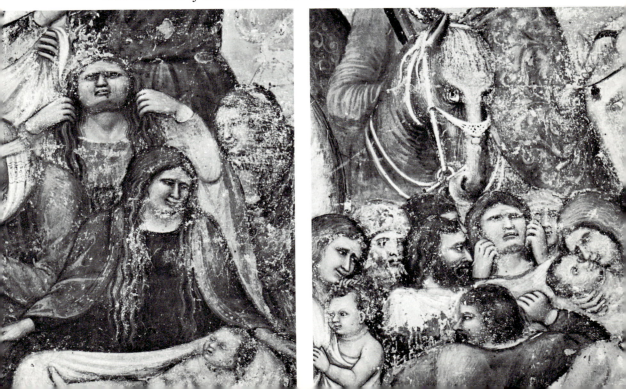

coupled nobility with restraint.[41] The disturbance of this quiet and elevated style in the early fourteenth century is one of the most fascinating episodes in the history of art. Jean Pucelle, the Parisian illuminator of the early four-teenth century, was as Panofsky says, "the first northern artist who replaced the Gothic Entombment by the Italo-Byzantine Lamentation with mourners wringing their hands or covering their faces in unutterable grief and the Virgin Mary throwing herself over the body of Christ in a final embrace."[42] The overturning of the traditional Gothic image was accomplished, as one knows, under the impact of Italian and specifically Sienese art. Duccio's *Lamentation* in Siena, probably the model of the Parisian illuminator, con-tains several of the well-established mourning gestures: the Virgin Mary kissing the dead Christ, Mary Magdalen frantically throwing up her arms, and two mourners wiping their tears with veiled hands. Jean Pucelle's *Entombment* (Fig. 44) in the *Hours of Jeanne d'Evreux*, although generally patterned after Duccio's *Lamentation*, is not a slavish copy nor a precise transposition of a panel painting into a miniature. The northern artist transformed his model by introducing new dramatic motifs or by emphasiz-ing dramatic elements that were rather latent in Duccio's composition. Jean Pucelle adds the figure of a huddled mourner in front of the sarcophagus (probably under the influence of another Italian source).[43] The faces of two female mourners (the figures at the extreme right and left of the miniature) are now completely veiled, an antique image of mourning that reached its final formulation in the figures of the French *pleurants*.

 A further difference between Duccio and Jean Pucelle, slight but charac-teristic, can be found in the representation of the most conspicuous gesture of mourning, the throwing up of the arms. In Duccio's picture, the mourn-ing Magdalen throws up her arms vertically (albeit rhythmically) and the hands themselves, pointing outward, continue the movement of the arms. In Pucelle's *Entombment* the raised arms are turned inward, the hands are bent downward toward the head (creating in one arm the motif of a "fracture"), and the fingers are intertwined. The basic formal pattern, which seems very similar to Duccio's at a first glance, is in fact quite different. Duccio's figure may be described as performing an "open" gesture of great dramatic force, a rhethorical movement of the arms in which the hands have no specific or additional function. The same gesture in Jean Pucelle's illumination is, so to speak, of a "closed" character, and leads back to the figure performing it. Moreover, the wringing of the hands and the intertwining of the fingers, in themselves gestures of despair well known already to Carolingian art,[44] are added to the movement of the arms. The Pucelle version of the thrown-up arms is not dominant in the following period, but apparently it was not

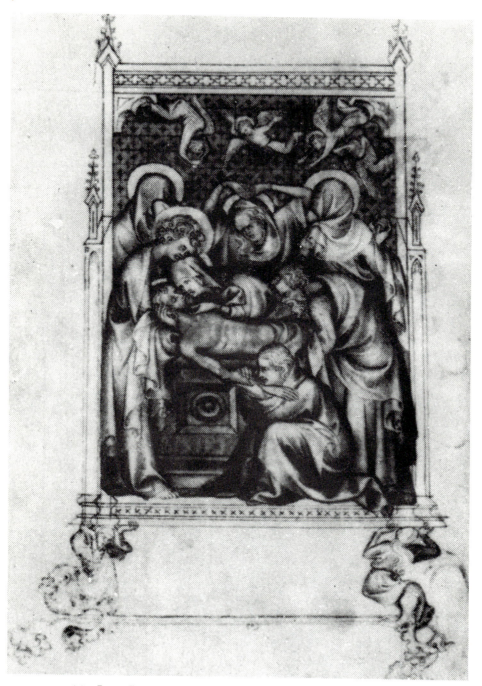

44. Jean Pucelle, *Entombment*, Hours of Jean d'Evreux

altogether forgotten. It recurs, for example, in the late fifteenth century in a sculpture by Veit Stoss.[45]

Italian influences carried the throwing up of the arms into distant regions of European art. Both this and other dramatic mourning gestures (such as the pulling of the hair) penetrated into French book illumination of the four-teenth century, occurring mainly in representations of the Lamentation and Entombment. The *Petites Heures du Duc de Berry* contains two different representations of the Lamentation, reflecting two different traditions of depicting the scene and two different emotional approaches to it. One of these illuminations, executed by Pseudo-Jacquemart, follows the northern and Italian *Vesperbild*.[46] It is conceived in a rather lyrical mood and, while pervaded by the emotionalism typical of the *Vesperbild*, it avoids all dramatic gesticulation by the mourning figures.

The other illumination, done by the so-called Passion Master, is more dramatic (Fig. 45).[47] Basically the artist here follows Jean Pucelle and, through his mediation, the Italian models. In dramatic effects, however, the Passion Master sometimes goes even farther than Pucelle: in his work the sarcophagus is placed diagonally, protruding toward the beholder; the mourners, emerging form the depth of space, move toward the sarcophagus — both elements emphasizing the expressive qualities of spatial relations, and creating criss-crossing diagonals which also contribute to the conveying of tension. In front of the sarcophagus there are two huddled mourners (where Jean Pucelle had only one), one of them kissing Christ's hand (as in Pucelle's minature), the other covering her eyes. In the representation of the thrown-up arms, the Passion Master is closer to Duccio than to Jean Pucelle. The raised arms of the mourning figure are opened wide and the outward-turned hands further emphasize the "open" character of the gesture. This miniature, Panofsky says, "reflects and transfigures the shrill excitement that pervades the Berlin *Lamentation* by Simone Martini."[48]

Although but few later representations of the Entombment reach the dramatic force of this illumination, northern artists continued to use the throwing up of the arms as a formula of mourning. In the *Lamentation* of the *Grandes Heures du Duc de Berry*, the throwing up of the arms is the single violent mourning gesture. One hand is so sharply bent outward that it almost forms a right angle with the vertically raised arm, an additional variation of the "fractured hand" as an expression of despair.[49]

In another Book of Hours of the Duc de Berry, the *Belles Heures*, probably written and illuminated in the first years of the fifteenth century, the tearing of the hair is the principal movement of lamentation. In an illumination of this manuscript, a *Vierge de pitié*,[50] St. John covers his eyes

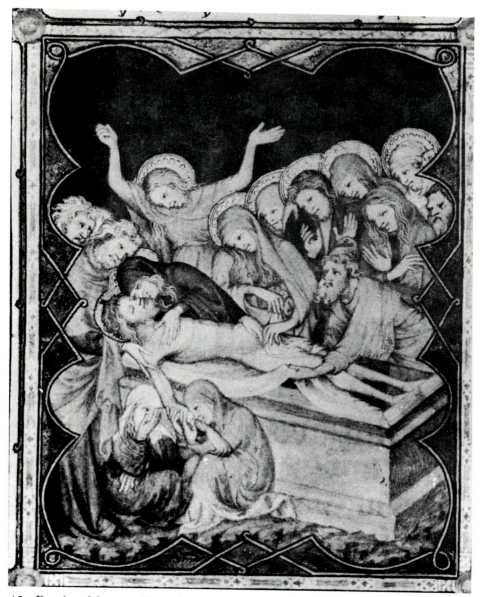

45. Passion Master, *Entombment*, Paris, Bibl. Nat., Lat. 18014, fol. 94 v.

while a female mourner jerks her blond hair quite unconvincingly. In another illumination of the same manuscript, the *Entombment*, the tearing of the hair is rendered more dramatically. The mourning woman throws up her head, her face being seen in sharp foreshortening, while the hands pulling the hair are placed horizontally.

Dramatic mourning gestures found their way also into early Netherlandish panel painting. In a *Descent from the Cross* by the Master of Flemalle (the central panel of a lost triptych which is known from a copy) the Virgin is

swooning in the arms of St. John, a mourning woman wrings her hands before her breast, and the impassioned Magdalen is stretching out her hands as though reaching for the body of Christ. The climax of dramatic gesticulation, however, is reached in the hovering angels. A hovering angel at the left of the panel, seen from the back, throws up his arms vertically, combining the dramatic quality of his gesture with the dramatic character of his position in space. At the right-hand side of the picture another angel, emerging from the depth of space toward the beholder, raises his hands to his face in a gesture of lamentation.[51] Similar gestures, in particular the throwing up of the arms, are frequent in Netherlandish painting of the early fifteenth century.[52]

The examples discussed so far clearly show that in the art of the fifteenth century, both in Italy and in Northern Europe, violent gestures of mourning, and even actions of self-injury, became more frequent and more articulate than they had been in former periods. Moreover, the examples adduced have shown that these motifs also penetrated into some of the most traditional sacred themes, playing a part in the transformation of the Crucifixion from a hieratic image into a dramatic scene, and in the emergence of the Lamentation as a scene in its own right. It will, therefore, hardly be an exaggeration to say that the depiction of such gestures is a significant testimony to some basic tendencies in the art of the fifteenth century. This, however, raises the question which we have outlined at the beginning of the present chapter: how are we to explain the fact that violent gesticulation, which in a somewhat earlier period seems to have been characteristic of sinners, is now performed by sacred figures in holy scenes?

VII

The Literary Sources

An attempt to understand the process by which the meaning of these gestures was transformed will have to consider the literary traditions and perhaps also the social customs that may have influenced artists, or that can at least be regarded as parallel expressions of the same shifting attitude toward gesticulation.

As we know, in the late Middle Ages a deep modification, which had a significant impact on all the arts, occurred in religious, cultural, and emotional life. In painting, the new wave of emotionalism, after a period of fermentation, eventually crystallized in such famous themes as the Man of Sorrow and the Madonna of Humility which have been investigated in well-known studies.[1] This "new emotionalism," as it has often been termed, forms an important but only a general background for our theme. In the following pages I shall restrict myself to some historical and literary sources that have a more immediate bearing on the specific postures and gestures studied in this book. I do not want to suggest that the social customs and literary texts which I shall now adduce should be considered as a direct source of trecento artists. But even if the texts are only seen as phenomena parallel to pictorial representation, they demonstrate that the gestures which appear in the art of the late thirteenth and of the fourteenth century were carefully observed in literature, and described in detail. We may therefore assume that an awareness of their form and meaning was common in that very society in which, and for which, the artists depicted these gestures in their works. Needless to say, this awareness did not exclude the use of

artistic models; it might, on the contrary, have reinforced it if these models presented gestures similar to those actually performed in society, or described in literary texts.

In Florence of the twelfth to fourteenth century, mourning was a ritual, performed according to strictly formulated rules. When a citizen died, particularly if he occupied a socially respcetable position, his death was announced by a public speaker and his fellow citizens were called to assemble in front of his house. This, it was said, occurred "*secondo il costume della terra.*"[2] (The gathering of many citizens around the house of the dead should perhaps be taken into account when discussing the multiplication of mourning figures in scenes of the Lamentation of Christ or the Entombment in Italian art of the thirteenth and fourteenth centuries.) Inside the house, the dead man was laid on a low bier, and around him gathered the women of the family and the neighborhood. Huddling on the floor, they started the ritualized lamentation. The rules of the mourning customs demanded that the women closest to the dead loosen their headdresses and allow their hair to flow freely. Then they began crying with loud voices, tearing their hair, rending and wounding their faces with their fingernails, and rending their garments down to the girdle.[3]

Contemporary documents describe such mournings in some detail. Perhaps the most important description is found in a chapter of Boncompagni's *Antiqua Rhethorica*. Boncompagni was a Florentine master of the *ars dictandi*, who taught and wrote in the late twelfth and early thirteenth century,[4] but who discussed subjects that were much wider in compass than pure rhetoric. In Chapter 26 of the *Antiqua Rhethorica* he described the "Habits of Mourning" as practiced (or as he believed they were practiced) from Rome to the Slavonic countries and the Saracen tribes. These customs, he says, are to be found throughout the world, but they differ from one country to another. Italian customs are, naturally, those he knew best, and they are described in great detail. He relates how in Rome the mourners sit near the body of the deceased, their hair loosened, shredding their faces with their nails, pulling their har, and rending their garments at the breast down to the navel. "In Tuscany there is lacerating of the face, rending of garments, and pulling of hair."[5]

Those postures and actions became typical patterns of expressing sorrow and grief, and could be employed on any appropriate occasion, even if it was not mourning for a death. Thus a saint who leaves his family and enters a monastery, S. Bernard Uberti, is mourned in similar forms; significantly, these gestures are again performed by women, his mother and sister.[6] The cruel treatment suffered by another saint is lamented by women who perform the same actions.[7]

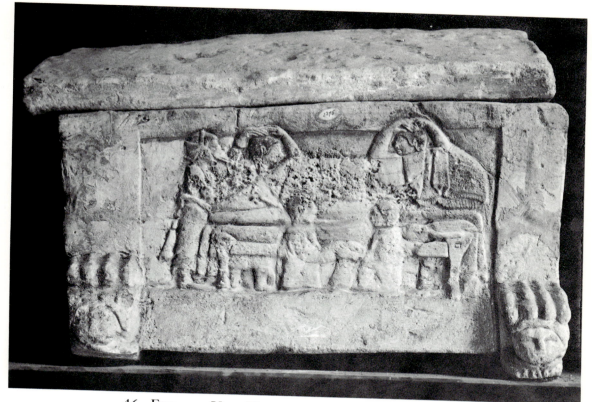

46. Etruscan Urn, Florence, Archaeological Museum.

The sources mentioned show that mourners huddling on the ground and performing actions of self-injury were a common sight in thirteenth-century Florence and in other Italian cities. Some of these customs broke down during the Black Death, but others persisted. The habit of the mourning women gathering in the house of the deceased persisted after the Black Death, as is indicated by Boccaccio,[8] and we may certainly assume that no radical changes occurred in the basic patterns of their behavior, and in the gestures carried out during the lamentations. (An illumination of a Boccaccio Codex in Paris, executed in the second third of the fourteenth century, shows the huddled mourners in a lamentation scene).[9] The huddled mourners in the Paris Boccaccio Codex may have been influenced by the similar figures in Giotto's *Lamentation of Christ*, perhaps in transmission through his school, but they also represent a social reality. It seems, therefore, plausible that Giotto, too, drew some inspiration from the mourning figures he saw in Florence and other Italian cities. Even if he derived his huddled mourners from Etruscan sarcophagi, as seems possible (Fig. 46),[10] he reshaped his models, adapting them to what he saw in everyday life. In an art permeated by naturalistic tendencies, as was the art of the early trecento, this would seem to be a plausible conjecture. The same would also hold true for the violent gesticulation of the mourners, so profusely attested in the literary sources.

Dramatic gesticulation is often described in secular literature of these centuries. The gestures of the fighting heroes form an important part of vernacular poems. But one also frequently finds in these poems descriptions of violent mourning gestures. Knights mourn the death of a count by tearing their beards, women tear their faces and breasts in lamenting the death of a king. Chrétien de Tryoes relates that a knight bewails the death of his sister with acts of violent self-injury.[11] By introducing these gestures the poets intend to suggest a spontaneous, convincing expression of emotion, although the acts themselves are conventional, as we know. In the thirteenth and fourteenth centuries stereotyped violent gesticulation is described in different contexts. The *Sachsenspiegel*, for example, a frequently illustrated late medieval text, discusses several highly crystallized gestures in detail, and prescribes their use. Some of them belong to the theme of our study. Thus the woman plaintiff should wring her hands and interlace her fingers in court, wrench off her headdress and tear her hair.[12] Performed in court, these gestures are of course not a spontaneous expression of emotion but an established form of social communication.

The examples adduced, which could easily be multiplied, prove that from the twelfth century onward violent gesticulation was closely observed, that it fulfilled a significant function in social life, and that it was regarded as an established means of expressing emotion.

So far we have referred to social customs, to patterns of behavior in everyday life. The works of art with which we dealt in the preceding chapter depict, however, central religious figures and events. Therefore I now turn to religious literature, particularly to descriptions of the Passion, in the Middle Ages, and I shall again disregard the general emotional background, in order to concentrate on the specific gestures studied in this paper.

Since the twelfth century, religious literature, as one knows, was permeated by an increasing emotionalism, which centered largely around the story of Christ's Passion. Sometimes the authors described in great detail and with much empathy the emotions and behavior of the Virgin and of the saints who witnessed the tragic event, paying considerable attention to the gesticulation of the figures. In the first part of this study I have attempted to show that early Christian authors considered violent gesturing inappropriate for holy figures. In the late Middle Ages this attitude underwent modification; the saints and the Virgin are now often described as dramatically mourning Christ with violent gestures. This change in attitude emerged, however, only gradually. The main stages of this transformatory process, as reflected in religious literature, are significant for an understanding of the meaning of the gestures, and I shall, therefore, indicate these stages by briefly analyzing a few selected literary examples.

The emotional tendency in medieval religious literature was to a large extent focused on the Virgin Mary and on her mourning for Christ. In an earlier period the *Lamentations* of the Prophet Jeremiah had already been included in the liturgy for Good Friday. It has been assumed that the prophet's *Lamentations* paved the way for the so-called *Lamentations of the Virgin Mary*.[13] The latter, a widely diffused type of medieval poetry, emerged in Western Europe at the time of the Crusades, no text apparently antedating the twelfth century.[14] In the *Lamentations* the Virgin Mary is frequently described as expressing her grief in movements of the body. She sheds tears, walks tensely and desperately around the cross, and faints at its foot. There are also some descriptions of gestures, especially of the hand. Already in the *Tractatus de Planctu Beatae Mariae*, wrongly attributed to St. Bernard, she is often said to raise her hands to the cross in an attempt to embody her grief.[15]

The *Lamentation* by Pseudo-Bernard proves that the conception of the restrained Virgin who does not weep while she contemplates Christ's death, a conception characteristic of the early Christian period, was giving way to a more human image of the mourning mother. It is, however, interesting to notice that in the earlier stages of Lamentation poetry there do not seem to be any elaborate descriptions of the Virgin injuring herself in frantic grief. Such a description may be found in a late antique apocryphal Gospel,[16] but in the Middle Ages it seems to have been replaced by a more hieratic and restrained image of the Virgin.

An early description of a violent action, close to self-injury, in the context of the Passion of Christ, can be found in St. Bonaventure's *L'Arbore della Croce*, written in the second half of the thirteenth century. St. Bonaventura's little book, although full of symbolic imagery, lacks the narrative character and visualizing quality that are so typical of popular religious literature in the thirteenth and fourteenth centuries. It has only a few descriptive details, one of which bears on our theme. St. Bonaventure relates how the centurion, who later became a martyr and a saint, watches Christ's agony on the cross with delight; but upon experiencing the earthquake and the resurrection of many saints at the moment of Christ's death, he is shaken and confesses his belief that Christ is the true Son of God. "And while he came to see, and to watch with delight, His Passion," St. Bonaventure says, "he went back, hitting the breast in sorrow and in fear and in bitter pain."[17] In interpreting the meaning of the gesture it should be borne in mind that it is performed by an ambiguous figure, standing on the borderline between sinner and saint. The meaning of the gesture is ambivalent, as is suggested by the motives of the centurion's behavior. It is not only sorrow for the death of Christ, and perhaps remorse for his own sins, that cause the centurion to beat his breast,

but also fear, the traditional context of actions of self-injury which we have found in contemporary representations of the Last Judgment.

Perhaps the best-known work of popular religious literature in thirteenth-century Italy is the *Meditations on the Life of Christ* wrongly attributed to St. Bonaventure. In this influential text the descriptive and visualizing tendency of popular religious literature of the period reached its peak. It is, therefore, not surprising that here gestures and physical actions expressive of emotive states are described in great detail. In the narration of the Passion certain typical gestures recur. St. John embraces the Virgin to prevent her from falling to the ground and, at the same time, veils his head in grief. The Virgin addresses the soldiers while she is "down on her knees, her arms crossed, with tear-stained face and hoarse voice." St. John and Mary Magdalen try to console her while they are kneeling, and sit down on the earth to mourn and lament. The Virgin grasps Christ's hand and huddles on the ground, as do the others, to lament.[18]

The influence of these descriptions on contemporary and later representations of the Passion in art has often been pointed out. In art-historical literature the impression sometimes prevails that the *Meditations* can explain most of the dramatic representations of the Passion scene in trecento art. For the specific theme of the present study, however, this does not seem to be true. The realism of the description and the presentation of sacred figures stirred by human emotions and displaying human "weaknesses" (such as the swooning of the Virgin) enable the reader to identify himself with these figures. But the emotionalism of the *Meditations* is not expressed in, and does not lead to, violent, frantic movements in which the holy figures hurt themselves in sorrow and despair. This restraint seems to be particularly true of the Virgin Mary. In chapters of the *Meditations* describing the Passion, the Virgin is not pictured as performing any of those violent gestures we have studied. The typical description of the Virgin Mary during the hours of the Passion says that she is absorbed by unutterable grief, that she is suffering indescribable pain, and that she is ready to die with Christ, but her physical actions are rather restrained; more often than not she is described as "gently shedding tears." The most touching passages are those reporting the words she utters, not those describing the actions she performs. A peak of dramatic behavior is indicated in the moments before the opening of the side: "The Lady and all of them . . . their sorrow is renewed and their fear and trembling increase."[19] Characteristically, no further physical details are here given, and it is perhaps also significant that in this more dramatic expression of emotion the Virgin is not alone. Her most overtly physical manifestation of feeling is here swooning and falling to the

ground (usually being caught by St. John or Mary Magdalen). While fainting is certainly a "human" feature, it does not have the quality of violent movement, actively carried out by the figure, and directed against herself. In the *Meditations*, then, the Virgin's image is characterized by deep sorrow but not by that despair which explains, or leads to, self-injury. The traditional connection of such acts with sinners and the damned may have been an important reason for the author's restraint when describing the gestures of the Virgin Mary.

The other figures who take part in the events of the Passion sometimes perform more dramatic gestures. On the Sabbath after the Crucifixion, the three Marys go to visit Christ's tomb while the Virgin remains in St. John's house. On their way to the sepulcher they pass the cross which is still standing and "with great cries and flood of tears, prostrate on their faces, they adored and kissed the cross."[20] On the same Sabbath there occurs the only violent action that the author of the *Meditations* recounts. The disciples, assembled in St. John's house, were "striking themselves with their hands and shedding tears, [and] blamed themselves for abandoning their sweetest Lord".[21]

The relationship between the descriptions of gestures in this famous text and some of the best-known pictorial representations of the late dugento and early trecento seems to be a very complex one. The general emotional attitude, as expressed in the *Meditations*, certainly formed the background for thirteenth-and fourteenth-century representations of the Crucifixion, the Descent from the Cross, and particularly the Lamentation. Many motifs (such as the swooning Virgin falling into the arms of St. John or of the Magdalen) in the works of art of this period can be sufficiently explained by this text. But one would look in vain in the *Meditations* for passages explaining the gestures of the angels in Giotto's *Lamentation* (Fig. 37b), or the violent tearing of the hair in Simone Martini's Berlin *Lamentation* (Fig. 41). In the representation of frantic gesticulation the painters may often have gone beyond what was described in religious literature of the time. Classical models as well as observation of life may have been of significance in this development. In the late thirteenth century the attitude of restraint had already given way to a more dramatic behavior, increasing the violence of gesticulation. In the literature of that period, the Virgin Mary performs certain gestures of self-injury that were typical of the Roman *conclamationes* but which were denounced by the early Fathers of the Chruch as "pagan": for instance, she beats her breast with her fist.[22] The opposed attitudes of the early Christian Church and of the later Middle Ages toward dramatic gesticulation are well illustrated by a comparison of St. Ambrose's assertion,

quoted above, that the Virgin Mary did not weep while standing beneath the cross,[23] and thirteenth-century *Lamentations* describing how she strikes herself in grief.

In Italian religious literature of the fourteenth century the attitude of temperance is altogether abandoned. Trecento texts abound in detailed accounts of frantic self-injury performed by sacred figures. An important document of this tendency is a long narrative poem, called *La Passione*, which was composed in 1364. Its author, Nicola Cicerchia, was a Sienese poet of minor merit and gifts who largely relied on literary traditions, and for this very reason reflects the trends present earlier in the century.[24] The *Passione* is patterned after the last chapters of the *Meditations*, but in descriptions of self-affliction performed by the Virgin Mary as well as by the disciples of Christ, it differs from its more famous model. I shall quote here a few examples of the more violent gestures as described by the Sienese poet.

On the way to Calvary, St. John *"tutto triema com 'al vento foglia"* and the Virgin *"co' le man' si frange."*[25] She also wrings her hands in grief.[26] With innumerable reiterations she falls to the ground without being prevented. During the Crucifixion, *"La donna allora del pasmo si sviglia"*[27]—she stretches her arms stiffly to the cross. When Christ dies on the cross, she beats her breasts.[28] St. John

> po' co' le mani 'l viso si percuote.
> Con dolenti sospir la lingua sciolge
> piangendo, c'a gran pena parlar puote.[29]

The Virgin strikes her cheeks so that they turn pale and red.[30] The Magdalen

> Dice:— Maestro, di morir contenta
> sare' i', stando teco!— e 'l viso frange,
> e 'l cape e 'l viso si percuote e 'l petto,
> dicendo:— Ome, maestro mie diletto!"[31]

The repentant St. Peter, after covering his head with his mantle and clutching his cheek, also

> Amaramente si frange e percuote,
> in terra cade, a nulla parlar puote.[32]

By quoting Cicerchia I do not want to suggest that his poem should be

regarded as a "source," that is, as a literary model for a visual representation. Many of the artistic representations so far discussed precede this poem. In Cicerchia's *Passione* one may even perhaps detect some — rather vague — indications that he looked at pictures representing the scenes that he described.[33] *La Passione* is interesting because it probably reflects some earlier literary models or traditions, and because it clearly shows the attitude of the fourteenth century toward violent gesticulation. This attitude permitted, and perhaps even required, that sacred figures display a dramatic behavior while taking part in tragic events, or stirred by deep emotions. In the process of transforming the image of the holy personage, neither art nor literature necessarily preceded one another; both seem to have been conditioned by the same general development of sentiment and imagery. It is in contexts such as these that one necessarily speaks of the basic and comprehensive attitudes or tendencies of a period, which, though difficult to define with precision, must be taken as a reality.

VIII

The Mourning Angels

The increasing emotionalism and violence of represented gesture crystallized, in the period under discussion, in several iconographic motifs, one of them being the mourning angels in the Crucifixion. About the middle of the thirteenth century, artists, particularly in Italy, began to represent angels frantically mourning the death of Christ, the process reaching a climax in the works of the great masters of the early trecento. The new motif persisted in the fourteenth and fifteenth centuries; it spread from the Crucifixion into related scenes (the Descent from the Cross, the Lamentation, and the Entombment) and attained a wide diffusion in European art, showing not only how fast a newly invented motif can reach across political and cultural borders but also how universal must have been the new emotional attitude that it expressed. I shall briefly analyze the principal stages of it development by discussing some selected examples.

When the mourning-angel motif appeared in thirteenth-century art it was, paradoxically, a theme both new and yet not without precedent. For composition and pictorial elements, artists depicting the mourning angels may have drawn from two established traditions: the representation of angels and of the Sun and the Moon in the Crucifixion.

The angels that appear in representations of the Crucifixion preceding the thirteenth century display a vast variety of style, but they are remarkably uniform in iconography and expression. In some early works of art, both in Italy and in Byzantium, angels are already encountered hovering symmetrically on either side of the cross, sometimes carrying what seem to be

96

scepters,[1] sometimes raising their hands to show the palms.[2] Both in mean-
ing and in mood they are opposed to sadness; their movements and gestures
are rather intended to exalt the majestic glory of Christ and of the Crucifix-
ion. In insular art, too, mighty angel figures sometimes hover on both sides
of the cross, but in character, and specifically in gestures, they convey
overwhelming power and are altogether removed from the emotional sphere
of lamentation.[3] In continental, particularly French, art from the ninth to
the twelfth or thirteenth century the angels in Crucifixions are more delicate
in form and more elegant in movement; but their meaning, the actions they
perform, and their emotional character are essentially unchanged. Hovering
symmetrically in the direction of the Crucified, restrained in gesture (al-
though sometimes resting their arms on the cross),[4] they express astonish-
ment, reverence, and adoration. It was this conception that was most clearly
expressed in the articulate motif (particularly frequent in Gothic art) of the
hovering agels holding chalices to catch the sacred blood of Christ, a cultic
and symbolic image which, transforming a tragedy into a mystic ritual, is
detached from the human emotions of sorrow and grief, and does not permit
the rendering of dramatic movements.

Reviewing the many examples, of which only a few have been mentioned
here, one comes to the conclusion that before the thirteenth century the
depiction of angels in the Crucifixion is restrained in character and does not
suggest lamentation.

But in representations of the Crucifixion, lamentation was at least sug-
gested, not by angels but by other figures, the personification of Sol and
Luna.[5] Particularly when they are rendered only as heads or isolated
figures,[6] the Sun and the Moon participate in the tragic event and express
their grief by performing a typical, though restrained, gesture of mourning,
the raising of the veiled hand to the face. I confine myself to reminding the
reader of a few famous examples. In a ninth-century manuscript in the
Morgan Library, the Sun and the Moon veil their faces, the latter dramati-
cally raising her hands while a billowing drapery further emphasizes the
spontaneous character of the movement.[7] In a ninth-century ivory in Berlin
the Sun and the Moon, this time represented as full-length figures, perform
quiet but clearly legible mourning gestures.[8] In a Gospel book from Metz,
produced in the eleventh century, the Sun raises her veiled hands to her face
and the Moon his hand to his cheek.[9] This gesture was common in twelfth-
century art. Famous examples are the Symbolic Crucifixion in the *Hortus
deliciarum* where the Sun veils her face, and the well-known relief called
Externsteine, executed in 1115, where both the Sun and the Moon veil their
faces in grief.[10] In representations of the Crucifixion a gesture of mourning,

however restrained, was thus frequently present, but it was not performed by angels.

Mourning angels over the cross seem to make their first appearance in Italian art of the eleventh century.[11] By the thirteenth century the motif is common and can be found in quite remote places. As an example we may refer to the weeping angels on some Crusader icons in Sinai, a selection of which has recently been published, including three panels that represent the Crucifixion. In two of these icons mourning angels occupy a prominent place (Fig. 47); in a third the figures of the angels are blurred, but what is discernible permits us to assume that their gestures were not different.[12] These angels, in sweeping postures, are symmetrically arranged on either side of the cross. They perform the same gesture: one angel veils his face with the edge of his mantle, the other hides his face in his bare hands. Although in itself the hiding of the face is the most restrained of mourning gestures, it cannot have arisen on Byzantine soil. "The high emotional pitch of these angels," Weitzmann says, "would suffice to indicate that this icon, despite its otherwise purely Byzantine iconography, was not designed by a Byzantine painter, but by a Westerner."[13]

In Western, especially in Italian, art of the late thirteenth century, the mourning angels became a significant feature in representations of the Crucifixion. One of the early monumental works incorporating the new motif is Cimabue's *Crucifixion* in the Upper Church of St. Francis in Assisi (Fig. 32). Here the mourning angels have so increased in size and number that they fill the whole upper part of the mural, counterbalancing the groups of the figures who stand beneath the cross. In Cimabue's angels, the old and the new, restrained symbolism and fervent emotionalism, are both blended and juxtaposed. Besides angels holding chalices for the blood of Christ, there are angels dramatically mourning His death. The range of clearly definable actions and gestures, however, is not larger than in the Sinai icons. The main lamentation gesture is the hiding of the face. In the representation of this gesture Cimabue reveals his genius, creating a variety of nuances and slight deviations from established images, and thus imparting a highly emotional quality to the hovering figures. Note, for instance, the tense relationship between the first angel to the left (who hovers toward Christ but hides his eyes in grief) and the first angel to the right who, also hovering toward Christ, turns his head away. In both figures the conflict of movement (the urge to be near to the cross, and the terrified revulsion from the scene of horror) is clearly brought out. The same twisted, chiastic movement is suggested in the angel of the upper row to the left (nearest to Christ) who dramatically plunges from the depth of space toward the cross, but hides his

47. Crusader Icon, Sinai.

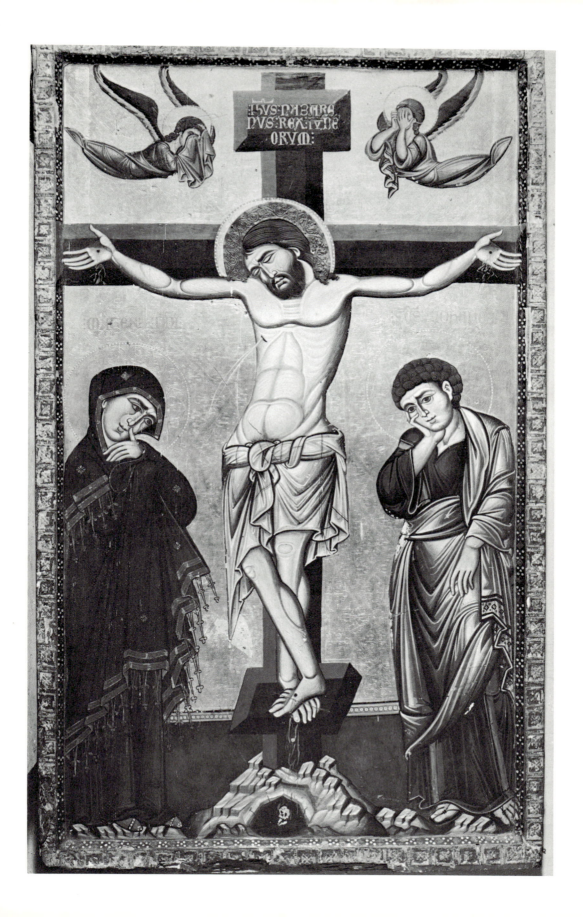

face with both hands. The opposing tendencies of a vigorous forward movement and a shrinking back (suggested by the hiding of the face) are already indicated in the Sinai icons, but Cimabue has transformed them into highly expressive features of art. The emotional quality of Cimabue's work, however, obscures the simple fact that the gestures themselves, insofar as they can be classified according to the actions performed, are gestures of quiet sadness that can ultimately be derived from the restrained representations of lamentation in Greek art.

In Giotto's work and times the history of the mourning angels reaches a new stage; contrary to former representations, the angels now perform actions of self-injury. In his Paduan *Lamentation* (Fig. 37b), where the hovering figures of angels take part in the mourning, Giotto extensively used the third dimension as an expressive device. Emerging from the unseen depth of space, the angels plunge toward the beholder in bold foreshortenings, increasing the dramatic quality of the whole work. A group of three angels, hovering above the head of Christ and the embracing Virgin, perform the mourning gestures typical in the art of the time. In the center of the group one angel raises his white garment to his face, hiding his eyes or wiping his tears; the angel to the right throws out his arms widely, echoing, I believe, the Hippolytus gesture of St. John; the angel to the left of the group lacerates his face, his curved fingers repeating the pattern of the violently tearing hand which we know from the *Death of the Knight Celano* (Fig. 33). Another angel in the same mural forcefully pulls his hair, thus completing the repertory of violent mourning gestures.

In works of art produced at this time angels frequently perform these same gestures. In a Crucifixion in the Lower Church of St. Francis in Assisi, probably by Giotto's assistants (Fig. 35), two of the mourning angels rend their faces, and a third rips the garment on his breast. The latter gesture also occurs in Giotto's *Crucifixion* in Padua.[14]

Similar motifs, although treated somewhat less dramatically, can also be found in Sienese art. In Duccio's *Crucifixion* in Siena some angels wipe their tears, and one (the second from the right) clearly tears his hair.[15] In Italian art of the ensuing decades vehemently mourning angels become a common feature in representations of the Crucifixion.[16]

Reviewing the history of the gestures performed by the mourning angels, we may, then, distinguish two phases. In the first stage, up to the late thirteenth century, the angels' actions are rather restrained, their main gesture being the hiding of the face or the wiping of tears. The intensification of emotions and movements that characterizes the second stage, beginning with the early fourteenth century, is clearly expressed in the frantic actions

of self-affliction now performed by the mourning angels. This motif, besides being a new focus of the emotional tendencies that pervaded the art of the period, also shows that the early trecento could conceive of sacred figures injuring themselves in grief.

Did the desperately mourning angels emerge only in art, or can the roots of this motif also be found in literature and in the religious imagery of the time? I was unable to find any contemporary text that would clearly describe angels hurting themselves in grief over the Crucifixion. However, the broad cultural trends of the period provide some scattered suggestions which, when viewed together, may indicate that the image of the mourning angels was not confined to painting.

In Italian literature of the thirteenth century, the Passion of Christ became an important theme, and angels sometimes participate in the lamentation. In a *Lauda* by Jacopone da Todi in which angels address the Virgin Mary, a dramatic emotionalism prevails which has an intrinsic affinity with our motif. Here the angels are the messengers who bring Christ's words to the Virgin:

> Dicete a la mia sposa
> Che deggia revenire;
> Tal morte dolorosa,
> Non me face partire.

They describe the crucified Christ as they saw Him:

> O alma, noi el trovammo
> sa nella croce appiso;
> Morto lo ce lassamo
> tutto battuto a aliso.
> Per te a morir s'e miso,
> caro d'ha comparato!

And the poet adds that the angels mourned Christ "*con pianto amaricato.*"[17]

Angels also appeared in early theatrical performances of the Passion. The Flagellants were among the first who enacted the Passion on the stage, at least one performance taking place in the Coliseum in Rome.[18] Sometimes we hear of angels taking part in such plays. In a thirteenth-century *Devozione de Veneredi Sancto* God the Father sends angels to Golgotha to watch the Crucifixion. When they arrive in front of the three crosses, one angel says to the other:

> Risguardate un poco, o Angeli beati,
> Sĩ cognositi nostro Creatore.

In the same play an angel tries to console the Virgin, but she answers him:

> Non me chiamar omai Maria!
> Da poi che perdo lo mio figlio piacente,
> Io so più trista che dona che sia.[19]

As one knows, these plays were a mixture of narration and action; the angels, however, seem to have actually appeared on the stage. Unfortunately, nothing can be known of the gestures they performed. But considering the dramatic emotionalism which characterized these plays, one imagines that the gestures were not restrained.

The image of angels participating in the Passion and in the mourning over Christ persisted in the fourteenth century. In Cicerchia's *Passione*, which I have already quoted, they also appear. In the great lamentation,

> Ogni alimento dolor manifesta,
> fra li angeli doloroso pianto suona.[20]

In these sources one finds no precise description of the gestures performed by the mourning angels. Even Cicerchia, who usually pictures the scenes in naturalistic detail, speaks only of a *"dolorosa pianto."* Nothing in the literary sources, so far as I am aware, indicates the specific gestures of rending the face or tearing the hair.

No definite conclusion can be reached on the basis of these rather fragmentary observations. It seems, however, that gestures of violence and self-injury were not characteristic of the mourning angels in the literary descriptions. While the broad emotional tendencies of the period certainly favored the depiction of lamenting angels, the gestures of self-affliction performed by them seem to be more characteristic of the visual arts. We are left to ponder the problem of the possible motives of artists in going beyond the limits of the literary imagery in representing angels frantically wounding themselves in grief. Was it a desire to enliven the scenes, to render them more convincing, that led artists to depict angels tearing their faces, pulling their hair, and rending their garments? In other words, was the image of the angel hurting himself a crystallization of the expressive naturalism of early trecento painting? Or did the image drive from other sources, which are beyond the realm of art? Whatever answers may emerge after a closer investigation of the literary traditions, the artistic tendency of expressive naturalism seems to have played an important part in the further development of these gestures in art.

IX

From Donatello To Riccio

In fifteenth-century art, gestures of self-injury are highly crystallized motifs that are transmitted from teacher to pupil. In studying their recurrence in the representation of certain themes, one is sometimes able closely to follow the continuity of a school, although some new patterns emerge in the course of such a development. One example of such a continuity links three successive generations of sculptors, from Donatello to Riccio.

Violent gesticulation obviously appealed to an artist of such strong expressive tendencies as Donatello. In his work gestures of fear, lamentation, and self-injury are frequent indeed, and in rendering them he clearly follows the traditions established in the fourteenth century. He represents such gestures only in scenes of the Passion of Christ: the Crucifixion, the Descent from the Cross, the Lamentation, and the Entombment; in other words, he employs them in the most typical traditional contexts. He also follows tradition in selecting the most specific actions of mourning: hiding the face, tearing the hair, throwing up the arms. But he often reshapes the gestures; without abandoning the motifs and patterns inherited from the previous century, he infuses them with new life by some slight deviations from the established norms. I shall briefly describe some of Donatello's most significant representations of such gestures.

Perhaps the earliest work in which Donatello represented a violent gesture of mourning is the *Entombment* relief in the Tabernacle in St. Peter's (Fig. 48), executed probably in 1432–1433.[1] In the center of the composition, behind the dead Christ, a female mourner with fluttering hair frantically throws up her arms. Here this old mourning gesture undergoes an interest-

103

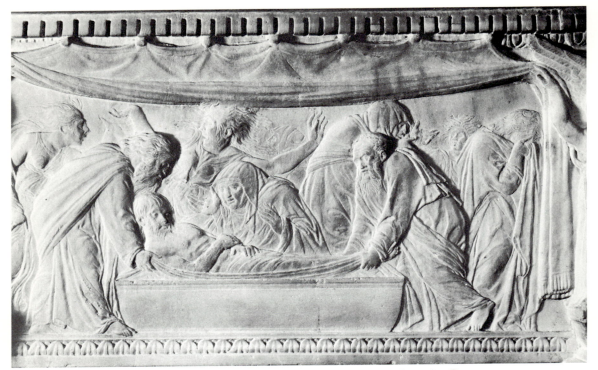

48. Donatello, *Entombment*, Tabernacle of St. Peter's, Rome.

ing transformation: the arms are not raised vertically, as was the usual
pattern, which Donatello knew well, but are instead spread out almost
horizontally. The attitude, however, differs from that of the half-raised arms
in late thirteenth-century images (Fig. 29) which are also lifted in a somewhat
horizontal position. In Donatello's *Entombment* the arms are stiff (in the
thirteenth-century image they are bent at the elbows), and the hands and
fingers are very dramatic in form, while in the earlier representations they
are always rigid. On the right-hand side of the same relief two figures,
moving out of the scene, visualize, so to speak, the crescendo of a gesture.
The figure that is nearer the center moves in a bent attitude toward the left,
her gesticulating hand close to her half-veiled face. The other figure, con-
stituting the border of the whole group, completely obscures her face with
her bare hand. To the extreme left of the relief a figure moves into the scene,
head bowed and hair fluttering, and it is to this figure that the central
mourner seems to address herself in her passionate gesticulation.

 This work poses an interesting historical problem. It has been said that in
carving this relief Donatello was influenced by the sarcophagus now in
Wilton House, which in the sixteenth century was still in Rome.[2] The figure
at the extreme right of the relief indeed bears a remarkable resemblance to a
similar figure in the sarcophagus, and also occupies a similar place in the
composition. However, no frantically gesticulating mourner appears on the

sarcophagus; a female figure, roughly corresponding to Donatello's mourner, does stretch out her one arm, but this movement is motivated not by an emotion of overwhelming grief but by the intention of restraining a Maenad rushing to the scene. Donatello's violently mourning figure is thus different, both in action and in mood, from the corresponding figure on the sarcophagus.[3]

In his later development Donatello was increasingly attracted by vehement gesticulation. An interesting result of this absorbing interest is the *Entombment* in S. Antonio in Padua, probably executed in 1446–1450. In the panels of this High Altar a high pitch of emotionalism prevails, crystallized in agitated movements; such an emotional character certainly favored the representation of violent mourning gestures.[4] The motifs of frantic gesticulation in the *Entombment* (Fig. 49) are taken over from the pictorial tradition, but the reshaping of some of them betrays Donatello's originality and power of invention. Thus to the left of the panel a figure is tearing her hair in a rather unusual form. The tearing of the hair, one of the oldest gestures of self-injury, was also one of the best-established formal patterns. As we have seen, two principal forms of rendering the gesture are known in the imagery of past periods: the dragging of the braids outward, away from the head (especially frequent in classical art) and the tugging of the hair downward (sometimes encountered in medieval art).[5] The mourning woman in Donatello's Paduan *Entombment* pulls her fluttering hair upward, an unusual form of a traditional motif. Looking at the composition, one feels that it may have been an improvisation of Donatello: the head of the mourning woman is closely framed by two other heads which leave no room for spreading the hands horizontally or representing them on a lower level. Be that as it may,

49. Donatello, *Entombment*, High Altar of S. Antonio, Padua.

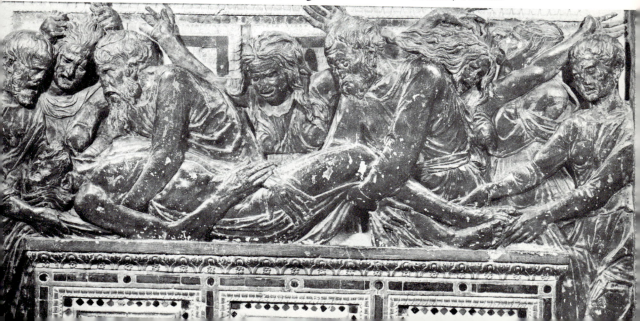

this slight change invests the gesture with a rare vividness, and is a good example of how an original artist turns a traditional motif into a new creation.

In the same relief we find several other gestures of mourning. In the background a figure grasps her head in grief; in the first row behind the dead Christ two figures fling their arms. Here, as in the *Entombment* in the Tabernacle of St. Peter's (Fig. 48), the arms are thrown out to the sides rather than upward. The extended arms of the mourners overlap, giving an additional dramatic note to the group. Their position is slightly reminiscent of the posture of the Crucified.

In this *Entombment* Donatello might have been influenced by a classical model. The posture of the dead Christ, it has been suggested, bears a striking resemblance to the figure of the dead Hector on an ancient sarcophagus.[6] It is therefore interesting to notice that in the sarcophagus the gesture of throwing out the arms in mourning does not occur at all. It is true that there is a female figure who stretches out both her arms, but in *one* direction, at the same time turning away from the scene. There is then, again, a basic difference between the ancient and the Renaissance figure.[7] Donatello's source of inspiration for these particular mourning figures and their explicit gestures must be sought elsewhere than in the Hector sarcophagus.

A *Lamentation*, in the Victoria and Albert Museum in London (Fig. 50), constitutes a new variation of an old theme. This relief, a work of high quality, is probably the only post-Paduan relief executed entirely by Donatello's own hand.[8] The dramatic climax of the group is the female figure in the background who frantically tears at her abundant hair. In dragging it outward she is close to classical models. But again Donatello invests the traditional motif with a new character by representing the figure in a twisted movement: while her body is seen in full frontal view, her face is shown in pure profile; it is lifted and turned away as if she could not bear the sight of the dead Christ. We have seen that in the early trecento, artists were already using the dimensions of space as an expressive device. In this *Lamentation* Donatello embodied the dramatic character inherent in the clash of different spatial axes in the tormented movement of the mourner's body, a movement which, so to speak, attains fulfillment in the gesture of tearing the hair.

Donatello's use of contrasts as a means of expression can clearly be seen in the London *Lamentation*. As if wishing to create a scale of emotive movements, close to the mourner tearing her hair he places another female figure who in quiet melancholy leans her head on her hand. The latter figure reminds us of Greek and Roman mourners, but the contrast between the

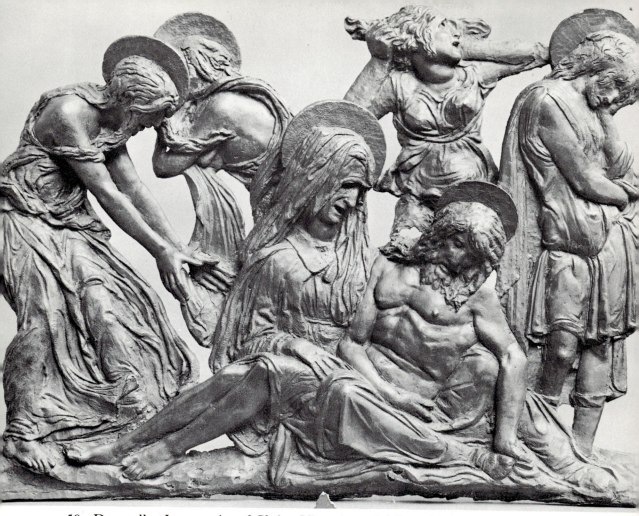

50. Donatello, *Lamentation of Christ*, Victoria and Albert Museum, London.

high pitch of expression and the restraint is a characteristic feature of Donatello's work.

To the left of this *Lamentation* a figure moves away from the scene, probably weeping and hiding her face. The gesture cannot be fully defined since the upper part of the figure is covered by the large halo of another personage who moves into the scene, but it is clearly suggested. The conflict of emotions and attitudes, which is so clearly expressed on the right-hand side of the relief, is here recreated as a conflict of movements and directions.

One should notice the frequent linking of violent gesticulation and the veiling of the face in Donatello's representations of lamentation. Both are, of course, traditional motifs. For Florentine artists of the fifteenth century, however, their combination may have held a particular interest. Alberti had described such a combination as a particularly expressive device, and had

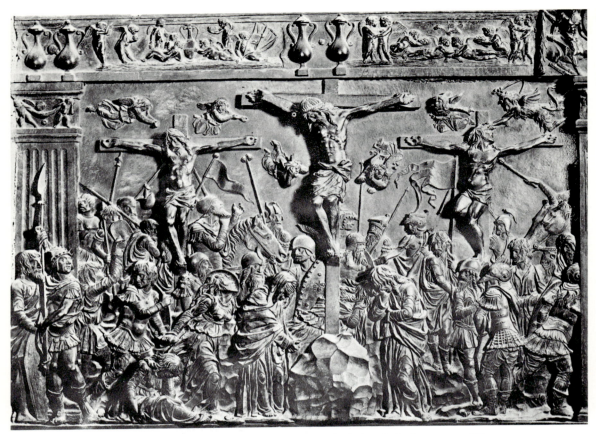

51. Donatello, *Crucifixion* (detail), North Pulpit of S. Lorenzo, Florence.
52. Donatello, *Crucifixion* (detail), North Pulpit of S. Lorenzo, Florence.

invested it with the authority of antiquity. In demanding that all the figures move "according to what is ordered in the *istoria*," Alberti tells of a picture, representing the immolation of Iphigenia, that has been described several times in ancient literature. The artist, he says, "painted Calchas sad, Ulysses more sad, and in Menelaos, then, he would have exhausted his art in showing him greatly grief-stricken. Not having any way in which to show the grief of the father, he threw a drape over his head and let his most bitter grief be imagined, even though it was not seen."[9] Donatello's frequent representation of violently mourning figures along with figures whose faces are veiled (or otherwise hidden) may have some connection with Alberti's description that was meant as an advice for artists.

As of some other works of Donatello, it has also been said of the *Lamentation* in London that it is influenced by classical models. Christ's figure in this relief does indeed resemble the figure of the wounded warrior in the so-called Amazon sarcophagi,[10] where, however, it should again be noted that no mourning figure is represented. If Donatello was indeed influenced by these sarcophagi, he added the violently mourning figures to his classical models.

Donatello's last works, the bronze twin pulpits of S. Lorenzo in Florence, are characterized by shrillness of lamentation and by naturalistic representation of violent gestures.[11] In the *Crucifixion* of the north pulpit (Fig. 51) a steeply plunging angel (to the left of Christ) violently pulls his hair or tears his face.[12] Another original motif is the bent head of St. John, whose drooping hair covers his face. Here (Fig. 52) the hair fulfills the function of the more traditional veil in late medieval mourners who cover their faces in grief. This is an original form of veiling the face which enhances the impression of a sudden movement. Donatello employed this motif in several variations in the twin pulpits, always conferring an unexpected dramatic quality on the figures. Behind the Virgin Mary a female mourner frantically rushes to the cross, throwing back her arm in a form slightly reminiscent of the Hippolytus gesture,[13] and holding in her hand a bunch of hair which she has torn from her head.[14] This motif, which I could not find in any earlier representation, is another manifestation of that expressive naturalism which conceives of gestures as real actions, showing also their physically tangible results.

In the *Descent from the Cross* of the same pulpit (Fig. 53), Donatello combines the falling-hair motif with more violent gestures. A figure whose hanging hair covers her face sharply lifts her head, opening her mouth to scream.[15] With her other hand she either grasps her head or tears her hair. This figure is repeated at the other side of the same relief, where she seems to

53. Donatello, *Descent from the Cross* (detail), North Pulpit of S. Lorenzo, Florence.
53a. Donatello, *Descent from the Cross* (detail), Norht Pulpit of S. Lorenzo, Florence.

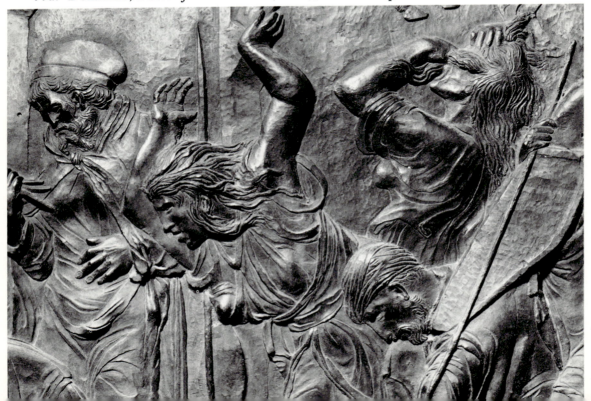

pull her hair. Another female mourner, rushing to the scene, frantically throws up her hands (Fig. 53a).

Violent gesticulation is a characteristic feature of Donatello's mature style. Both by showing the emotional vehemence of action (accompanied by a strong mimical expression) and by representing the gestures in actual physical detail, his work reveals the tendency toward expressive naturalism. While this tendency was probably influenced by a certain conception of ancient art, common in the fifteenth century, it is remarkable that precisely for the gesture of self-injury Donatello seems to have had no ancient models. In representing these gestures he rather continues, and intensifies, the trecento tradition.

In the Paduan school of sculpture, which was deeply influenced by Donatello, the master's motifs of dramatic gesticulation persisted and were further developed. Bellano, Donatello's pupil who participated in the execution of some of the master's last works, used these gestures in his relief *Samson Destroying the Temple* in S. Antonio in Padua (Fig. 54).[16] The frightened

54. Bellano, *Samson Destroying the Temple*, S. Antonio, Padua.

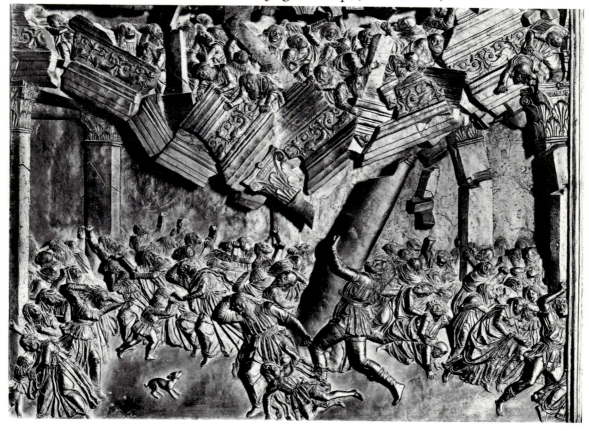

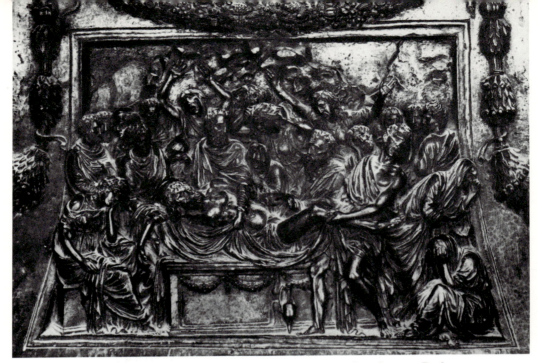

55. A. Riccio, *Entombment*, Easter Candle, Santo, Padua.

Philistines express their horror by flinging up their arms and tearing their hair. Of all Bellano's works, this relief is particularly close to Donatello.[17] It is, however, Bellano's pupil, Andrea Riccio, whose work shows the full impact of expressive naturalism in the representation of violent gesticulation.

Frantic gesturing and self-injury are frequent motifs in Riccio's work, and they appear in the chief contexts which tradition has designated for them; such gestures are performed by the damned in hell, by mourners in a secular bewailing (to which I shall come back in the next chapter), and, predominantly, by wailing saints in the Lamentation of Christ.

In the *Mount of Hell*, a work of Riccio's youth, the iconography of which is influenced by Dante's *Divine Comedy*, the figures of the damned, emerging from the jaw of a fantastic animal, grasp their heads and tear their hair.[18] The gestures are here rather weak and lack the dramatic quality characteristic of his mature style. In spite of his predilection for the fantastic and the demonic, he did not come back to the theme of hell, and this early work remains isolated. Gestures of self-injury, however, frequently recur in Riccio's many representations of the Entombment.

An early representation of the Entombment can be found on the monumental Easter candle which Riccio produced, in the first years of the sixteenth century, for the Santo in Padua. This Easter candle has been described as a "mixture of Christian scenes and pagan representations, deliberately obscure in its allegories, with a predominantly literary background."[19] In the *Entombment* (Fig. 55), however, one of the four reliefs

adorning the base of the candle, the obscure symbolism cannot be sensed. The scene is clear both in narrative content and in the emotions of the figures, the latter being expressed mainly by movements and gestures. Riccio's debt to tradition, especially to Donatello and to Paduan naturalism, is obvious at first glance. Here, Planiscig says, the pupil of the Donatello School "presents us with the whole inherited apparatus that by now had become necessary for the scene of Entombment."[20] This is also true of the gestures. In the background of this *Entombment* two figures throw up their arms in grief. Riccio takes over Donatello's innovation of representing two mourning figures throwing up their arms, but he deviates from his model in form. In the *Entombment* under discussion the extended arms do not overlap, as they do in Donatello's Paduan *Entombment* (Fig. 50). The figure to the right throws out her arms diagonally, performing, so to speak, an "open" gesture, while the flung-up arms of the figure to the left, bent at the elbows and turned inward, form a "closed" pattern. To the left of the group a female figure rushes to the scene and, while bending over Christ, violently tears her hair and opens her mouth to scream. Below, a huddled mourner grasps her head, reminding one of a similar figure in Donatello's *Entombment* in Padua.

Frantic gestures of mourning and self-affliction are particularly frequent in Riccio's later works and, to a large extent, have determined our concept of his style. I shall therefore mention only a few representations which are of particular interest for this study. In the background of the *Entombment* in Paris (Fig. 56) we see, besides the figures throwing up their arms, which are similar to those in the previously mentioned relief, a woman mourner violently tugging her hair upward, thus repeating a specific Donatello motif.

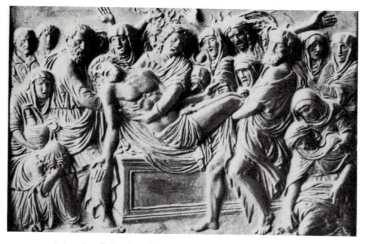

56. A. Riccio, *Entombment*, Louvre, Paris.

Another Donatello motif in the same relief is the huddled mourner to the left whose falling hair veils her face.[21] In another *Entombment* by Riccio, a relief that originally adorned a door of the Tabernacle in the Church of the Servi in Venice (now in the Archaeological Museum of Venice),[22] a woman pulls her hair upward with both hands (the strandlike forms of the hair remind one of the serpents on Medusa's head) and opens wide her screaming mouth. In the left-hand corner another female mourner flings up one arm. In its twisted movement this figure vividly recalls the dancing Maenad, a well-known image in sixteenth-century representations of the Crucifixion.[23]

Riccio probably drew from several sources in his representations of violent gestures of mourning, but he mainly relies on Paduan naturalism, and continues the tradition established by Donatello.[24] But by comparing his representation of mourning gestures with that of his immediate predecessors, one sees that he intensified the dramatic tendencies inherent in his school. This development, although rooted in the Paduan tradition of sculpture from Donatello to Riccio, reveals, needless to say, tendencies that are characteristic of the art of the whole period.

In attempting to establish the distinctive character of these gestures, their sources, and the functions they fulfill in Paduan art (and perhaps also in the whole art of the late quattrocento) one notices, first, that their representation does not imply any bold iconographic innovations. In depicting religious themes, the artists represented violent mourning gestures in the same scenes (the Crucifixion, the Lamentation, and the Entombment) where they had already been common in earlier stages of Italian art, and ascribed them to the same figures who had performed them for almost two centuries. It does not seem, therefore, to be necessary to look for new texts to explain Donatello's and Riccio's representations. One notices further that the gestural motifs themselves are also not basically new; the actions of bewailing represented in the works here discussed are the most traditional ones: throwing up the arms, tearing the hair, and veiling the face. The originality of the artists is revealed only in the slight variations on the well-established motifs. It is, finally, interesting to notice that, in the particular realm of mourning gestures, both Donatello and Riccio do not seem to have drawn directly from classical art but rather from the artistic traditions of the fourteenth and fifteenth centuries.[25] The violence and dramatic intensity that characterize Donatello's and Riccio's representations of mourning gestures is, then, not the result of iconographic, nor even of basic formal, innovations, but can best be explained by considering the expressive tendencies that permeated the art of that period.

The tradition of art theory may be of value in this context, although it

illuminates only a general disposition or trend. Italian theory of art, throughout its development, has emphasized that the power to express the passions is the main value of art.[26] The specific gestures of lamentation are not discussed, but a vivid representation of the Passion, mainly by means of gesture, is often recommended. Such a general tendency, when translated into an actual work of art, was likely to crystallize in a dramatic representation of traditional motifs. In this connection it is worth mentioning that for Leonardo, writing roughly about the same time that Riccio created his *Entombments*, the representation of a weeping figure also includes the typical gestures of self-injury. "He who weeps also tears his garments and hair with his hands, and scratches his face with his fingernails. . . ."[27] This fragment may suggest what kind of images an artist of the late fifteenth century saw in his mind when he attempted to represent the weeping figures in a Lamentation of Christ.

X

The Humanistic Tomb

This study has concentrated on two religious themes, the damned in the Last Judgment and the mourners in the Lamentation of Christ. In the period between the late thirteenth and early fifteenth century these are indeed the main, or only, themes in the representation of which gestures of despair and self-injury are encountered. In the fifteenth century, however, the range of themes in which passionate and furious gestures could be rendered was significantly expanded, including now a secular (or perhaps, semisecular) subject. Figures desperately pulling their hair, violently tearing their faces, or hurting themselves in other ways now appeared in a certain group of tombs which may be termed "humanistic." Such figures are intimately connected with the mourners in the Lamentation of Christ, but they also indicate the wider scope and further development of frantic gestures in Renaissance and Baroque art. I shall, therefore, briefly discuss some of the main monuments that belong to the group of humanistic tombs.

We need not investigate the general conception and the specific artistic forms of the humanistic tomb.[1] As is well known, in some of its major aspects the sepulcher in quattrocento Italy reflects a fundamental change in attitude as compared to the typical conception of the tomb in the Middle Ages. One of the expressions of the new spirit that pervaded the humanistic tomb is the introduction of mourning figures. These are by no means limited to one meaning. They might represent what Panofsky called the "Arts Bereft" or Virtues lamenting the death of the deceased on whose tomb they appear.[2] But sometimes such figures seem to be devoid of any specific

116

symbolic meaning, their main function being only the performance of mourning, the lamentation being expressed by gestures of the hand and movements of the body. In some works the mourners perform most vehement, frantic movements and actions of self-injury. These personages raise an interesting question. The very fact that the dead is now violently mourned reflects, of course, a new outlook, contradicting medieval beliefs. While to the medieval believer death is a stepping-stone to redemption (and for this very reason a Father of the Church condemned lamentation),[3] it is now considered a tragic event, justifying vehement grief. The new attitude should be seen in the broad context of the Renaissance reversion to classical ideas. The mourning figures themselves, both in their gestures and in the general spirit of the representation, indeed vividly recall ancient art. Humanists of the fifteenth century of course knew the Roman *conclamatio* rites from literary descriptions, and the contemporary artists were acquainted with some classical representations which they copied or forged.[4] There is, in fact, little doubt that the violently gesticulating figures on Renaissance tombs were intended by the artists, and accepted by the public, as manifestations of the *Rinascimento dell' Antichità*. The historian, however, cannot help asking how these figures are related to the images of the damned and particularly of the mourners of Christ that emerged in Italian art of the previous century. Are the passionately mourning figures on the humanistic sarcophagi and tombs, imbued as they are with a classical spirit, really the opposite of these late medieval motifs, or do they have something in common with them, and are they perhaps parallel manifestations of the same trends? What is new and what is old in them?

Mourning figures that adorn the tomb of a simple mortal (even if he were a king or a knight) are, of course, common in the late Middle Ages, as is shown by the *pleurants* on late Gothic tombs. Originating in French sculpture of the early fourteenth century, these figures spread throughout France in the second half of the century and, with the wave of Gothic influence, penetrated into Italy.[5] In form and artistic conception the figures of the *pleureurs* or *pleurants* were capable of undergoing radical transformations. From small figurines, attached to the tomb or dwelling in its niches, they became the life-size bearers of the bier.[6]

The main function of these figures is to manifest lamentation over the deceased; in other words, they fulfill precisely the same function as the mourners of Christ or the lamenting figures on humanistic tombs. The way of expression, however, is altogether different. As one knows, the *pleureurs* or *pleurants* are usually represented in a standing position, clad in long robes, their distinctive feature being the complete veiling of the face. Even where

they seem to move, as in the *Tomb of Philippe Pot*, they do not display any dramatic quality.[7]

No deeper difference in expression could be perceived than that between the *pleurants* and the wildly mourning figures on some Italian tombs of the fifteenth century. In the Italian works the mourners are not veiled but display their distorted physiognomies; their bodies are not rigid but frantically contorted; instead of a mystical and withdrawn air, they possess a high degree of psychological naturalism. And above all, they hurt themselves violently in their grief, a feature completely lacking in the restrained Gothic mourners. The Italian mourners, while contemporary with, or somewhat later than, the Gothic *pleurants*, could then not have emerged from them. But on the other hand, are the frantic figures on the humanistic tombstones directly derived from Roman *conclamatio* scenes?

The complex relationship between Christian and pagan traditions in the representations of mourning figures on fifteenth-century sepulchral monuments can at least be adumbrated by an analysis of two well-known tombs: one of Andrea Riccio's reliefs decorating the tomb of Girolamo and Marcantonio della Torre (originally in S. Fermo in Verona, now in the Louvre), and a relief by Verrocchio, or his school, the tomb of Francesca Tornabuoni, and now in the National Museum of Florence.

Riccio's eight bronze reliefs of della Torre *père et fils* offer perhaps the most perfect example of the humanistic tomb which, pervaded by a pagan spirit, owes its very existence to the intellectual climate of the fifteenth century. This monument "displays the life, death, and, if one may say so, the apotheosis of the two scientists."[8] The "pagan" attitude of narrating the life and of commemorating the virtues of the dead on his tombstone is matched by a deliberately classicizing style and by a wealth of detail which explicitly refers to classical antiquity, as it was conceived by Renaissance humanists: the setting largely consists of Roman buildings or ruins, the clothes are consistently *all'antica*, and Roman gods, brought in as statues, are present in most of the scenes. In this sepulchral cycle there are such specifically pagan episodes as the offering of a sacrifice to Aesculapius and, after death has occurred, the transportation of the soul (in the form of a child carrying a book) to the Elysian Fields instead of its being uplifted to a Christian heaven. One of the reliefs, following the death (probably of Marcantonio, who died of a malarial fever at the age of thirty), represents mourning (Fig. 57).

The mourning scene differs from the others by being less classical and less restrained. No Roman architecture forms the background of the scene,[9] and no statues of pagan gods or goddesses are visible. On the other hand,

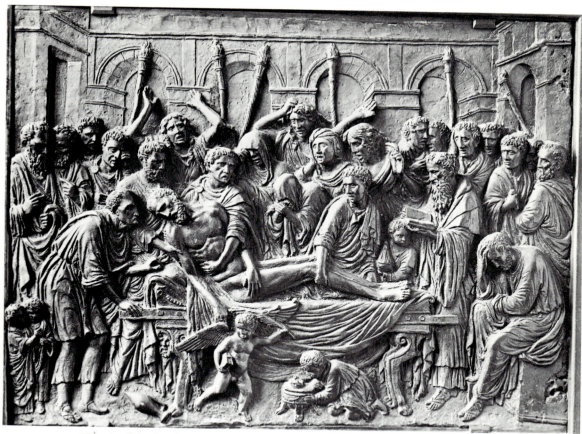

57. A. Riccio, *Lamentation of Marcantonio della Torre*, Louvre, Paris.

Riccio's expressive naturalism, well known to us from his religious works, is here more clearly visible than in the other seven reliefs of the tomb. The composition, consisting of many figures, grows in dramatic power toward the center, where a group of figures, standing behind the dead, mourn his fate by violently flinging up their arms, veiling their faces, and wiping their tears. In the exact center of the relief a figure, situated in the most distant row and somewhat higher than all the others, frantically tears her hair. The style of this scene, especially of the mourning figures, is not as restrained, sublime, and noble as that of the others. The draperies are not as elaborate, the movements of the figures are not as rhythmically weighed and balanced; and above all, the faces and gestures are dramatic and even distorted. The exceptional style of the wailing episode, as compared to the other panels, has been recognized. While the other scenes are classicizing, Planiscig says, this scene is "pure quattrocento."[10]

However, this scene of violent mourning, which is so difficult to reconcile with the other panels of the della Torre tomb, is well known from Riccio's other works. In the *Entombment* of the Easter candle in Padua, which

we have examined in the previous chapter (Fig. 55), the composition resembles the mourning scene of the humanistic tomb, closely related motifs and gestures being arranged in a similar way. In both, the group of mourners is framed by two figures throwing up their arms while a woman in the center frantically tears her hair. Very similar are also the composition and gestures in Riccio's *Entombment* panel in the Louvre (Fig. 56). Both works, as one knows, preceded the reliefs of the della Torre tomb. Comparing the wailing scene of the tomb with Riccio's earlier representations of the Entombment and the Mourning of Christ, Planiscig rightly concludes: "Basically, nothing has changed."[11]

That Riccio should have drawn gestures and compositional motifs from his earlier representations of the Lamentation of Christ for the rendering of the bewailing of a humanist is, of course, not surprising. In our context, however, this fact bears an important testimony. It clearly shows that even in the early sixteenth century, the immediate model for violent mourning, and for a scene that claims to imitate a Roman *conclamatio*, was not an authentic Roman work of art, but a Lamentation of Christ, a scene that had emerged only some three centuries earlier. Behind the Renaissance image of a Roman wailing scene there is the late medieval theme of the Lamentation of Christ.

A very characteristic example of the complex problems involved in the representation of violent mourning and gestures of self-injury on a "humanistic" tomb is provided by the relief which was intended for the sarcophagus of Francesca Tornabuoni. Francesca, the wife of Andrea Tornabuoni, Lorenzo the Magnificent's envoy to Rome, died in childbirth. Her husband, of whose deep distress we have a moving testimony in a letter which he sent to the Florentine ruler, ordered an elaborate and magnificent tomb for her. According to Vasari, the tomb was executed by Verrocchio, but most scholars agree that the reliefs that have come down to us are a product of Verrocchio's workshop, with perhaps only the design being done by the master himself.[12]

The large relief is divided into two halves. On the left-hand side, the newborn child is being presented to his father, who is surrounded by a number of figures in attendance, some of whom display moderate signs of sadness. On the right-hand side of the relief (Fig. 58) the death of Francesca Tornabuoni is represented. In the center of the scene, the dying Francesca rests, propped up on her bed (which looks rather like a bier) and supported by a female attendant who stands behind her. Another female figure, holding Francesca's half-raised hand, bows her head as if wishing to kiss the hand of the dying mother. On the lowest level of the composition, a bulky

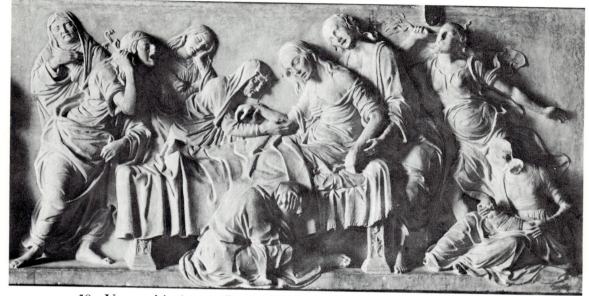

58. Verrocchio (attr.), *Death of Francesca Tornabuoni* (detail), Florence.

mourner huddles on the ground, resting her head in her hand and completely
hiding her face. To the left and right of this central group are represented
mourners who are clearly inspired by ancient art. The figure to the left, her
body shown in a twisted movement, leans forward; her face, which is turned
toward the dying Francesca Tornabuoni, vividly recalls an ancient mask.
Opening her mouth to scream, she grasps her hair with her right hand,
tearing it in despair. To the right of the central group another mourning
woman, rushing to Francesca's deathbed, is shown in a sweeping diagonal
movement. She throws back one of her arms (echoing the Hippolytus
gesture),[13] and violently pulls her hair with the other. This mourner, in her
rushing movement, her lifted face, and her fluttering drapery, obviously
reminds one of the most frantic Maenad figures in Hellenistic art.

In an old study of this monument, Eugène Müntz said that the relief
displays a *"double défault"*; on the one hand, it represents in heroic style an
event that should be understood as occurring in actual life; on the other, it
disturbs that heroic style by motifs of a *"brutalité excessive."*[14] Müntz did not
specify what he meant by that "excessive brutality," but he was obviously
referring to the dramatic gestures of mourning.

The "double défaut" of the death scene has its historical sources. It was
noticed long ago that Verrocchio (or whoever designed the Tornabuoni
relief) depended on an ancient sarcophagus representing the death of

Alcestis.[15] The story of Alcestis, the faithful woman who is ready to die for her husband, can be found on ancient sarcophagi, particularly on those destined for girls and women. One of these sarcophagi, to which the Torna-buoni relief shows obvious similarities, is now in the Villa Faustina in Cannes, but until the middle of the nineteenth century it was in Rome. If Verrocchio did indeed visit Rome—a matter of dispute among scholars—he could have seen it. But he could have known it also in different ways, as the relief of the Alcestis sarcophagus was copied by draughtsmen. The one drawing that has come down to us, it is true, was made some seventy years after Verrocchio's death,[16] but he could have seen an earlier copy. If not, he must have been acquainted with another specimen of the same group of sarcophagi, since the similarities between the Tornabuoni relief and the Alcestis sarcophagus are too close to be dismissed as mere chance, or as only originating from a similar attitude.

In his relief for the tomb of Francesca Tornabuoni, Verrocchio used only one part of the sarcophagus, which I shall briefly describe. In the middle of the sarcophagus Alcestis is resting on her bed, her unbound hair falling freely on her shoulders. Her two children, Ermelos and Perimela, are standing in front of the bed, on a lower level. Although they are meant as mourning figures, they do not perform any dramatic gestures. Behind Alcestis' head a crying maid seems to raise her hands to the face, but it is difficult to establish precisely the action she performs. Another mourning maid is barely visible.

This group was known in Renaissance art, although its meaning was not correctly apprehended.[17] Verrocchio, looking for a *Pathosformel*, took over for his tomb the more dramatic group of the sarcophagus. But did he copy his model faithfully, or did he change it? Can one discern later influences in his use of the classical model?

The general composition of the central group in both works is, as I have already said, obviously similar; certain isolated elements also show great similarity. In Verrocchio's relief the bed, looking like a bier, is represented in the same, somewhat awkward position as in the sarcophagus. But besides these classical elements one easily detects in the work of the Renaissance master features and motifs that originated in Christian art: Francesca Torna-buoni is being held by one of her maids in a posture that calls to mind the position of the dead Christ in many representations of the Entombment; her hand is being raised by another female figure—a motif that is lacking in the ancient sarcophagus but is well known from many representations of the Lamentation of Christ.[18] In the central group, then, certain late medieval motifs have crept into the classical pattern.

Another symptomatic detail is the mourning figure in front of Francesca Tornabuoni's bed. Verrocchio replaced the two small standing children of the sarcophagus in Cannes by a huddling mourner. This figure, probably that of a wailing woman, is seen in strict profile, but it has most of the features that were so well known in Renaissance art after Giotto's huddled mourners. As in Giotto's work, the huddling mourner in Verrocchio's relief is bulky and compact; being placed in the first row of the composition, she fulfills the function of creating a scale of depth in space. Unlike the huddled mourners in Giotto's *Lamentation*, the head of Verrocchio's figure is not veiled by cloth, but the face is hidden by the hand grasping the head, thus repeating a modern variation of the old mourning gesture of veiling or hiding the face. In spite of Verrocchio's unmistakably ancient inspiration, one cannot help noticing that, in this figure, he has introduced a typical Florentine motif that emerged from representations of the Lamentation of Christ.

The interaction and blending of classical and late medieval conceptions reach a climax in the two frenzied female mourners who move from both sides toward the deathbed of Francesca Tornabuoni. In style these figures, who perform violent actions of self-injury, are clearly permeated by a late Hellenistic spirit. It is, therefore, interesting to notice that in the Alcestis sarcophagus these specific actions are not represented at all. Here one female figure, standing in front of Alcestis and lightly touching her, mildly lowers her head in sadness. The maid behind Alcestis raises here hands to her face, but she stands upright and quiet, her gesture, both in action (as far as it can be determined) and in expression, lacking the violence that characterizes Verrocchio's work. The frantic gestures of self-injury, then, belong, at least in this particular work, to the language of fifteenth-century Florentine art rather than to the antique model. Thus the most violently gesticulating figure, the mourner to the right who is so clearly imbued with a late classical spirit, pulls her braid upward, reminding one of a typical Donatello motif.

In sum, then, the frenzied mourners on humanistic tombs, although certainly intended by the artists as classicizing figures, are deeply influenced by that typical trend in quattroncento art that emerged from, and found its fullest expression in, the representation of religious themes, mainly in the Lamentation of Christ.

A Concluding Remark

The observations made in this study are based on a series of examples. While examples can never exhaust such a vast theme as gestures of despair and self-injury, they can, I hope, render in concrete form some of the main tendencies and problems of their artistic representation.

In following up the history of certain themes, one can observe the emergence of violent gestures of fear and mourning in Italian art. As we have seen, these gestures appear in the thirteenth century, but it is only in the fourteenth that they become frequent and are cast in articulate forms. Both the frequent occurrence of these gestures and the articulation of their rendering reflect basic tendencies of trecento art, in which dramatic movements were considered as an essential part of the representation of nature.

The increasing frequency of gestures of despair in art seems to have been accompanied by a gradual change in their meaning. Originally actions of self-injury were probably confined to the figures of sinners and the damned. In the fourteenth century, however, they also appear in scenes of central religious significance, mainly in the Lamentation of Christ and in the Crucifixion. Sometimes the same gesture is performed by a sinner and a saint. Thus, to recall but one example, the *Ira* in the Arena Chapel (Fig. 18) rends her garment at the breast; but in the same chapel Giotto represented the same gesture performed by an angel in the *Crucifixion*.[1] The lacerating of the face is often performed both by the damned in the Last Judgment and by the holy mourners of Christ. This migration of gesture-motifs from one iconographic context to the other may have resulted from two basic process-

124

es: In the religious imagery of the period the holy figures are conceived as stirred by dramatic emotions, and they express their grief in violent actions, often hurting themselves. The literature of the late thirteenth and of the fourteenth century clearly reflects this transmutation of sacred figures as pictured in the religious imagery of the period. In trecento art, on the other hand, the representation of traditional scenes became increasingly focused on the expressive character of the events and themes, thus according to dramatic gestures a significant function in visualizing emotion. In fact, the high emotional pitch of the gestures of self-injury seems to have exerted such a fascination on the artists that it helped to bridge the gap between the depiction of sinners and saints.

These two processes — the frequency and articulation of gestures of self-injury on the one hand, and the change of their meaning on the other— are interconnected and yet sometimes contradictory; they were probably an important source of Renaissance art. In a few examples I have tried to indicate the influence of these complex developments on the art of the fifteenth century. A quotation from Leonardo's notes suggests the further life of the images with which we have been dealing. In describing his vision of the Deluge, a theme intimately connected with that of the Last Judgment, Leonardo combines gestures and images which had frequently been rendered in the groups of the damned and in representations of the Virgin lamenting her Son:

> . . . Others were not content with shutting their eyes, but laid their hands one over the other to cover them the closer that they might not see the cruel slaughter of the human race by the wrath of God. . . . Ah! how many mothers wept over their drowned sons, holding them upon their knees, with arms raised spread out towards heaven and with words and various threatening gestures, upbraiding the wrath of the gods. Others with clasped hands and fingers clenched gnawed them and devoured them until they bled, crouching with their breast down on their knees in their intense and unbearable anguish.[2]

Notes

CHAPTER I

1. For the nude woman among the elect and its classical sources, of. H. Graber, *Beiträge zu Nicola Pisano* (Zur Kunstgeschichte des Auslandes, 90), Strasbourg, 1911, p. 20, and G. Swarzenski, *Nicolo Pisano*, Frankfurt-am-Main, 1926, pl. 35. It might be added that the damned woman in the Siena pulpit is surrounded by figures of unmistakably classical origin. See the frightened figure to her left, and the figure to her right (recalling the image of a wounded soldier) who is being attacked by a Silenus-like mask, here representing the devil.

2. N. Fasola, *Nicolo Pisano*, Rome, 1941, p. 7, reproduces a similar figure from the northern transept of the Cathedral of Rheims, also representing one of the elect. But the medieval figure, like the classical one, lacks the specific gesture of the hand raised to the mouth.

3. The holding of one hand with the other (usually grasping the wrist of the left hand with the right) seems to have been a formula of pain, sadness, and despair. Usually, however, in this combination the hands are not raised, but held down. See, e.g., the damned in the Last Judgment on the western porch of the Parma Baptistery (of. Geza de Francovich, *Benedetto Antelami*, ii, Milan-Florence, 1952, pl. 148, fig. 253). For interesting observations, cf. A. Haseloff, *Eine Thürinigsch-Sächsische Malerschule des 13. Jahrhunderts*, Strasbourg, 1897, pp. 306 ff.

4. A group similar to the standing sinners in Torcello, though consisting of only three figures, may be found in a Byzantine manuscript of the eleventh century (Rome, Bibl. Vat., Cod. gr. 394, f. 12 v). (Cf. J. R. Martin, *The Illustration of the Heavenly Ladder of John Climacus*, Princeton, 1954, fig. 73.) As in Torcello, the figures are naked, and the central one seems to bite his hand. I have not studied the relationship of this manuscript to the Torcello mosaic.

5. Traini's restraint becomes evident in other respects as well. Both in Pisano's relief and in Giotto's mural the figures are more agitated, their movements affecting their whole bodies, while in the Camposanto fresco the damned stand upright, gesticulation being restricted to heads and hands (only in the lowest row is there some pushing and pulling). Francesco Traini's "psychological" approach can be seen in an additional aspect. While Pisano and Giotto, faithful to the medieval tradition, combine the moment of judgment and the torture of hell into a single scene, (thus representing a constant situation), Traini concentrates on the psychological reaction of the damned. He presents a fleeting moment rather than a durable situation. Significantly, he also excludes Hell from his fresco of the Last Judgment. The fact that Christ addresses the damned alone (cf. M. Meiss, *Painting in Florence and Siena after the Black Death*, Princeton, 1952, p. 76) also adds to the impression of a brief emotional moment (for the significance of Christ's gesture, see *ibid.*, p. 77, note 16). Professor Meiss kindly calls my attention to the fact that the momentary character of the whole scene is also expressed in the other groups, particularly in the agitated movements of the Apostles.

6. F. Schottmüller, *Fra Angelico* (Klassiker der Kunst), 1911, p. 182.

7. *Ibid.*, p. 223.

8. P. Jessen, *Die Darstellung des Weltgerichts bis auf Michelangelo*, Berlin, 1894, p. 9, note 4, Jessen refers to a guidebook (N. Battaglini, *Torcello antica e moderna*, Venice, 1871) which I have not seen. For an earlier example in Byzantine art, cf. above, note 4.

9. G. Voss, *Das jüngste Gericht in der Kunst des frühen Mittelalters*, Leipzig, 1884, p. 32.

10. A. Bouillet, *Le Jugement dernier dans l'art aux deux premiers siècles*, Paris, 1894, p. 24.

CHAPTER II

1. In addition to the studies quoted in Chapter I (notes 8–10), cf. Paeseler, "Die römische Weltgerichtstafel im Vatikan," *Jahrbuch der Biblioteca Hertziana*, ii, 1938, pp. 311–394. For a recent, though not full, bibliography on the Last Judgment in art, cf. *Enciclopedia universale dell'arte*, iv, Rome-Venice, 1958, col. 856 (s.v. "Escatologia"), and the literature mentioned by J. Wettstein, *Sant' Angelo in Formis et la peinture médiévale en Campanie*, Genève, 1960, p. 60, note 203. In this literature gestures do not seem to have been discussed. Voss, *Das jüngste Gericht in der Kunst des frühen Mittelalters*, Leipzig, 1884, p. 38, makes some observations on a sinner wringing his hands in the Utrecht Psalter (cf. E. T. De Wald, *The Illustrations of the Utrecht Psalter*, Princeton, 1932, p. v) but does not discuss gestures of self-injury. The other authors only describe the Torcello figure without investigating the history of the motif.

2. The attempt to achieve an expressive effect by the movement of the *whole* figure rather than by an isolated limb is, I think, a classical element of style, still (or

again) effective in the period to which the early representations of the Last Judgment belong. It is not the lack of expression, as has sometimes been said, but a different approach to conveying it that characterizes, for example, the damned in the Cosmas Indicopleustes.

3. Cf. W. Vöge, *Eine deutsche Malerschule um die Wende des 1. Jahrtausends* (Westdeutsche Zeitschrift für Geschichte und Kunst, Ergänzungsheft vii), Trier, 1891, fig. 33, and pp. 285–305 for a discussion of gestures in Ottonian art.

4. The touching of the forehead with one hand was a classical gesture of mourning, already represented in the fourth century B.C., especially in sepulchral art. In the Apulian Medea-vase in Munich (cf. E. Pfuhl, *Malerei und Zeichnung der Griechen*, Munich, 1923, fig. 795), Creon and Meropa rush to the help of their daughter, each of them raising one hand to the head. For further examples, see H. Kenner, *Lachen und Weinen in der griechischen Kunst* (Oesterreichische Akademie der Wissenschaften, Sitzungsberichter der phil.-hist. Klasse, Bd. 234, Abh. 2), Vienna, 1960, pp. 46 ff., 56 f. For a collection of texts, see K. Sittl, *Die Gebärden der Griechen und Römer*, Leipzig, 1890, pp. 19 ff., 21 f.

5. Cf. H. Wölfflin, *Die Bamberger Apokalypse*, Munich, 1921, pl. 63. For the meaning of this gesture, cf. esp. Chapter VI.

6. Cf. Paeseler, "Die römische Weltgerichtstafel," p. 354.

7. Munich, Bayerische Staatsbibliothek, Cod. lat. 935, fol. 60r. Cf. A. Katzenellenbogen, *Allegories of Virtues and Vices in Medieval Art*, New York, 1964, fig. 59.

8. Often reproduced. Cf. J. Wettstein, *Sant' Angelo in Formis*, pp. 60 ff. A somewhat later, but more provincial, representation of the Last Judgment in South Italy, a mural in S. Angelo in Pianella (cf. E. Bertaux, *L'Art dans l'Italie méridionale*, Paris, 1904, pp. 284 ff.), does not render hell or sinners at all.

9. The motif of devils pushing the damned toward hell, a common feature in representations of the Last Judgment both in the East and the West (but less frequent in French Gothic sculpture, where the damned are usually pulled rather than pushed), may have been derived from Roman representations of soldiers pushing the captive leader of a defeated army toward the victorious (Roman) commander. See, for example, the representation of this event on the column of Trajan, scene xviii (K. Lehmann-Hartleben, *Die Trajanssäule: Ein römisches Kunstwerk zu Beginn der Spätantike*, Berlin-Leipzig, 1926, pl. 12).

10. For this panel, cf. Paeseler, "*Die römische Weltgerichtstafel,*" passim.

11. The representation of crying through the gesture of wiping away the tears with the veiled hand originated in Greek art (cf. the Greek vase from the fifth century B.C. in the National Museum in Athens, reproduced by Kenner, *Lachen und Weinen*, fig. 3). But it was apparently only in Roman art that this motif was used more frequently both in fresco painting (see, e.g., the fresco in the Casa di Sirico in Pompeii; cf. S. Reinach, *Répertoire de peintures grecques et romaines*, Paris, 1922, p. 176, no. 1) and in sarcophagi (cf. Roscher, *Myth. Lex.*, i, col. 75, s.v. "Adonis"). This motif was also common in provincial Roman art; cf. Kenner, *Lachen und Weinen*, pp. 59 ff. for some examples.

12. Reproduced in *I Mosaici del Battisterio, III, Le Storie del Giudizio Finale*,

Florence, n.d., pl. 28. This example was kindly brought to my attention by
Professor Meyer Schapiro.

13. *Ibid.*, p. 43.

14. For violent movements as a characterization of sinners, see below, p. 000.

15. The hiding of the face or of the eyes in the bare or veiled hand was well
known in antiquity as a gesture expressing grief or fear. Pausanias, for example,
describes one of Polygnot's pictures in the following way: "Beside Medusa is a
shaved old woman or eunuch, holding on the knees a naked child. It is represented as
holding its hands before its eyes in terror" (*Description of Greece* x, 26, 8; in the Loeb
edition, vol. iv, p. 252). Kenner, *Lachen und Weinen*, pp. 24 f, believes that Pausanias
has misunderstood the meaning of the gesture, which in the fifth century B.C. was
used only for mourning. For additional examples, see the mourning gestures in a
fragment of a Campanan painting (cf. John Beazley, *Campanafragments*, London,
1933, p. 13) and the Eros figure in three Pompeian representations of Ariadne
abandoned by Theseus (cf. Reinach, *Répertoire de peintures*, p. 111, nos. 7–9). In early
Christian art the gesture occurs several times Cf. Garrucci, *Storia della arte Cristiana*,
Prato, 1872–1881, v, pl. 380, 4; vi, pls. 459; 500) and the *Vienna Genesis*, ed.
Wickhoff, Prague, 1895, pl. ix. In the Middle Ages the gesture appears in the
Utrecht Psalter (illumination of Psalm 6). Another Carolingian example is an ivory,
formerly in Berlin (cf. A. Kuhn, *Allgemeine Kunstgeschichte*, Einsiedeln, 1909, ii, p.
319). In Ottonian art it is found, for example, in the Codex Egberti (cf. Vöge [see
note 3], figs. 67, 68). For a discussion of this gesture in medieval art, cf. J. J.
Tikkanen, *Die Psalterillustrationen im Mittelalter* (Acta Societatis Scientiarum Fen-
nice, xxxi, no. 5), Helsingfors, 1903, p. 254. In the thirteenth century this gesture
seems to have belonged to the repertory of movements represented in the Last
Judgment and other dramatic scenes. See, e.g., Pisano's *Last Judgment* in the Pisa
pulpit (cf. A. Venturi, *Giovanni Pisano: His Life and Work*, Paris, 1928, p. 114) and the
Massacre of the Innocent in the Pistoia pulpit (*ibid.*, pl. 84). The gesture occurs several
times in Traini's *Last Judgment* in Pisa.

16. The tympanum of Autun has many dramatic gestures which are related to
our theme, as, for instance, the hiding of the face and the clutching of the neck. Such
a concentration of violent gesticulation seems to be very rare in French sculpture of
the twelfth century. I do not know of any other work in which all these gestures
occur together.

17. The similarity of posture between the damned in Roger van der Weyden's
Last Judgment and the traditional image of Adam and Eve expelled from Eden has
been noticed by E. Panofsky, *Early Netherlandish Painting: Its Origins and Character*,
Cambridge, Mass., 1953, p. 270. O.M. Dalton, *Byzantine Art and Archaeology*,
London, 1911, p. 670, has observed a similarity in the coloring of the retributory
angels in some representations of the Last Judgment and of the Expulsion from
Paradise.

18. Often reproduced. Cf. A. Boeckler, *Die Bronzetür von Verona* (Die
frühmittelalterlichen Bronzetüren, III), Marburg, 1931, pl. 51.

19. *Ibid.*, pl. 53. Boeckler (p. 41) ascribes this panel to "Style 2."

20. *Ibid.*, p. 54.

21. Cf. J. J. Tikkanen, *Die Genesismosaiken von S. Marco in Venedig*, Helsingfors, 1889, p. 21.

22. Cf. *ibid.*, p. 21; Bertaux, *L'art dans l'Italie méridionale*, p. 265.

23. The motif of Adam and Eve looking backward as they are expelled from Paradise was not only widespread in pictorial representations but also known in literature. Cf. the Book of Painters of Mount Athos (*Malerhandbuch des Malermönchs Dionysius vom Berge Athos*, Munich, 1960, p. 79), which reads: ". . . while fleeing, they look back." And see below, p. 16 ff. and note 32, for a similar indication in the *Adam Play*. Voss *Das jüngste Gericht* (see above, note 1), p. 70, quotes and interesting text by Ephraim the Syrian that reads: "They are being chased by wild angels, pushed and beaten, and gnashing their teeth they are looking backwards while they are approaching that terrible place where they will have to suffer the whole punishment."

24. Tikkanen, *Genesismosaiken*, pl. ii; A. Venturi, *Storia dell' arte Italiana*, Milan, 1901–1940, ii, fig. 463. The artistic origin of this work (Byzantine or Western) is not clear. Bertaux, *L'art dans l'Italie méridionale*, pp. 430 ff., especially p. 433, believes that the artist was not a Greek, but that the gestures conform to a Byzantine tradition.

25. Venturi, *Storia*, ii, p. 326, interprets the gesture as biting the hand; somewhat hesitant, he says: "Adamo sembra mordersi una mano." W. Köhler, *Die Karolingischen Miniaturen: Die Schule von Tours*, Berlin, 1930–1933, p. 126, interprets the gesture differently: "Die vordere Figur, wohl Adam, legt die abwärts gedrehte Hand mit leicht gekrümmten Fingern in Mundhöhe an die Wange; es ist der Gestus des traurigen Grübelns." A similar interpretation by Tikkanen, *Genesismosaiken*, p. 40, note 2.

26. Köhler, *Karolingischen Miniaturen*, ii, pp. 29, 31, 124. F. F. Leitschuh, *Geschichte der Karolingischen Malerei, des Bilderkreises und seiner Quellen*, Berlin, 1894, p. 387, points out that in Carolingian art the hand plays a major part in shaping the expression. While this is certainly true, the great importance of the hand is not restricted to Carolingian art but is characteristic of medieval art in general, particularly before the twelfth century.

27. Similar gestures which are, however, less tense in character occur in the lower "register" of the page in which the Rebuking is represented.

28. Cf. Köhler, *Karolingischen Miniaturen*, i, pl. 70 and pl. 51 (Grandval Bible). In the *Expulsion from Paradise* in the Carolingian Bible of S. Paolo fuori le mura (cf. Venturi, *Storia*, ii, fig. 233), Eve's hand is also represented in the same fractured position.

29. Tikkanen, *Genesismosaiken*, p. 40, note 2. The figures express "ihre Trauer durch die vor dem Kinn schlaff hängende Hand."

30. For a discussion of this gesture in classical art, see Kenner, *Lachen und Weinen* (see above, note 4), *passim;* G. Neumann, *Gesten und Gebärden in der griechischen Kunst*, Berlin, 1965, pp. 130 ff., 136 ff. A famous example of this very common gesture is the *Sarcophagus of the Mourning Women* in Istanbul. According to Kenner, p. 51, there

is not a single gesture or posture in "this masterpiece of ancient sepulchral art which represents a symphony of weeping in the ancient moderate and restrained sense" that is new or deviates from tradition. As a gesture of sadness, in the original restrained connotation, it appears in Ottonian art, where it is performed by Mary standing beneath the cross. Vöge, *Eine deutsche Malerschule* (see above, note 3), p. 290, believes that in this specific context the gesture had not been rendered before in medieval art (I have not investigated the history of this particular gesture in medieval art). It should be pointed out that in formal design this gesture differs from what I have called the fractured hand. In the sadness gesture, both in classical and in Ottonian art, the lines flow harmoniously and do not show the sharp bend which is a characteristic feature of the other gesture.

31. *Das Adamsspiel*, ed. K. Grass, Halle a/s, 1891, p. 1 (". . . et gestum faciant convenientem rei, de qua loquuntur"), p. 30 (". . . dolorem gestu fatentes"). Cf. also G. Cohen, *Histoire de la mise en scéne dans le théâtre religieux français du moyen âge* (Academie Royale Belgique, Classe de Lettres et Sciences morales et politiques et Classe des Beaux Arts, i), Brussels, 1906, pp. 57–61. And see also A. d'Ancona, *Origini del Teatro Italiano*, Turin, I 1891, pp. 78 ff.

32. *Adamsspiel*, p. 1 ("quicunque nominarevit paradisum, respiciat eum et manu demonstrat"), p. 30 ("Cum fuerient extra paradisum, quasi tristes et confusi, incurvati erunt solo tenus super talos suos . . ."). This reminds us of the crouching position of some of the damned in hell; see, for instance, the figures of the damned in Pisano's Siena pulpit, or the damned in the fresco of *Hell* in the Camposanto in Pisa. It is conceivable that there was a tradition of representing both Adam expelled from Paradise and the sinners in Hell in a crouching position. I have not followed up this question.

33. *Adamsspiel*, p. 30: "Cum venient Adam et Eva ad culturam suam et viderint ortas spinas et tribulos, vehementi dolore percussi prosternent se in terra." Throwing oneself to the ground is an old gesture of despair, already found in early Christian literature. The apocryphal Book of James, chapter 13 (E. Hennecke, ed., *Neutestamentliche Apokryphen*, Tübingen, 1924, p. 90; M. R. James, ed., *The Apocryphal New Testament Being the Apocryphal Gospels Acts, Epistles, and Apocalypses*, Oxford, 1953, p. 44), reads: "And he smote his face and cast himself down upon the ground on sackcloth and wept bitterly."

34. For the striking of the thighs as a mourning gesture, cf. J. Camus, "L'expression de Dante '*ei si batte l'anca*," *Giornale storico della letteratura Italiana*, xliii, 1904, pp. 166–168. To the sources mentioned by the author should be added Plautus, *Miles gloriosus*, vv. 201 ff.

35. Cohen, *Histoire de la mise en scène* (see above, note 31), p. 60, characterizes them as "mouvements crudes."

36. E. Lommatzsch, "Darstellung von Trauer und Schmerz in der altfranzösischen Literatur," *Zeitschrift für romanische Philologie*, xliii, 1924, p. 53, quotes from a fourteenth-century manuscript the following passage: "Tantost comme il (Adam) senti le savour en son cors avalee, il apersut bein et senti sa grant destorbance; il le jeta et mist sa main a sa gorge, ne n'i laissa le morsel plus avaler en

nulle maniere. Et por se dient li plusors que de ci avient que li homme ont encoires le not ens es gorges." This particular motif is perhaps represented in a manuscript of the same period (Paris, Bibl. Nat., fr. 9561, fol. xv) reproduced by M. Meiss, *French Painting in the Time of Jean de Berry*, London, 1967, fig. 408.

37. See below, chapter III, esp. pp. 23 ff., 26 ff.

38. De Wald, *The Illustrations* (see above, note 1), pls. xlv, c, briefly discussed by Leitschuh, *Karolingische Malerei* (see above, note 26), p. 386. Cf. also Tikkanen, *Psalterillustrationen*, (see above, note 15), p. 252, note 3. For a broader discussion of gestures in Carolingian art, cf. Köhler, *Karolingische Miniaturen* (note 25), ii, pp. 305 ff., and W. Weisbach, *Ausdrucksgestaltung in mittelalterlicher Kunst*, Zürich, 1948, pp. 18 ff.

39. Cf., for example F. X. Kraus, *Die Miniaturen des Codex Egberti in der Stadtbibliothek zu Trier*, Freiburg, 1884, pl. 13. As in some other illuminations of the tenth and eleventh centuries, the tearing of the hair is here represented as a pulling of the braids, and therefore the hands are not raised to the top of the head (as usual in classical art) but remain on a lower level. In the same illumination of the Codex Egberti one finds two additional typical mourning gestures: the hiding of the face in the palms of the hands and the throwing up of the arms. The latter gesture is rendered in an Orans-like form, so that again the hands are not raised above the head.

40. Cf. R. Stettiner, *Die illustrierten Prudentiushandschriften*, Berlin, 1895, 1905, p. 189 (St. Gallen, Stiftsbibliothek, 135, illumination to *Psychomachia*, v, 28–41). Here the woman tearing her hair is seen from the back, a very rare posture in the representation of this gesture. Another female figure in the same illumination raises her hand to her mouth, but the meaning of this gesture is not clear. The figures of this illumination show many twisted movements, the dramatic quality of which is emphasized by the fact that the organic form of the bodies is clearly brought out beneath the cloth.

41. M. Schapiro, *The Parma Ildefonsus: A Romanesque Illuminated Manuscript from Cluny and Related Works*, New York, 1964, p. 15 and fig. 4, and p. 65, note 283, and fig. 75, for a Spanish copy.

42. A. Boeckler, *Das goldene Evangelienbuch Heinrich III*, Berlin, 1933, pl. 79. Cf. Schapiro, *The Parma Ildefonsus*, p. 15, note 29. Another gesture of fear, in form and mood, even more distantly related to the motifs studied in this paper, is the grasping of the head with both hands. In the Utrecht Psalter, we find it in the illumination to Psalm 78 (ed. De Wald, pl. 72), where it is probably also derived from late antique or early Christian models. In early medieval art this seems to be a very rare gesture, but from the twelfth century onward it appears more frequently (I have already mentioned it in a figure of the damned in Autun).

43. For an interesting collection of examples, cf. H. W. Janson, "The Right Arm of Michelangelo's 'Moses,' " *Festschrift Ulrich Middledorf*, Berlin, 1968, pp. 241–247, and pls. cxii–cxiii.

44. *Ibid.*, p. 242.

45. Leydensis Vossianus 38, fols. 6v, 7v (cf. L. W. Jones, and C. R. Morey, *The*

Miniatures of the Manuscripts of Terence, Princeton, 1930–1931, figs. 33, 47). Most illuminated Terence manuscripts prior to the thirteenth century have the same gestures in the same places, thus obviously attesting to a tradition. Two of the manuscripts, however, the Leyden Manuscript just mentioned and the Parisus Latinus 7900 in the Bibliothèque Nationale, seem to be more advanced in this respect. In these manuscripts violent gesticulation is rendered more frequently and in a more articulate form. The text to which the illustration discussed refers is that of *The Lady of Andros*, act iii, scene 3 (in the Loeb edition, ii, pp. 22 ff.).

46. Par. Lat. 7900, fol. 11v (Jones and Morey, *The Miniatures*, fig. 241) to *The Eunuch*, act iv, scene 3 (Loeb ed., i, pp. 198 ff.).

47. Jones and Morey, *The Miniatures*, figs. 732–736, to *Phormio*, act iii, scene 3 (Loeb ed., ii, pp. 62 ff.). The presentation of these gestures in the Ambrosianus Latinus, fol. 162 (Jones and Morey, fig. 732), a manuscript of the ninth to the tenth century, is particularly dramatic.

48. Jones and Morey, *The Miniatures*, pp. 42 ff., 113 ff., 195 ff., 203 ff. Sittl, *Die Gebärden* (seen above, note 4), p. 205, believes that these gestures in the Terence manuscripts are a creation of the Carolingian Renaissance.

49. Cf. M. Bieber, *The History of the Greek and Roman Theater*, Princeton, 1939, p. 400, note 1, and p. 204, note 71; J. J. Tikkanen, *Zwei Gebärden mit dem Zeigefinger*, Helsingfors, 1913, p. 9.

50. Cf., for instance, the interesting discussion by H. P. L'Orange, *Studies on the Iconography of the Cosmic Kingship in the Ancient World*, Oslo, 1953, pp. 139 ff.

CHAPTER III

1. The basic work on gestures in ancient culture remains K. Sittl, *Die Gebärden der Griechen und Römer*, Leipzig, 1890, which, as far as I can see, is still unsurpassed in its rich collection of material, particularly of texts. For gestures in Roman art, cf. R. Brilliant, *Gesture and Rank in Roman Art* (Memoirs of the Connecticut Academy of Arts and Sciences, vol. xiv), New Haven, 1963 (with good bibliography). For gestures in early Christian art, cf. M. L. Heuser, "Gestures and their Meaning in Early Christian Art," Ph.D. thesis, Harvard, 1957. Neither work discusses the specific gestures investigated in the present study. The study of I. Jucker, *Der Gestus des Aposkopein: Ein Beitrag zur Gebärdensprache der antiken Knust*, Zürich, 1956, also investigates a different gesture.

2. For the most important, and best known, reference in classical literature to the rhetor's attitude and gestures, cf. Quintilian, *Inst. Orat.*, XI, iii, 159 ff.; Cicero, *Brutus*, xxiii, 89; Petrobius, *Satyr.*, 3.

3. Cf. Nonnos, *Doinysiaca*, xix, 198 ff., for a suggestive description of the expressive gestures in the *mimus:* "So saying, Maron danced with winding step, passing the changes right over left, and figuring a silent eloquence of hand inaudible. He moved his eyes about as a picture of the story, he wove a rhythm full of meaning with gestures full of art . . . he depicted with wordless art the cupbearer of Cronides offering the goblet to Zeus, or pouring the dew divine to fill up the bowl . . . when

he looked at the satyrs, with voiceless hands he acted Ganymedes, or when he saw the Bacchant woman, he showed them goldenshoe Hebe in a picture having sense without words. . . . So Maron sketched his designs in pantomime gestures, lifting rhythmic feet with the motions of an artist. . . . This is what he acted with gesturing hands" (quoted from Loeb ed., translated by W.H.D. Rouse, ii, pp. 105 ff.). Cf. also vii, 18–22. See also Tertullian, *De spectaculis*, xvii, where the interesting distinction is made between the conventional gestures of the mime ("filth in the gestures of the actor of the farce") and the emotional gesticulation betraying spontaneous reactions ("Those women themselves, who have murdered their own shame, shudder [you can see it in the gestures] to find themselves in the light and before the populace"), Loeb ed, p. 275.

4. M. Bieber, *The History of the Greek and Roman Theater*, Princeton, 1939, pp. 317 ff.

5. Quintilian stresses the convention of clear-cut characters in the theater, through he rejects the exaggerated gesticulation of the actors as a model for the orator. "Some places are best suited by a rapid, and others by a restrained delivery. . . . But the slower the delivery the greater its emotional power: thus, Roscius was rapid and Aesopus weighty in his delivery, because the former was a comic and the latter a tragic actor. The same rule applies to movements. Consequently on the stage young men and old, soldiers and married women all walk sedately, while slaves, maidservants, parasites and fishermen are more lively in their movements." *Inst. Or at.*, XI, iii, 111–112 (ed. Loeb, iv, p. 303).

6. For a good survey, cf. Daremberg-Saglio, *Dictionnaire des antiquités grecques et romaines*, Paris, 1873–1919, ii, 2, pp. 1367–1409, s.v. "Funus."

7. *Hom. in acta ap.*, 21, 3 (French translation, *Oeuvres completes*, ix, 1866, pp. 97 ff.). Cf. also Sittl, *Die Gebärden der Griechen und Römar*, pp. 65 ff.

8. Lucian, *On Funerals*, ed. Loeb, iv, pp. 112–131. The passage quoted is on p. 119. Needless to say, self-injury as an expression of sorrow and grief, particularly in mourning for a death, has been practiced from time immemorial. To give but a few literary examples from the Greek world I shall mention Herodotus, who relates (vi, 58; ed. Loeb, iii, p. 205) that at the death of a king a man and a woman in each household had to "put on signs of defilement" and the thousand who mourned him "zealously smite their foreheads and make long and loud lamentations." Sophocles' *Electra* (vv. 85 ff.) speaks of "the strains of my lament, the wild blows dealt against this bleeding breast." Euripides' *Electra* (vv. 145 ff.) tears with her nails her "tender throat" and beats her head with her hands. See also the ironical description in Cicero's *Tusculan Disputations* III, xxvi, 62: ". . . The different odious forms of mourning, neglect of person, women's rending of the cheeks, beatings of the breast and thighs and head. Hence the famous Agamemnon of Homer and Accius too, 'Oft tearing in his grief his unshorn hair,' which inspired the sitticism of Bion that the fool of a monarch plucked out his hair in grief, for all the world as though baldness were a relief to sadness. But all this is due to the belief that it is a duty" (Loeb ed., p. 299). Cf. also H. Kenner, *Lachen und Weinen in der griechischen Kunst* (Oesterreichische

Akademie der Wissenschaften, Sitzungsberichter der phil.-hist. Klasse, Bd. 234, Abh. 2), Vienna, 1960, pp 56 ff.

9. Nonnos, *Dionysiaca*, xxiv, 179–217 (ed. Loeb, ii, pp. 237–239).

10. Needless to say, not all these representations reached the dramatic climax of self-injury. A good example of a *conclamatio* without actions of self-injury is provided by a sarcophagus in the British Museum (cf. S. Reinach, *Répertoire de reliefs grecs et romains*, ii, Paris, 1912, p. 496, 1), which shows the gestures of the hand supporting the head, the touching (or smiting?) of the forehead, the hand to the breast, the hand covering the eyes, and the arms thrown upward and outward as an expression of excessive grief. For a typical representation of self-injury in a *conclamatio* scene, see the Etruscan Urn in the Archaeological Museum in Florence (cf. E. Panofsky, *Tomb Sculpture*, New York, 1964, fig. 80).

11. For the weeping figure as a possibly Roman invention, cf. Kenner, *Lachen und Weinen*, pp. 60 ff. Similar gestures are known from the fifth and fourth centuries B.C. (cf. the Apulian vase in Munich, reproduced by E. Pfuhl, *Malerei und Zeichnung de Griechen*, Munich, 1923, fig. 795) but, as Kenner, *loc. cit.*, has correctly stressed, they are not clear representations of weeping.

12. For the revival of the Hippolytus gesture, see below, p. 71.

13. See C. Robert, *Die antiken Sarkophag-Reliefs*, Berlin, 1890–1919, iii, 2, figs. 230 a, b; Reinach, *Répertoire de Reliefs*, iii, p. 322, 2. In the Renaissance this lid was walled in the Villa Borghese and well known to Roman artists. The frantic tearing of the hair with both hands occurs, of course, frequently. See, for example, the Meleager sarcophagus in the Palazzo dei Conservatori in Rome (cf. Reinach, iii, p. 193, 4). For the tearing of the hair with one hand, while the other is stretched out, cf. the Meleager sarcophagus in the Museum of the Capitol Rome (Reinach, iii, p. 192, 4). For a combination of two gestures (touching the forehead and pulling the hair), cf. the sarcophagus in Florence (cf. Robert, iii, 2, fig. 282, and Reinach, iii, p. 34, 3).

14. Reinach, *Répertoire de Reliefs*, ii, p. 437, 3; Robert, *Sarkophag-Reliefs*, iii, 2, fig. 242. Robert, p. 312, believes that Oeneus raises his hand to his chin.

15. See O. Jahn's study "Hippolytus und Phaidra" in his *Archaeologische Beiträge*, Berlin, 1847, pp. 300–330, which is still interesting.

16. Robert, *Sarkophag-Reliefs*, iii, 2, fig. 171; Reinach, *Répertoire de Reliefs*, iii, p. 31, 1.

17. Robert, iii, 2, fig. 152b.

18. Reinach, ii, p. 263, 1; Robert, iii, 2, fig. 161. Robert describes (p. 199) the gesture as follows: "Theseus . . . hebt die Rechte in einem Gestus des Schreckens zum Kinn empor."

19. Robert, iii, 2, fig. 163. Similar gestures occur in two other sarcophagi of the same group, one in the Villa Pamfili in Rome (*ibid.*, fig. 254) and the other in Chiusi (*ibid.*, iii, 1, fig. 255). In these sarcophagi the gesture, of course, is performed by Oeneus.

20. In the Spalato sarcophagus (see preceding note) another figure, an old man, keeps his finger to his mouth, but the restrained, meditative air that characterizes

him does not permit us to ascribe a more dramatic meaning to his gesture.

21. Robert, iii, 2, fig. 167; Reinach, iii, p. 275, 5. Of a Hippolytus sarcophagus in the Villa Medici, Robert says that the left arm of Theseus "seems originally to have been raised in a gesture of terror" (p. 199), and of a figure at the left end of the same sarcophagus he says (p. 189) that "with the right hand at the forehead, he [i.e. the figure] performs the well known gesture of pain, here probably of abhorrence."

22. In the texts listed in Roscher, *Ausführliches Lexicon der griechischen und römischen Mythologie*, Leipzig, 1884–1927 (s.v. "Meleagros" and "Hippolytus"), I could find no direct reference to such a gesture. Homer, when relating the story of Meleager, though in another phase of events, mentions a certain violent gesticulation of Althaia.

> . . . she her brother's death bore hard,
> And pray'd to Heav'n above, and with her hands
> Beating the solid earth, the nether pow'rs,
> Pluto and Prosperpine, implor'd,
> Down on her knees, her bosom wet with tears,
> Death on her son invoking.
>
> (*Iliad*, ix, 695 ff.)

This gesture, however, is different from those represented in the sarcophagi in form (in the text Althaia does not tear her hair and beat herself) and perhaps also in meaning, as it seems to have the connotation of rage rather than of despair and mourning. It is also interesting to notice that in the Hippolytus plays, some of which have come down to us (cf. Euripides' play), no mention seems to have been made of these particular gestures. In Philostratus the Elder's *Imagines*, ii, 4, the image of self-hurting wailing women is invoked as a literary form: "Indde you mountain-peaks over which thou didst hunt with Artemis take the form of mourning women that tear their cheeks . . ." (ed. Loeb, p. 143).

23. Cf. The Attic-Geometric vase reproduced by Pfuhl, *Malerei und Zeichnung der Griechen*, fig. 10. The gesture of tearing the hair as an expression of grief, particularly in Lamentations, is of course as old as mankind. See, for example, the variations of this gesture in the Egyptian relief *Lamentation Over a High Priest* in the Staatliche Museen in Berlin, reproduced by Panofsky, *Tomb Sculpture*, fig. 18. Here, however, the gesture is not performed by any frontal figure. In Greek art the gesture had a very rich history, of which I shall mention only a few examples: a white lekythos from the classical period (Pfuhl, fig. 539) showing a mourning scene where a woman, represented in three-quarter view, is tearing her hair; another white lekythos representing a visit to a grave (the stele occupies the center of the painting) where the woman tearing her hair is seen almost in profile (Pfuhl, fig. 546); and finally a third representation of a mourning woman (Pfuhl, fig. 550) who with one hand tears her hair while she stretches out the other. Her figure is seen in an almost full frontal view, but her head is turned in profile. In her twisted movement this mourning woman differs from the representations of Althaia on the sarcophagi.

24. But see below, note 29.

25. South Italian vase in Berlin. Cf. L. Sechan, *Etudes sur la tragédie grecque dans ses rapports avec la céramique*, Paris, 1926, fig. 88. This figure curiously reminds one of much later representations of Eve expelled from Paradise. The twisted posture, the figure moving to the right while her head is turned to the left and her hand is raised to the mouth in terror, are typical features of medieval representations of the Expulsion. I do not mean to imply that there had been any kind of "source" relationship between the two themes, but this is an instance where one wonders about what some psychologists call an "archetype."

26. Bieber, *The History of Greek and Roman Theater*, p. 62.

27. For an interpretation of this wall painting as a scene of comedy, cf. M. Bieber, *Die Denkmäler zum Theaterwesen im Altertum*, Berlin and Leipzig, 1920, p. 158. A. Dietrich, *Pulcinella: Pompejanische Wandbilder und Römische Satyrspiele*, Leipzig, 1897, pp. 139 ff., believes that the picture represents a slave who has beaten the hetaera. Although this interpretation is not very convincing, it also confirms our assumption that the specific gesture of the sudden raising of the hand to the mouth is an expression of pain, or perhaps of rage.

28. The wall painting from Herculaneum, now in the Museo Nazionale in Naples, has often been reproduced; cf. Bieber, *Greek and Roman Theater*, fig. 238. In both paintings the raised hand is veiled with a cloth, a motif well known from later art in an altogether different iconographic context. For the assumption of a prototype, cf. Bieber, p. 400.

29. *Inst. Orat.*, XI, iii, 103 (ed. Loeb, iv, p. 299).

30. J. de Witt, *Die Miniaturen des Vergilius Vaticanus*, Amsterdam, 1959, pl. 16 (pict. 27). Although Vergil (*Aeneid*, iv, lines 663 ff.) speaks only of "lamentation and sobbing and bitter crying of women," the illuminator, faithful to the traditional *conclamatio*, has represented gestures of self-injury. It is only of Dido's sister (in the illumination probably the woman behind Dido) that Vergil says "with torn face and smitten bosom."

31. Pict. 25 (ed. de Witth, pl. 14). Vergil tells (iv, lines 589 ff.) that Dido "rent her yellow hair" and beat her breast when, looking out from the watchtower, she saw the fleet departing.

32. F. Cumont, *Recherches sur le symbolisme funéraire des Romains*, Paris, 1942, fig. 15 and p. 99, where the gesture is interpreted as an expression of "desperate fear."

33. C. R. Morey, *Early Christian Art*, Princeton, 1942, fig. 143.

34. See fols xiii (cf. H. Gerstinger, *Die Wiener Genesis*, Vienna, 1931, pl. 26), representing women lamenting Deborah's death; xvii (Gerstinger, pl. 33), Joseph interpreting the dreams of the prisoners; xiv (Gerstinger, pl. 48), lamentation over Jacob and his entombment.

35. Fol. xvii. Cf. Gerstinger, pls. 26, 27 (and see *ibid.*, text volume, pp. 96 ff.).

36. Fols. xiii, xxiii.

37. Cf. F. J. E. Raby, *A History of Christian Poetry from the Beginnings to the Close of the Middle Ages*, Oxford, 1953, pp. 89 ff; Heuser, Gestures and their meaning, pp. 187 ff.

CHAPTER IV

1. For some Carolingian examples, see above, p. 14 ff.

2. Cf. W. Frenzen, *Klagebilder und Klagegebärden in der deutschen Dichtung des höfischen Mittelalters* (Bonner Beiträge zur deutschen Philologie, Heft 1), Würzburg-Aumühle, 1936, pp. 5 ff. Frenzen particularly emphasizes the "static character" of the mourning scenes in this period (cf. pp. 10 ff.).

3. The literature on the medieval attitude toward gesticulation is both wide and, from the point of view of the present study, nonfocused. The most informative and comprehensive study is still G. Zappert, "Uber den Ausdruck des geistigen Schmerzes in Mittelalter," *Denkschriften der Kaiserlichen Akademie der Wissenschaften*, phil. hist. Klasse, v, Vienna, 1854, pp. 73–136, which constitutes an admirable collection of texts, but completely disregards art. The main criticism of this study is that the author conceives of the Middle Ages too much as an undivided, homogeneous period. Individual aspects of medieval gesticulation, especially in literature and theater, have been studied later. An interesting discussion of gestures in German theater of the late Middle Ages may be found in M. Herrmann, *Forschungen zur deutschen Theatergeschichte des Mittelalters und der Renaissance*, Berlin, 1914, especially pp. 176–256 and *passim*. Herrman has many insights (some of them quite disputable) into the medieval language of gestures, but unfortunately he often omits to indicate his sources. Gesticulation in Middle English literature has been studied quite recently by W. Habicht, *Die Gebärden in englischen Dichtungen des Mittelalters* (Bayerische Akademie der Wissenschaften, Phil.-hist. Klasse, Abhandlunge, Neue Folge, Heft 46), Munich, 1959; especially valuable for our theme are pp. 35–49, 68–86, 94–104, 133–135. For French medieval literature, cf. E. Lommatzsch, "Darstellung von Trauer und Schmerz in der altfranzösischen Literatur," *Zeitschrift für romanische Philologie*, xliii, 1924. Violent gestures of pain are discussed in his study, pp. 45 ff.

4. Cf. *Martini Episcopi Bracariensis Opera Omnia*, ed. C. W. Barlow, New Haven, 1950, p. 245: "Si continens es, et animi tui et corporis motus observa, ne indicarsi sint." This work was apparently widely read. For proof that Middle English writers were acquainted with it, cf. Habicht, *Die Gebärden in englischen Dichtungen*, p. 44.

5. He says that "necessarie observandum est, ut recta sit facies, ne labra detorqueantur, ne immodicus hiatus distendat rictum, ne supinus vultus, ne deiecti in terram oculi, ne inclinata cervix, neque elata aut depressa supercilia." Quoted after Habicht, *Die Gebärden in englischen Dichtungen*, p. 44.

6. Martin of Braga condemns loud laughing accompanied by lively gestures; St. Basilius requests that one should not laugh with grinning lips. CF. Habicht, *loc. cit*. It has been noticed by Habicht (p. 98) that while medieval literature abounds in the description of gestures of lamentation, it rarely describes gestures of joy.

7. Cf. St. John Chrysostomus, *Hom. in cap. 50 Genes*. Cf. Zappert, "Ausdruck des geistigen Schemerzes," p. 97, note 130. In the Bible Jacob's mourning over Joseph is related in the Book of Genesis, 50: 10.

8. "You are witnessing indeed painful obsequities; but blessed Mary also stood by the cross of her Son, and the Virgin watched the passion of her Only-begotten. I read of her standing, I do not read of her weeping." *De con. Valent.*, 39 (cf. *Sancti Ambrosii Liber de Consolatione Valentiniani: A Text with a Translation, Introduction and Commentary* by T. A. Kelly, Washington, D.C., 1940, p. 209). Zappert, "Ausdruck des geistigen Schmerzes," p. 127, note 264, quotes further examples. In the *Speculum humanae salvationis* the Virgin's restraint is contrasted with the loud lamentations of Jacob over Joseph, whom he believed dead, as types of an interiorized and an openly shown pain:

> Jacob ex dolore scidit vestes suas licet exteriores
> Maria autem scidit vestimenta sua in vires interiores.

An oriental text of the fourth century, the so-called *Nicodemus Gospel* or *Acta Pilati* relates that the Virgin tore her face with her nails while mourning Christ (C. Tischendorf ed., *Evangelia Apocrypha*, Leipzig, 1876, p. 313), but this type did not gain influence until the late Middle Ages.

9. Isidor Pelusiotes (Epist., L, 2, 137) as quoted by Zappert, "Ausdruck des geistigen Schmerzes," p. 76, note 19.

10. Christians, instead, should recite Psalms. Cf. St. John Chrysostomus, *Oratio de sanctis Berenice et Prosdoce* (French translation, iii, pp. 377 ff.). See also his *In Joan. hom.*, 62 (Saint John Chrysostom, *Commentary on Saint John the Apostle and Evangelist*, translated by Sister Thomas Aquinas Goggin, New York, 1960, ii, p. 177): "However, neglecting to consider these truths [i.e. of Christian faith], you urge your maid-servants to tear themselves to pieces, as if by this means honoring the departed, while actually it is a mark of the greatest dishonor. Truly, honor for the dead does not consist in lamentations and moanings, but in singing the hymns and psalms and living a noble life." Similarly the *bardicatio* (the death song) was condemned because of its pagan character. Cf. Du Cange, *Gloss.*, i, 593, s.v. "bardicatio."

11. For the concept of the "gesture figure" (Gebärdenperson"), i.e. a figure whose only or principal function is to perform certain gestures, see Habicht, *Die Gebärden in englischen Dichtungen*, pp. 133 ff.

12. *In Joan. hom.*, 62 (English translation, ii, p. 177). Cf. also hom. 85 (Engl. trans., ii, pp. 427 ff.). In spite of the condemnation of the wailing women by the Fathers of the Church, these "gesture figures" persisted in the Middle Ages, and occasionally laws were issued against them. Cf. Du Cange, *Gloss.*, v, 716, col. 3; and Muratori, *Antiq. Ital.*, ii, 238 ff.

13. As Lommatzsch, "Darstellung von Trauer und Schmerz," p. 59, note 1, has shown, the "tears of the crocodile" were well known in the Middle Ages. Brunetto's *Tresor* (Lat. 185) says of the crocodile: "Se il vaint l'ome, il le manjuo en plorant." A Provençal Physiologus (cf. Appel, *Prov. Chrest.*, Leipzig, 1902, 125, 79) adds: "cant lo maniat, ela lo plora totz los temps que vieu." Medieval satire often depicts the widow who violently mourns her husband but who is easily consoled by another

man. In some of these works lively descriptions of mourning gestures are given, particularly those involving the hand.

14. Zappert, "Ausdruck des geistigen Schmerzes," p. 100, note 149, quotes the *Ritter mit dem Löven*, vv. 1310 ff. Cf. also St. John Chrysostom, *In Joan. hom.*, hom. 62 (Engl. translation, ii, p. 174): "What are you doing, O woman? Tell me, do you who are a member of Christ shamelessly strip yourself in the middle of the market-place, when men are present there?"

15. *Summa Theologica*, ii, 2, quaestio 168, art. 3. The whole *quaestio* bears the significant title "De modestia prout consistit in exterioribus corporis motibus." E. K. Chambers, *Medieval Stage*, Oxford, 1903, i, p. 58, rightly stresses that Thomas did not condemn the *histriones* altogether but only some of them. In the present context it is of importance that gesticulation is one of the criteria of condemnation.

16. The text of this Penitenial is reprinted in *ibid.*, ii, pp. 262–263.

17. Cf. *Book of Vices and Virtues*, ed. W. N. Francis, 1942, p. 287, as quoted by Habicht, *Die Gebärden in englichen Dichtugen*, p. 45.

18. Cf. *ibid.*, pp. 43 ff.

19. James, *Apocryphal New Testament*, p. 515.

20. *Ibid.*, p. 517.

21. *Ibid.*, p. 534.

22. *Ibid.*, pp. 542 ff. Cf. also E. J. Becker, *A Contribution to the Comparative Study of the Medieval Visions of Heaven and Hell, with Special Reference to Middle English Versions*, Baltimore, 1899, *passim*, especially pp. 41, 77, for many parallels.

23. Several Latin versions have come down to us (one full, the others abridged) as well as Greek, Syriac, Coptic, and Ethiopic versions. The *Apocalypse of Paul* has been translated "in almost every European language." Cf. James, *Apocryphal New Testament*, p. 525.

24. See C. Fritzsche, "Die lateinischen Visionen des Mittelalters bis zur Mitte des 12. Jahrhunderts," *Romanische Forschungen*, iii, 1887, pp. 337–369.

25. Cf. *Inferno*, Canto ii, v. 28 (the visit of the "chosen Vessel" to hell). An "Anonymous Contemporary" of Dante (*L'Ottimo Commento della Divina Commedia . . . d'un Contemporaneo di Dante*, ed. Pisa, 1827) mentions St. Paul in his commentary to this line (p. 16). The "Anonymous Florentine Commentator" (*Commento alla Divina Commedia . . . d'Anonimo Fiorentino del secolo XIV*, ed. P. Fanfani, Bologna, 1866) discusses in this context the possibility that St. Paul, while Christ appeared to him, also had a vision of hell (p. 39). Francesco da Buti, finally (*Commento di Francesco da Buti sopra la Divina Commedia di Dante Alighieri*, Pisa, 1858), explicitly refers to the "unapproved" book of St. Paul in his commentary on the image of the "chosen Vessel." He says: "Trovasi in uno libro, che non è approvato, che san Paolo andasse all' inferno, e per questo ne fa qui menzione l'autor nostro" (i, p. 63).

26. For the wide diffusion of this idea, cf. A. Dietrich, *Nekyia: Beiträge zur Erklärung der neutestamentlichen Petrusapokalypse*, Leipzig, 1893, pp. 205 ff. *The Apocalypse of Paul* (cf. James, p. 514) also relates that men and women who slandered the way of justice are hung by their tongues.

27. James, *Apocryphal New Testament*, p. 516.

28. E. Hennecke, ed., *Neutestamentliche Apokryphen*, Tübingen, 1924, p. 578.

29. *Ibid.*, p. 630, sentences 12–13. Cf. also p. 637, sent. 273: "One can see people who, in order to save the health of the whole body, cut off limbs and throw them away. How much better [to do this] for the sake of chastity." The *Sayings of Sextus* had been translated into Latin by Rufinus (died 410), who attributed them to Sixtus (or Xystus), the Roman bishop and martyr of the third century. St. Jerome rejected this attribution (in *Jerem.*, 4, 22; Migne, *Patr. Lat.*, 24, 817; and Ctesipe, 233, 3, *Patr. Lat.*, 22, 1152). St. Augustine discussed it several times and changed his mind as to its author (*De nat. et grat.*, 64; *Retract.*, 2, 42). The small pamphlet is preserved in many manuscripts—an additional indication that it was well known in the Middle Ages. Cf. Hennecke, ed., *Neutestamentliche Apokryphen*, p. 627.

30. *Ibid.*, p. 547.

CHAPTER V

1. L Volkmann, *Iconografia Dantesca*, London, 1899, p. 19.

2. *L'Ottimo Commento della Divina Commedia . . . d'un Contemporaneo di Dante*, ed. Pisa, 1827, p. 219. "E Pero il [i.e., the Minotaur] figurano li poeti mezzo uomo, e mezza bestia, per la vita bestiale; e per la tirannica il pongono, che mangiasse carne umane. . . ."

3. *Comedia de Dante degli Allaghieri col commento di Jacopo della Lana* (ed. L. Scarabelli), Bologna, 1886, p. 241. "Qui mostra l'ira de' tiranni iniqua, che a lor medesimi quando non puonno ad altri nuoceno."

4. *Commento di Francisco da Buti sopra la Divina Commedia di Dante Alighieri*, Pisa, 1858, p. 325. "Qui si dimostra che ben che la violenzia nasca da superbia, à per sua compagna l'ira sempre, come è chiaro a chi considera la violenzia; e notantemente dice *fiacca*: imperò che l'ira sí rompe l'animo dalla sua constanzia e dal dovere."

5. Della Lana, p. 500. "Chiaro appare come 'l fe' per ira."

6. Da Buti, p. 833. "Provocato da ira che la movea il dolore."

7. Seneca, *De ira*, I, i, 3–4: "But you have only to behold the aspect of those possessed by anger to know that they are insane. For as the marks of a madman are unmistakable–a bold and threatening mien, a gloomy brow, a fierce expression, a hurried step, restless hands, an altered colour, a quick and more violent breathing – so likewise are the marks of the angry man; his eyes blaze and sparkle, his whole face is crimson with the blood that surges from the lowest depths of his heart, his lips quiver, his teeth are clenched, his hair bristles and stands on end, his breathing is forced and harsh, his joints crack from writhing, he groans and bellows, bursts out into speech with hardly intelligible words, strikes his hands together continually, and stamps the ground with his feet" (ed. Loeb, pp. 107 f.). And III, iii 2: "Therefore our first necessity is to prove its foulness and fierceness, and to set what fury he rushes on working de-struction–destructive of himself as well and wrecking what cannot be sunk unless he sinks with it" (ed. Loeb, p. 259). Cf. also III, iii, 4 (ed. Loeb, p. 261) A seventeenth-century author, John Bulvver in his *Chirologia: or the Natvrall Language of the Hand*, London, 1644, p. 73, rightly says of Seneca that he was

"not unskilfull in this art of Chiromanticall Phisiognomie." I am indebted to Professor Janson for having called my attention to this important book.

Seneca's treatise exerted a deep influence on the later descriptions of the physiognomic features of anger. For an interesting example of this influence, see Martin of Braga, *De ira* (in *Martini Episcopi Bracariensis Opera Omnia*, ed. C. W. Barlow, New Haven, 1950, pp. 150–158), which begins with a chapter called "De habitu irae." This chapter is a summary of Seneca's descriptions. See the editor's note, p. 145.

8. *On Restraining Anger*, X. Quoted after the edition of A. R. Shilleto, p. 277.

9. Petronius (ed. Loeb), p. 325.

10. For *Ira* stabbing herself, see Prudentius, *Psychomachia* (ed. Loeb, i, pp. 287 ff). For the illuminated manuscripts of the *Psychomachia*, see R. Stettiner, *Die Illustrierten Prudentiushandschriften*, Berlin, 1895, 1905.

11. See A. Katzenellenbogen, *Allegories of Virtues and Vices in Medieval Art*, New York, 1964, fig. 59.

12. F. Schottmüller, *Giotto* (Klassiker der Kunst), 1904, pl. 89, fig. 51.

13. *Commento alla Divina Commedia . . . d'Anonimo Fiorentino del secolo XIV*, ed. P. Fanfani, Bologna, 1866, p. 185. The passage of Aristotle to which he refers is probably *Nicomachean Ethics*, III, viii, 10. The "Contemporary" Commentator (*L'Ottimo Commento*, p. 109) mentions Seneca in this context, without however referring to any particular passage.

14. Della Lana, pp. 172 ff. (in the introduction to the canto) and p. 180 commenting on vv. 115 ff: "Qui li fa noto Virgilio che questi così fatti funno quelli che al mondo funno vinti da ira; soggiungendo a sua notizia che anche sono genti sotto l'acqua nera, le quali per le loro percussioni, romori, e biastemmie faceano pullulare l'acqua, cioè gorgogliare, sì che si potea imaginar lor movimento."

15. Da Buti, pp. 216–218. "Ora è da vedere la convenienzia de' tormenti sopra notati nel testo, alla punizione del peccato dell' ira. . . . Ancora è conveniente che nell' inferno si percotano coloro, che nel mondo s'ànno percosso, e straccinsi con li denti a pezzo a pezzo, come ànno stracciato nel mondo lo prossimo, et ancora sè medesimi: imperò che molti irosi si percuotono, e mordonsi le mani." (p. 217).

16. I am very grateful to Professor Meiss for having put at my disposal the plates of the then not yet published book by P. Brieger, M. Meiss, C. Singleton, *Illuminated Manuscripts of the Divine Comedy*, Princeton, 1969, The following section is based on these plates. The illuminations are quoted according to the numbers in the plates (cited as *Ill. Mss.*) and the information contained in them. For the illumination discussed here, see *ibid.*, fig. 152a (Florence, B. N. Palat., 313, 28 r).

17. *Ill. Mss.*, fig. 156a.

18. *Ibid.*, fig. 158b (Vatican, lat. 4776, 42 v).

19. *Ibid.*, fig. 159f (Madrid, B.N., 10057, 22 v).

20. *Ibid.*, fig. 163a (Paris, B.N., it. 2017, 134 v).

21. *Ibid.*, fig. 163c (Paris, B.N., it. 2017, 147 r).

22. Cf., *ibid.*, fig. 150a, a Venetian manuscript of ca. 1345 (Budapest, Univ.

Libr., 33, 10 v); *ibid.*, fig. 151a, an Emilian or Paduan manuscript of the second quarter of the fourteenth century (London, B.M., Egerton 943, 21 v) where the Minotaur is a menacing animal with a human head; *ibid.*, fig. 153a, a Pisan manuscript from ca. 1345 (Chantilly, Musée Condé, 597, 95 r) where the Minotaur, of the usual type, is represented facing Dante and Vergil but does not bite himself; *ibid.*, fig. 154, a manuscript from Pisa (or Genoa?) produced ca. 1385 (Altona, Christianeum, 18 v) where the Minotaur shoots at Dante and his guide; *ibid.*, fig. 157b, an Italian work of the late fourteenth-century (New York, Morgan Libr., M. 676, 20 v) where the Minotaur shoots at Dante and Vergil; *ibid.*, fig. 158a, an Italian manuscript of the middle of the fourteenth century (Paris, Arsenal, 8530, 19 v) where the Minotaur is of the usual type but wears horns, is situated at the left-hand side of the illumination, above Dante, and shoots in the air (I am not sure that this figure represents the Minotaur; it may also be the figure of one of the Centaurs); *ibid.*, fig. 160a, an Emilian manuscript of the early fifteenth century (Modena, Estense, R. 4. 8, 16 v) where the Minotaur again shoots at the poets.

23. Cf. note 15.

24. *Ibid.*, fig. 89a (Paris, B.N., it. 2017, 59 r). In composition this group reminds one of the group of the damned in the *Last Judgment* in the Baptistry in Florence, See above, p. 11 ff.

25. *Ibid.*, fig. 84a.

26. "Contemporary" Commentator (*L'Ottimo Commento*, p. 72): "Questo Minos è in figura d'uno discreto e giusto giudice, siccone fu discreto e giusto Minos, Rè nell' isola di Creti. . . ." Jacopo della Lana, p. 151, says: "Or questo Minos moralmente parlando significa Giustizia ed è uno punitore di vizii." The Anonymous Florentine Commentator, p. 141, says: "Fu Minos rè di Creti, et figliuclo di Giove; et fu quasi il primo che feco legge: *Ut legum Minos justissimus auctor.* Fue giustissimo datore et facitore della legge; et per la sua giustizia diceono i poeti antichi, lui essere guidice d'inferno. . . ."

27. Da Buti, p. 151: "E però fingono i poeti che Minos, perchè fu giusto latore delle leggi, fosse giudice costituito dell'infernali; ma lo nostro autore finge che questo uficio sia di uno demonio, il quale per servare in parte la poesi de' poeti; cioè secondo il nome; egli lo nomina Minos: imperò che non è consonante alla ragione che li uomini sieno posti per giudici dell'inferno. E questo finge per fare verisimile la fizione; ma, quanto alla verità, nell'inferno non è bisogno di giudice: imperò che l'anima giudica sè medesima, come si parte dal corpo, di quello che è degna, constrignentela a ciò la coscienzia sua. E questo intese l'autore per Minos; cioè la coscienzia umana, la quale è vero giudice in ciascuno che la à. . . ." On the action of Minos' tail: "E sotto questo intende che la coscienzia con la coda; cioè con l'ultimo atto del peccato e della iniquità in della quale all' ultimo si muore, che come veleno serpentino uccide l'anima riconoscendo i gradi e i modi del peccato suo, sè medesima condanna di quello che è degna" (p. 152).

28. *Ill. Mss.*, fig. 125 (London, B.M., Yates Thompson 36, 14 r).

29. Da Buti, p. 233: "Questo finge l'autore, perchè, secondo la lettera, conveniente cosa è che lo iroso sostegna di quel che à fatto, e come è stato nocivo a sè

medesimo nel mondo; cosí è ancora nell'altro mondo. Ma allegoricamente vuol dimostrare essere questo medesimo nel mondo, che l'uno iroso strazia l'altro, e perchè per rabbia lo iroso in se medesimo si volge, e si morde, e si straccia."

30. *Ill. Mss.*, fig. 118b.

31. *Ibid.*, fig. 118c.

32. "Trocandosi coi denti; le membra l'uno all'altro, et ancor si può intendere a sè medesimi." Da Buti, p. 216.

33. *Ill. Mss.*, fig. 167b.

34. "Poichè l'autore ha trattato di coloro, che se medesimi uccisero, qui intende d'esemplificare di quelli, che usarono le violente mani nelle loro facultadi, e poi in loro persone." *L'Ottimo Commento*, p. 252.

35. *Ill. Mss.*, fig. 70a. (Holkham Hall, 514, p. 6). The Holkham Hall master seems in general to have been attracted by lamentation gestures and he represents them often. Cf. *ibid.*, fig. 57a (Holkham Hall ms., p. 5).

CHAPTER VI

1. Cf. K. Weitzmann, "The Origin of the Threnos," *De artibus opuscula XL: Essays in Honor of Erwin Panofsky*, New York, 1961, pp. 476–490, for the development of the Threnos theme in Byzantine art. Cf. also G. Millet, *Recherches sur l'iconographie de l'Evangile aux XIVe, XVe et XVIe siècles*, Paris, 1916, pp. 461 ff., 489 ff.

2. Cf. G. Swarzenski, "Italienische Quellen der deutschen Pietà," *Festschrift Heinrich Wölfflin*, Munich, 1924, pp. 128 ff., who distinguishes between the traditions of a "narrative Lamentation" and of a Lamentation as a "representative group" (p. 130). In the present context it is important to stress the obvious difference between Byzantine and Italian Lamentations, the latter being more agitated in movement and more dramatic in expression than the former. Cf. also Weitzmann, "Origin of Threnos," p. 490.

3. See W. Pinder, "Die dichterische Wurzel der Pietà," *Repertorium für Kunstwissenschaft*, xlii, 1920, pp. 145–163.

4. Cf. Swarzenski, "Italienische Quellen der deutschen Pietà," pp. 128 ff.; A. Bush-Brown, "Giotto: Two Problems in the Origin of his Style," *Art Bulletin*, xxxiv, 1952, pp. 42–46.

5. Cf. O. Siren, *Toskanische Maler in XIII. Jahrhundert*, Berlin, 1922, p. 57., and pp. 187 ff. In front of this "wildly mourning Magdalen," Siren believes (p. 189), one senses "einen Hauch von individuellem Pathos." This cross was perhaps painted by Enrico di Tedice.

6. Cf. Siren, *Toskanische Maler*, pl. 18, and pp. 84 ff. Siren assumes (p. 86) that Berlinghieri did not invent the gesture of throwing up the arms, but took it over from Byzantine art. Siren admits, however, that he could not find earlier examples.

7. See K. Weitzmann, "Thirteenth Century Crusader Icons on Mount Sinai," *Art Bulletin*, xiv, 1963, pp. 179 ff., and fig. 12.

8. Weitzmann, "Origin of the Threnos," fig. 16, adduces a mourning figure throwing up her arms from a Byzantine Gospel Lectionary (Vatican, MS gr. 1156,

fol. 194 v), executed in the eleventh or twelfth century. As Weitzmann, pp. 486 f., points out, the figure is removed from the main scene. The removal from the center seems also to agree with a certain restraint in the dramatic character of the gesture. The hands of this figure are only half-raised, so that the gesture, although clearly meant as an expression of mourning, retains something of the character of veneration and prayer. In Italian representations, the hands are usually thrown up vertically, and thus have a shriller expressive tone, excluding any connection with a cultic movement. Here I should like to mention an illumination from a Coptic manuscript in Paris (Bibl. Nat., Coptic 13, fol. 85) poorly reproduced by Millet, *Recherches*, fig. 493) representing the Descent from the Cross. On the right-hand side of the illumination two dramatically mourning women are represented, one standing behind the other. The figure in front holds a long garment to her face with one of her hands and with the other, outstretched diagonally, tears it in despair. The woman behind her raises both hands vertically and, in violent mourning, also tears a garment. Professor Weitzmann, who kindly discussed this illumination with me, believes that some of the gestures in Coptic 13 may be based on actual observation of nature.

9. A gesture that suggests rather than actually represents the tearing of the face appears also in another mural in the upper church of Assisi, the *Confession of the Resurrected*. Cf. P. Toesca, *Gli Affreschi della Vita di San Francesco nella Chiesa Superiore del Santuario di Assisi*, Florence, n.d., photograph 237. The exact meaning of the gesture is not clear; it may represent fear, but it may also be a formula for mourning.

10. For the revival of the "Hippolytus gesture," cf. Bush-Brown, "Giotto" (see above, note 4); E. Panofsky, *Early Netherlandish Painting: It Origins and Character*, Cambridge, Mass., 1953, p. 24 and note 2; idem., *Renaissance and Renascences in Western Art*, Stockholm, 1960, pp. 68, 152 f.

11. Cf. Panofsky, *Early Netherlandish Painting*, p. 24 and note 1.

12. Cf. a *Dormition* by Giotto and assistants in Berlin, Staatliche Museen (cf. B. Berenson, *Italian Pictures of the Renaissance*, London, 1963, fig. 52); a *Lamentation* by a contemporary of Giotto, whereabouts unknown (Berenson, fig. 76). For a further development of these figures in northern art, cf. below, p. 84.

13. An ancient work of art which comes close to Giotto's representation of the huddled mourners is the Etruscan Urn in the Archaeological Museum in Florence (E. Panofsky, *Tomb Sculpture*, New York, 1964, fig. 80 [our fig. 46]). However, both in size and in expression the mourners on this urn do not attain the significance which they have in Giotto's *Lamentation*. There are also interesting differences in detail. The mourners on the Etruscan Urn are not veiled; they do not turn toward the dead, but, sitting in profile, face each other. Cf. also the relief from the tomb of the Haterii in the Lateran Museum in Rome (Panofsky, *Tomb Sculpture*, fig. 99), famous for its realism, where the mourners assume an altogether different position to Giotto's figures.

14. See below, p. 89 ff.

15. See above, p. 58 ff, and figs. 28, 29.

16. Cf. the chapter on the Mourning Angels.

17. The history of this gesture (raising the folded hands to the cheek), which has not been investigated, seems to be interesting. In Greek and Roman art it does not seem to have occurred; in any case, it was not frequent. In ancient art a roughly equivalent gesture is the raising of *one* hand to the cheek or the chin (famous examples are the figures in the *Sarcophagus of the Mourning Women* in Istanbul). The raising of both hands, in a folded position and with intertwined fingers, is not mentioned either by H. Kenner, *Lachen und Weinen in der griechischen Kunst*, Vienna, 1960, or by G. Neumann, *Gesten und Gebärden in der griechischen Kunst*, Berlin, 1965. The gesture appeared, however, in medieval art before Giotto—e.g., on the bronze panels of the door of S. Zeno in Verona (cf. above, chapter II, note 19).

18. In addition to the general posture, which in Nicola Pisano's period is unusual enough to make certain a drawing from an ancient source, there are several details which clearly point to the Meleager sarcophagi. Bush-Brown, "Giotto," p. 43, has pointed out the following common features: the wild hair of the figure, the gathering of the garment on the shoulder, and the fastening of the shoulder strap.

19. See the literature quoted in note 10.

20. Cf. Berenson, *Italian Pictures of the Renaissance*, fig. 76 (location unknown). Among the many early Italian examples of throwing up the hands as a mourning gesture we may mention a remarkable diptych in the Treasure of the Cathedral in Toledo (cf. Berenson, *Studies in Medieval Painting*, New Haven, 1930, fig. 25, and p. 34), and in particular the mosaic in the dome of the Baptistery in Florence (*I Mosaici del Battisterio, III, Le Storie del Giudizio Finale*, Florence, n.d.). For the well-known influence of these mosaics on Giotto, cf. R. van Marle, *Recherches sur l'iconographie de Giotto et de Duccio*, Strasbourg, 1920, *passim*. Cf. also G. Millet, *Recherches*, (cf. above, note 1), figs. 533, 535 ff. For the diffusion of this gesture into Spain, cf. M. Meiss, "Italian Style in Catalonia." *Journal of the Walters Art Gallery*, iv, 1941, pp. 45–87, especially figs. 2b, 27. For this gesture in Northern art see below, note 52.

21. *Leon Battista Alberti on Painting*, trans. J. R. Spencer, New Haven, 1966, p. 78.

22. In Varchi's last lecture on the similarity and difference between poets and painters, reprinted in Barocchi, *Trattati d'arte de Cinquecento*, i, Bari, 1960, p. 55.

23. Vasari, *Le vite*, ed. Milanesi, i, p. 378 (the *vivezza* of Giotto's figures), p. 380 (their *vivi affetti*).

24. This impression, which one gets from the pictorial representations, is reinforced by the theological assumption that the Virgin's death is immediately followed by her ascension to heaven, the so-called *assumptio corporalis*. For a brief survey of recent theological investigations of this subject, cf. *Lexicon für Theologie und Kirche*, Freiburg, 1957–1967, i, col. 1071 f. (v. "Aufnahme Marias in den Himmel").

25. Berenson, *Italian Pictures*, fig. 52. While the raising of the folded hands to the face is obviously a mourning gesture, the clutching of the beard is quite ambiguous in meaning; it may represent a mild mourning gesture, but more likely it signifies "awe in presence of the divine". Cf. H. W. Janson, "The Right Arm of Michelangelo's 'Moses,' " *Festschrift Ulrich Middeldorf*, Berlin, 1968, pp. 241–247. Janson's interpretation (which does not refer to our picture) should be distinguished

from a different type of clutching the beard, as, for instance, in the Terence manuscripts (cf. above p. 18 ff). While Janson refers to patriarchal figures with long beards, which are often "combed" by the grasping hand, in the Terence manuscripts the beards are short and the figures rather seem to pluck at them. Here again one can see how similar gestures, distinguished from each other only by small details, can have quite different meanings.

26. Berenson, *Italian Pictures*, fig. 56. The gestures are: folding the hands, raising one hand to the cheek, and throwing up the hands. In the latter gesture, however, the hands are only half-raised. While in form the movement certainly resembles the restrained mourning gesture of moderately throwing up the arms (cf. Giotto's *Lamentation*, our fig. 37), it here expresses astonishment rather than mourning.

27. Brit. Mus., Royal xx, D. 1, reproduced in E. Panofsky and F. Saxl, "Classical Mythology in Medieval Art," *Metropolitan Museum Studies*, iv, 2, 1933, fig. 50, and pp. 161 ff. The traditional composition of the Lamentation even served as a model for so different a theme as a didactic illustration of the Anatomy — cf. W. Heckscher, *Rembrandt's Anatomy of Dr. Nicolaas Tulp*, New York, 1958, pp. 86 ff., and fig. 5.

28. Berenson, *Italian Pictures*, fig. 125.

29. *Ibid.*, fig. 140.

30. *Ibid.*, fig. 439.

31. *Ibid.*, fig. 398.

32. Vasari, *Le vite*, i, p. 655.

33. Weitzmann, "Origin of the Threnos" (cf. note 1, above), fig. 16.

34. R. van Marle, *The Development of the Italian Schools of Painting*, The Hague, 1923–1933, ii, fig. 63.

35. Van Marle, *Italian Schools*, ii, fig. 94.

36. This detail may be influenced by a passage in the *Meditations on the Life of Christ* (English trans. I. Ragusa and R. Green, Princeton, 1961, pp. 331 ff.), where it is, however, the Virgin herself who is prevented from reaching Christ by a multitude of people. In a fourteenth-century poem on the Passion by the Sienese poet Cicerchia (see below, chapter VII, note 24). pp. 348 ff., the Virgin breaks through the crowd to embrace Christ. Cf. M. Meiss, *Painting in Florence and Siena after the Black Death*, Princeton, 1952, p. 130.

The expressive force of Simone Martini's representations of the Passion has been noticed by Vasari, *Le vite*, i, p. 549.

37. This painting raises an interesting problem in the reading of gestures. To the left of the picture a group of holy women raise their hands to receive the body of Christ; to the right of the cross there is only one figure raising her hands. The gesture on both sides of the picture is very similar, yet the meaning is different. While the gestures to the left have, so to speak, a functional meaning (the figures are reaching for the dead body of Christ), the raising of the hands by the figure to the right is only a formula expressing mourning. The reading of a gesture is thus obviously based on the context.

38. E. Cecchi, *Pietro Lorenzetti*, Milan, 1930, p. 23, and pl. 60.

39. Van Marle, *Italian Schools*, ii, fig. 224; Cecchi, *Pietro Lorenzetti*. p. 74, and p. 27. Cf. also E. T. De Wald, "Pietro Lorenzetti," *Art Studies*, 1929, pp. 131–166, especially p. 162.

40. *Ibid.*, p. 162.

41. Cf. E. Mâle, *L'art religieux de la fin du Moyen Age en France*, Paris, 1931, pp. 6 ff; Panofsky, *Early Netherlandish Painting*, p. 23.

42. *Ibid.*, p. 30.

43. *Ibid.*, p. 31, and note 2. See also K. Morand, *Jean Pucelle*, Oxford, 1962, pp. 14 ff., who does not, however, discuss the huddled mourner. It should be noticed that Pucelle's mourner is neither veiled nor seen from the back, as are Giotto's mourners. Panofsky, *Early Netherlandish Painting*, p. 305 proposes Simone Martini's *Lamentation* (see fig. 41) as a possible model.

44. See above, p. 15 ff.

45. The figure belongs to the Altar of St. Mary in Cracow. Cf. T. Müller, *Sculpture in the Netherlands, Germany, France, and Spain: 1400-1500*, Baltimore, 1966, pl. 134, and p. 126.

46. Paris, Bibl. Nat., lat. 18014, fol. 286. Cf. M. Meiss, *French Painting in the Time of Jean de Berry*, London, 1967, fig. 175, and pp. 182 ff.

47. Meiss, *French Painting*, fig. 113, and Panofsky, *Early Netherlandish Painting*, fig. 34. For a discussion of the Passion Master, cf. Meiss, *French Painting*, pp. 160 ff.

48. Panofsky, *Early Netherlandish Painting*, p. 44.

49. Paris, Bibl. Nat., lat. 919, fol. 77. A good color reproduction in Meiss, *French Painting*, fig. 216.

50. J. Porcher, *Les Belles Heures de Jean de France*, Paris, 1953, pl. 79.

51. In the Walker Art Gallery in Liverpool. Cf. Panofsky, *Early Netherlandish Painting*, fig. 230, and p. 168.

52. I shall mention only a few examples of Flemish panel painting in the fifteenth century: a mourning woman in the Crucifixion (left part of the diptych by Jan van Eyck in the Metropolitan Museum in New York; the angels in the central panel of Rogier van der Weyden's triptych in the Gemäldegalerie in Vienna; the angels in a *Calvary* by a Follower of Rogier van der Weyden in Berlin, Kaiser Friedrich Museum; the mourning women in the Crucifixion (central panel of a Triptych) by a Follower of Rogier van der Weyden, Zug, Allberg Collection; the mourners in Hugo van der Goes, *Lamentation*, Vienna, Gemäldegalerie. Cf. Panofsky. *Early Netherlandish Painting*, figs. 301, 322, 398, 399, 457.

CHAPTER VII

1. Cf. E. Panofsky, "Imago Pietatis," *Festschrift für Max J. Friedländer zum 60. Geburtstag*, Leipzig, 1927, pp. 261–308; M. Meiss, *Painting in Florence and Siena, after the Black Death*, Princeton, 1952, pp. 132–156. Cf. also W. Pinder, "Die dichterische Wurzel der Pietà," *Repertorium für Kunstwissenschaft*, xiii, 1920, pp. 145–163.

2. Cf. R. Davidson, *Die Geschichte von Florenz*, i, Berlin, 1896, p. 759, note 1. Davidsohn refers to Lapo di Casti Glionchio, *Epistola osia ragionamento*, ed. Mehus, 1753, p. 47; I was unable to see this text.

3. Davidsohn, *Geschichte von Florenz*, pp. 758 ff.

4. For Boncompagni, cf. *Enciclopedia Italiana*, vii, p. 396, and L. Rockinger, *Briefsteller und Formelbücher des elften biz vierzehnten Jahrhunderts*, i, Munich, 1863, pp. 117 ff. As far as I know, only a section of Boncompagni's work has been published.

5. Cf. Rockinger, *Briefsteller*, pp. 141–143. I quote two passages: "In Tuscio fit excoriacio uultuum, pannorum scissio, et euulsio capilorum." Of Roman mourning rites he says: "Romani non intelliguntur de morte alicuius dolere, nisi cum urguibus partem excorcient faciei, capillos euellant, et usque ad umbilicum uel pectus uestimenta rescindant.

"Ducuntur etiam Rome quedam femine precio numario ad plangendum super corpora defunctorum, que conputatrices uocantur, ex eo quod sub specie rithmica nobilitates diuicias formas fortunas et omnes laudabiles mortuorum actus conputant seriatim. Sedet namque conputatrix aut interdum recta, uel interdum procliuis stat, super genua crinibus dissolutis, et incipit preconia laudum uoce uariabili iuxta corpus defuncti narrare, et semper in fine clausule ho uel hy promit more plangentis, et tunc omnes astantes cum ipsa flebiles uoces emittunt. Set conputatrix producit lacrimas precii, non doloris." A closer investigation of Boncompagni's text could probably yield interesting information.

6. Cf. Davidsohn, *Geschichte von Florenz*, i, p. 759, note 3.

7. *Ibid.*

8. Cf. *Decamerone*, introduction to the First Day.

9. Cf. F. Burger, *Geschichte des florentinischen Grabmals*, Strasbourg, 1904, fig. 44.

10. See above, chapter vi, note 13. It should be said again that, in representing the huddled mourners, Giotto profoundly altered his classical models, if he indeed drew from them. In our context, the main changes are: (a) the huddling of the mourners *around* the dead, as was the custom of his time, and not beneath the bier, as often found in classical art, and (b) the complete veiling of the mourners. Whatever the reasons for these changes (the first one may have been the result of a stylistic development), the result is a new image.

11. Many examples in G. Zappert, "Uber den Ausdruck des geistigen Schmerzes im Mittelalter," *Denkschriften der Kaiserlichen Akademie der Wissenschaften*, phil. hist. Klasse, v, Vienna, 1854, pp. 109 ff.

12. "Es sey gleich ein weib order magd, ob sie uber dergleichen ding klaget, die sollen ihre schleier, stirnbande, hauben oder andere so sie haben, von ihrem haupt reissen und ihr haar reuffen und ihre hende winden." Quoted after K. von Amira, *Die Handgebärden in den Bilderhandschriften des Sachsenspiegels (Abhandlungen der philosophisch-philologischen Klasse der Königlichen Bayerischen Akademie der Wissenschaften*, xxiii), Munich, 1909, p. 234. M. Herrmann, *Forschungen zur deutschen Theater geschichte des Mittelalters und der Renaissance*, Berlin, 1914, pp. 177 ff., distinguishes, in discussing medieval theater in Germany, between "labile gestures" which are

spontaneous but not fully crystallized in meaning, and "stabile gestures" which are clear-cut in meaning but lack immediacy. The gesture of the *Sachsenspiegel* obviously belongs to the second type, yet it is meant to convey spontaneous emotion.

13. E. Wechssler, *Die romanischen Marienklagen*, Halle a/S, 1893, p. 96, points out the interesting fact that many of the *Marienklagen* quote a verse from Jeremiah's *Lamentations*, i: 12 ("O vos omnes, qui transitis . . . "), and often either begin or conclude with this quotation.

14. Cf. Wechssler, Marienklagen; p.11. It seems to be generally accepted that the Western *Lamentations of the Virgin Mary*, both in Latin and in the vernacular Romance languages, developed under the influence of a similar Byzantine literary form, transmitted to the Latin world by the intermediation of the Crusaders.

15. "Manibus levabat in altum." Cf. *Liber de passione Christi et doloribus at planctibus matris ejus*, in Migne, *Patr. lat.*, vol. 182, cols. 1133–1142. The sentence quoted is on col. 1138. The *Lamentation* by Pseudo-Bernard prefigures some of the most popular motifs in the later development of this literary genre: e.g. the Virgin's swooning and falling to the ground.

16. The *Nicodemus Gospel*, in C. Tischendorfed ed., *Evangelia Apocrypha*, Leipzig, 1876.

17. Cf. A. Levasti, *Mistici del Duecento e del Trecento*, Rome-Milan, 1935, p. 174 ff. The Gospel of Matthew (27: 54), the only one to mention this particular event, only says that the captain and his soldiers were "dreadfully frightened." The Gospel of Luke (23: 48) says that the crowd "returned to the city beating their breasts."

18. *Meditations on the Life of Christ*, English trans. I. Ragusa and R. Green, Princeton, 1961, p. 342.

19. *Meditations*, p. 338.

20. *Meditations*, p. 360. Interestingly, the author of the *Meditations* says that on the same Sabbath "the Lady kept a tranquil and quiet mind, for she had the most certain hope of the Resurrection of her Son" (p. 349).

21. *Meditations*, p. 348.

22. In a *Lamentation of the Virgin* published by Coussemacker, *Drames liturgiques du Moyen Age: texte et musique*, Paris, 1861, pp. 190 ff., there are many regulations for the gestures to be performed by the Virgin. Among others there are the following instructions: "Hic percutiat pectus . . . hic manus elevet . . . hic percutiat manus." Cf. also A. d'Ancona, *Origini del Teatro Italiano*, i, Turin, 1891, pp. 37 ff. In the *Vita beatae virginis et salvatoris rhytmica*, which was widely read in the fourteenth, fifteenth, and sixteenth centuries, the Virgin Mary knows no restraint in her gestures of lamentation:

> Complocit manus, tundens pectus, stridat, clamat, plorat,
> Evulsit crines, peplum scidit, caput verberavit,
> Genas sulcans unguibus vestes laceravit,
> Modo cadit, modo surgit, nunc stabat, nunc sedebat,
> Sepe versus filium manus extendebat.

Quoted after Herrmann, *Theatergeschichte*, p. 208 (cf. H. von Vögtlin, *Stuttgarter literarischer Verein*, 180, 1888).

23. See above chapter IV, note 8.

24. Cf. *Cantari religiosi senesi del Trecento*, ed. G. Varanini, Bari, 1965, pp. 309–379. Professor Meiss kindly called my attention to this poem. For Cicerchia, cf. the editor's note on pp. 542 ff.

25. *Cantari religiosi*, p. 348.

26. *Ibid.*, p. 350. One cannot help noticing that even the description of the Virgin's swooning is more dramatic than in the *Meditations*.

27. *Cantari religiosi*, p. 353.

28. *Ibid.*, pp. 356 ff.

29. *Ibid.*, p. 359.

30. *Ibid.*, p. 361:

> Po' si batteva l'una e l'altra guancia,
> che diventar le fe' livid'e rosse.

31. *Ibid.*, p. 368.

32. *Ibid.*, p. 376.

33. See, e.g., his descriptions of the brown color of the Virgin's mantle (pp. 360, 364, stanzas 204, 221). And see also Cicerchia's observation that the dead Christ has lost his "pink color" (p. 364, stanza 181) which calls to mind Cennini's precept for the depiction of a dead man: "And do not apply any pink at all, because a dead person has no colour" (*The Craftman's Handbook*, trans. D. V. Thompson, Dover ed., 1954, p. 95). Some additional motifs in the poem may perhaps also be influenced by the imagery of contemporary art, as, for example, St. Peter hiding his face in his mantle (p. 376, stanza 269) and the trilingual inscription on the cross (p. 351, stanza 171). These are, of course, only conjectures.

CHAPTER VIII

1. See the metal reliquary in the Palazzo Venezia in Rome. Cf. E. Sandberg-Vavalà, *La croce dipinta italiana*, Verona, 1929, fig. 6. For the angels as the last addition to the traditional pattern of the Crucifixion, cf. *ibid.*, pp. 159 ff.

2. See, e.g., an early Byzantine ivory in Rome, reproduced by Sandberg-Vavalà, fig. 5.

3. I limit myself to mentioning a few well-known examples: the manuscript in St. Gall, of Irish origin, produced in the eighth century (often reproduced; cf. P. Thoby, *Le Crucifix des origines au Concile de Trente*, Nantes, 1959, fig. 22); the Sacramentary from Gelloe, also of the eighth century (Paris, Bibl. Nat., Ms. Lat. 12048; cf. Thoby, fig. 22); and a manuscript of the tenth century, where we still see the majestic angels, symmetrically hovering toward Christ, without any indication of mourning (Paris, Bibl. Nat., Ms. lat. 943; cf. Thoby, fig. 23).

4. For agnels resting their arms on the cross, see the tympanum at Champagne (Ardeche); cf. A. Kingsley Porter, *Romanesque Sculpture of the Pilgrimage Roads*, Boston, 1923, ill. 1186.

5. This theme has been studied several times. Cf. Cabrol-Leclercq, *Dictionnaire*, Paris, 1924–1953, xv, 2, cols. 1574–1583; L. Hautecoeur, "Le soleil et la lune dans les crucifications," *Revue archéologique*, cinquième série, xiv, pp. 13–32; cf. also *Revue d'histoire de religions*, 132, 1946, pp. 5–47.

6. When Sol and Luna are represented in more circumstantial form, as in the famous Carolingian ivory in Munich, no signs of mourning are discernible.

7. Ms. 709; cf. Thoby, *Le Crucifix*, fig. 29 bis.

8. Number 39 in the catalogue of the ivories in the Kaiser Friedrich Museum; cf. Thoby, *Le Crucifix*, fig. 44.

9. Paris, Bibl. Nat., Ms. lat. 10438; cf. Thoby, *Le Crucifix*, fig. 42.

10. For *Externsteine*, cf. E. Panofsky, *Die deutsche Plastik des XI. bis XIII. Jahrhunderts*, Munich, 1924, pl. 15.

11. See the ivory casket of Farfa (ca. 1071–1072), now in the library of the Benedictine monastery of S. Paolo fuori le mura. Cf. H. Bloch, "Monte Cassino, Byzantium and the West in the Earlier Middle Ages," *Dumbarton Oak Papers*, No. 3, 1946, pp. 165–224, and fig. 250. Bloch, p. 212, calls attention to the connection of the Farfa casket to S. Angelo in Formis. In the *Crucifixion* in S. Angelo in Formis there are in fact mourning angels. Another important example is the fresco of the *Crucifixion* in S. Urbano alla Caffarella, Rome (cf. G. Ladner, "Die italienische Malerei im 11. Jahrhundert," *Jahrbuch der kunsthistorischen Sammlungen in Wien*, N.F., v, 1931, pp. 33–160; the *Crucifixion* is reproduced in fig. 75, a seventeenth-century drawing of it in fig. 76). Ladner describes the gestures in S. Urbano alla Caffarella as "more vivid" than before and as emphasizing the action performed (pp. 111 ff). It is, therefore, interesting to notice that the angels, clearly addressing Christ, do not perform any violent gestures. It is, however, possible to read them as mildly mourning. M. Schapiro, *The Parma Ildefonsus*, New York, 1964, p. 47, note 190, stresses the Italian character of the angels above the cross, although this motif is influenced by Byzantine models.

12. K. Weitzmann, "Thirteenth Century Crusader Icons in Mount Sinai," *Art Bulletin*, xlv, 1963, pp. 179 ff, and figs. 1, 3, 5. Cf. also *idem.*, "Icon Painting in the Crusader Kingdom," *Dumbarton Oak Papers*, No. 20, 1966, fig. 22, 27, and an additional icon with violently mourning angels on fig. 9.

13. Weitzmann, *Art Bulletin*, p. 180.

14. C. Weigelt, *Giotto* (Klassiker der kunst), Stuttgart, 1925, pl. 59.

15. The motif of the angel tearing his hair persists in Duccio's school. See the *Crucifixion* in Leningrad (cf. C Weigelt, *Duccio*, Leipzig, 1911, pl. 61), where one angel holds his folded hands to his face in a gesture of weeping and with the other tears his braids.

16. I shall mention only a few additional examples, characteristic of different regions and stages of development. In the *Pala d'oro* there are two Crucifixions with angels (cf. W. Volbach, A. Pertusi, B. Bischoff, H. Hahnloser, G. Fiocco [under the direction of H. Hahnloser], *La Pala d'Oro*, Florence, 1965, nos. 57, 81). In the

earlier representation (fig. 81, pl. xliv), probably of the twelfth century (for the date cf. *ibid.*, 94), the angels turn away from the cross and perform gestures of astonishment and veneration. In the later *Crucifixion*, produced by a fourteenth-century artist (cf. fig. 57, pl. xxx, and cf. pp. 92 ff. for the date) the angels raise their mantles to their faces in the well-known mourning gesture—an additional confirmation that, at least in this region, the motif of the mourning angels emerged between the twelfth and the fourteenth century. The rendering of the mourning gesture in the later *Crucifixion* is rather clumsy. In fact, the angels do not hold their mantles in front of their face, but rather beside the cheek, perhaps another indication that the motif was not as yet fully crystallized in fourteenth-century Venice. It was, however, known in Venetian art; cf. the mosaic in the Baptistery in S. Marco, cf. Sandberg-Vavalà, *Croce dipinta*, fig. 9. In the fourteenth century the gesture spread, under Italian influence, into northern art. In the Crucifixion of Jean Pucelle's *Hours of Jean d'Evreux* (cf. K. Morand, *Jean Pucelle*, Oxford, 1962, pl. x) an angel makes a violent mourning gesture, the meaning of which is, however, not clear (rending of garment?). In the tympanum of the southern transept in Rouen, a work of the fourteenth century, mourning gestures are performed by angels, although it is difficult to establish their precise meaning. Cf. L. Lefrancois-Pillion, "Nouvelles études sur les portails du transept à la Cathédrale de Rouen," *Revue de l' Art Chrétien*, lxiii, 1913, pp. 281—299, particularly p. 288.

17. Iacopone da Todi, *Le Laude*, Bari, 1915, pp. 86 ff. The poem is called "Come li angeli si maravigliano de la peregrinazione de Cristo nel mondo." One of the early texts referring to the image of the mourning angels is the Pseudo-Bernard's *Lamentation of the Virgin*, a text that clearly mirrors the conflicting tendencies in the image of mourning angels. "Quaedam et illae plorabant feminac sanctae, quarum prior erat numerus, paucique virorum, qui ingerent Christum simul cum Virgine matre. Erant et angeli simul cum illa dolentes, taman tolentes si poterant, qui de pio dolentes, et justo dolore. Compatiebantur in more Christi dolendo, gaudentes quod redimeretur genus humanum, flabant, ut arbitror, amarissime mente conturbati, quia matrem Christi videbant tanto dolore teneri. . . . Flebat luctus, et planctus, et moeror ab angelis praesentibus ibi quales docebat luctus spiritus almos. Imo mirare, si angeli cuncti no flevissent etiam in illa beatitudine ubi est impossibile flere." Cf. Migne, *Patr. Lat.*, vol. 182, col. 1139.

18. The performance in the Coliseum took place in 1261. Cf. A. d'Ancona, *Origini del Teatro Italiano*, Turin, 1891, i, p. 114 ff.

19. *ibid.*, pp. 198 ff.

20. *Cantari religiosi senesi del Trencento*, ed. G. Varanini, Bari, 1965, p. 355 (stanza 186).

CHAPTER IX

1. Cf. H. W. Janson, *The Sculpture of Donatello*, Princeton, 1957, pl. 137, and pp. 95 ff.

2. Cf. F. Burger, "Donatello und die Antike," *Repertorium für Kunstwissenschaft*, xxx, 1907, pp. 1–13, particularly pp. 11 ff. For the sarcophagus, cf. Robert,

Sarkophagenreliefs, iii, 2, pl. 89, fig. 275, and p. 334, for an account of its history. The relief was drawn by dal Pozo. Janson, *The Sculpture of Donatello*, pp. 98 ff., says that the gestures in Donatello's *Entombment* are derived from early trecento art rather than directly from classical works. Our observations fully accord with this interpretation.

3. For an interesting discussion of such "inversions" in Donatello's work, cf. F. Saxl, "Die Ausdrucksgebärde in der bildenden Kunst," *Bericht über den 12. Kongress der Deutschen Gesellschaft für Psychologie in Hamburg vom 12.–16. April 1931*, Jena, 1932.

4. See, for example, the *Dead Christ with Two Angels* (Janson, *The Sculpture of Donatello*, pl. 314) where the mourning angels are desperately clutching their cheeks, a rather unusual motif in the representation of this specific theme. Note also the strong expressive agitation of the faces in all the panels of the High Altar.

5. For the general context, cf. above, p. 82 ff., 90.

6. Cf. Burger, "Donatello und die Antike," p. 11.

7. Burger, who claims (*ibid.*, pp. 11 ff.) that this female figure is Donatello's model, has overlooked, I think, the basic difference between stretching out the arms in one direction and flinging them apart in both directions; the first gesture has a "functional" meaning (preventing somebody from entering the scene) while the second has only an "expressive" character.

8. Janson, *The Sculpture of Donatello*, p. 208.

9. *Leon Battista Alberti on Painting*, trans. J. R. Spencer, New Haven, 1966, p. 78. In classical literature this picture has been described by Quintilian, *Inst. Orat.*, II, xiii, 14; Cicero, *Orator*, xxii, 74; and Pliny, *Nat. Hist.*, XXXV, xxxvi, 73–74.

10. Cf. Burger, "Donatello und die Antike," p. 12. For a good example of the Amazon sarcophagus, referred to by Burger, see C. Robert, *Die antiken Sarkophag-Reliefs*, Berlin, 1890–1919, ii, pl. 27.

11. The specific expressive character of this work may have some connection with its unusual iconography, which has been noticed by scholars. Cf. Janson, *The Sculpture of Donatello*, p. 217, for an account of the literature.

12. *Ibid.*, p. 406. The details of the gesture cannot be seen clearly, but its general meaning can be read with confidence.

13. Compare the arm of this figure with the respective figure in the *Crucifixion* in the Lower Church of St. Francis in Assisi (fig. 35).

14. Cf. M. Semrau, *Donatellos Kanzeln in San Lorenzo*, Breslau, 1891, p. 132.

15. The screaming mouth occurs several times in fifteenth-century sculpture. See, e.g., Neccolò dell' Arca's *Bewailing of Christ* in S. Maria della Vita in Bologna (cf. C. Seymour, Jr., *Sculpture in Italy: 1400–1500*, Baltimore, 1966, pls. 126, 125), a particularly good example. Here I should like to add a general observation. H. Kauffman, *Donatello*, Berlin, 1935, p. 182, says, rather poetically, that "Donatello's Crucifixions are Lamentations of the Virgin Mary." As far as gesticulation is concerned the Virgin Mary is certainly not the most dramatic figure in Donatello's Crucifixion and Entombments, a feature which I have tried to explain above. The most vehement actions are performed by figures who are less sacred. In this respect,

too, Donatello followed the tradition established by the fourteenth century.

16. Cf. Pope Hennessy, *Renaissance Sculpture*, London, 1963, pl. 122; L. Planiscig, *Venezianische Bildhauer der Renaissance*, Vienna, 1921, fig. 96 and pp. 95 ff.

17. Cf. *ibid.*, p. 104.

18. A bronze sculpture in the Kunsthistorisches Museum in Vienna. Cf. L. Planiscig, *Andrea Riccio*, Vienna, 1927, fig. 72 and p. 87.

19. Planiscig, *Riccio*, pp. 247 ff.

20. Planiscig, *Riccio*, p. 282.

21. The swooning Virgin is represented to the right of this relief, a motif that does not occur in Donatello's representations of the Lamentation or the Entombment. Needless to say, after the *Meditations on the Life of Christ* this became a common image in art and literature.

22. Cf. Planiscig, *Riccio*, fig. 329.

23. Cf. E. Wind and F. Antal, "The Maenad under the Cross," *Journal of the Warburg Institute*, i, 1937–1938, pp. 70–73.

24. Planiscig, *Riccio*, p. 288, believes that Mantegna's famous engraving the *Entombment* was of decisive importance for Riccio's compositions. As far as gestures are concerned, Riccio's representations of flung-up arms may indeed have been derived from Mantegna's engraving. A particular indication of such a connection may be seen in the billowing drapery surrounding the figure throwing up her arms. This drapery is prominent in Mantegna's engraving and occurs several times in Riccio's works (cf. the *Entombments* in Paris [Planiscig, *Riccio*, fig. 326], Vienna [*ibid.*, fig. 327], and especially another *Entombment* in Vienna [*ibid.*, fig. 335]). The billowing drapery of this particular figure does not occur in Donatello or does not have the same significance. On the other hand, however, Mantegna does not represent the tearing of the hair, which is a frequent gesture in Donatello's work. In another context Planiscig, *Riccio*, p. 286, says that Donatello's reliefs in the Santo were Riccio's main source of inspiration.

25. For Donatello, see Janson's analysis referred to above, note 2. For Riccio, cf.. Planiscig, *Riccio*, p. 388, who stresses that the gestures are closer in form and spirit to the quattrocento than to classical art.

26. Cf. R. Lee, *Ut Pictura Poesis: The Humanistic Theory of Painting*, New York, 1967, pp. 23 ff., 71 ff.; and see my study, "Der Ausdruck in der italienischen Kunsttheorie der Renaissance," *Zeitschrift für Asthetik und allgemeine Kunstwissenschaft*, xii, 1967, pp. 33–69.

27. *Leonardo da Vinci: Treatise on Painting*, trans, and ed. by p. McMahon, Princeton, 1956, p. 155 (nr. 420).

CHAPTER X

1. Cf. F. Burger, *Geschichte des florentinischen Grambmals*, Strasbourg, 1904; E. Panofsky, *Studies in Iconology*, pp. 183 ff; and *idem.*, *Tomb Sculpture*, New York, 1964, pp. 67 ff.

2. Panofsky, *Tomb Sculpture*, pp. 74 ff., 87 ff.

3. Cf. above Chapter IV, notes 8, 10.

4. Wailing scenes were indeed preferred by Renaissance forgers. Cf. a relief in the Louvre (see A. Baumeister, *Denkmäler des Klassichen Altertums*, 1885, i, fig. 325) still listed as genuine by Baumeister, but see Daremberg-Saglio, *Dictionnarie, des antiquités grecques et romaines*, Paris, 1873–1919, ii, p. 1387, note 22); a Venetian relief in the Este Collection containing two motifs derived from Michelangelo (cf. Planiscig, *Venezianische Bildhauer*, fig. 347, and E. Panofsky, *Hercules am Scheideweg*, Leipzig, 1930, p. 32) and a large *conclamatio* scene (cf. Planiscig, *Riccio*, fig. 490 and p. 388). And see O. Kurz, *Fakes*, New York, 1967, pp. 116 ff. However, no violent gestures are presented in these forgeries.

5. E. Mâle, *L'Art religieux de la fin du Moyen Age en France*, Paris, 1908, p. 417, quotes as the earliest example a representation on a tombstone bearing the date 1316 (I have been unable to investigate this example). By the middle of the century the *pleurants* are more frequent, reaching a climax in Claus Sluter's famous figures. For the penetration of these figures into Italian art, cf. Panofsky, *Studies in Iconology*, New York, 1939, pp. 185 ff.

6. Besides Sluter's figures (cf. H. Davies, *Claus Sluter*, Paris, 1959, pp. 19–26, 107–127, 170), see the Tomb of Philippe Pot in the Louvre (cf. Mâle, *L'Art religieux.*, fig. 229 and p. 419). Cf. also F. de Montemy, "Les pleurants bourguignons du musée de Cluny," *Les musées de France*, Bulletin, 1913, pp. 38 ff.

7. Their expression is best described by Mâle, *L'Art religieux*, p. 419: "Ils marchent d'un pas lourd, accablés par ce mort, qui pèse sur leur épaule, mais qui semble peser encore plus sur leur coeur. Rien de plus réel, rien de plus solide que ces huit chevaliers, massives comme des pillers romans, et, en même temps, rien de plus mystérieux."

8. Panofsky, *Tomb Sculpture*, pp. 70 ff., and fig. 291–199; Pleniscig, *Riccio*, figs. 485–489, 491–492, 495, and pp. 381 ff. For background and iconography (omitting, however, the scene of lamentation), cf. F. Saxl, "Pagan Sacrifice in the Italian Renaissance," *Journal of the Warburg Institute*, ii, 1939, pp. 346 ff., especially pp. 355 ff. Girolamo's friend, Fracastoro, eulogized him in a long humanistic poem.

9. The row of arches that here forms the background is a common motif in quattrocento sculpture, particularly in the school of Donatello. Its nonclassical quality becomes apparent when we compare this panel with the other scenes of the same tomb, particularly the *Sacrifice* or the *Funeral*. A classicizing element in the *Bewailing* is the putto who is trying to blow out the flame and, perhaps, the torches in the hands of some of the mourners.

10. Planiscig, *Riccio*, pp. 385 ff.

11. *Ibid.*

12. Cf. Vasari, *Le vite*, Milanesi ed., iii, pp. 259–260. And see Burger, *Das florentinische Grabmal*, pp. 394–398 (Excursus ix); E. Müntz, "Andrea Verrocchio et le tombeau de Francesca Tornabuoni," *Gazette des beaux arts*, 1891, 3e période, iv, pp. 277–287; H. Egger, *Francesca Tornabuoni und ihre Grabstätte in S. Maria sopra Minerva*, Vienna, 1934.

13. This has been noticed by Panofsky, *Renaissance and Renascences*, Stockholm,

1960, p. 68.

14. Müntz, "Andrea Verocchio," p. 283.

15. F. Schottmüller, "Zwei Grabmäler der Renaissance und ihre antiken Vorbilder," *Repertorium für Kunstwissenschaft*, xxv, 1902, pp. 401–408.

16. The drawing in the well-known Codex Coburgiensis, fol. 44. The sarcophagus is reproduced in C. Robert, *Die antiken Sarkophag-Reliefs*, Berlin, 1890–1919, iii, pl. iv, no. 22 (another example, a sarcophagus in the Villa Pamfili in Rome, *ibid.*, no. 23). For the history of the sarcophagus cf. Robert, p. 26. The sarcophagus has been in an open courtyard, Via de Monserrato 148–149, for a long time, and this fact probably explains its poor condition.

17. In the drawing in the Codex Coburgiensis the figure of Alcestis is rendered as that of a man.

18. This motif seems to have been particularly frequent in Venetian art. I shall mention a few examples in which the dead Christ is represented in a half-erect position, resembling that of Francesca Tornabuoni, while one of his hands is held up by an additional figure: Crivelli, *Pieta between Jerome and a Female Martyr*, Berlin (cf. B. Berenson, *Italian Pictures of the Renaissance: The Venetian School*, London, 1957, fig. 129); Crivelli, *Pietà*, Brera, Milan (Berenson, fig. 159); G. Bellini, *Pietà*, Vatican, Pinacoteca (*Ibid.*, fig. 216); G. Bellini, *Monochrome Pietà*, Uffizi (*ibid.*, fig. 239), seen more in frontal view; Antonello da Messina, *Dead Christ Upheld by Angels*, Venice, Museo Correr (*ibid.*, fig. 281); Antonello da Saliba, *Dead Christ Upheld by Angels*, Venice, Ducal Palace (*ibid.*, fig. 300); Cima de Conegliano, *Pietà*, Galleria Estense, Modena (*ibid.*, fig. 454, seen in frontal view). W. Heckscher, *Rembrandt's Anatomy of Dr. Nicolaas Tulp*, New York, 1958, p. 131, note 40, mentions the inclined position of Francesca Tornabuoni in connection with representations of the Anatomy.

A CONCLUDING REMARK

1. Cf. above, p. 42 and Fig. 18, and notes 14 ff. to Chapter VIII.

2. 315 J. P. Richter, *The Literary Works of Leonardo da Vinci*, Oxford, 1939, no. 608 (vol. i, pp. 353 ff.).

Index